Females in tl

Penelope Jackson

Females in the Frame

Women, Art, and Crime

Second Edition

Penelope Jackson
Tauranga, New Zealand

ISBN 978-3-030-44691-8 ISBN 978-3-030-44692-5 (eBook)
https://doi.org/10.1007/978-3-030-44692-5

Cover image: Portrait of Queen Victoria (1887) by Stephen Catterson Smith RHA (the
younger) (1849–1912), oil on canvas, collection of the Royal College of Surgeons, Ireland.
Destroyed in 1916
Cover design by eStudio Calamar

This Palgrave Macmillan imprint is published by the registered company Springer Nature
Switzerland AG
The registered company address is: Gewerbestrasse 11, 6330 Cham, Switzerland

For David, and our children Lucy and Harry

Acknowledgments

I am grateful to the following people for their assistance during the course of my research and writing. Many others are cited within the text. Direct contact and assistance came from: Kent Ball, Julia Bell, Paula Binns, Marianna Bullmore, Noah Charney, Christine Cloughley, Marc Cowart, Vincent Delieuven, Lauraine Diggins, Lynley Dodd, Guillaume Faroult, Michelle Frauenberger, Frances Jones, Susan Leyden, Michael MacDonald, Bryony Millan, Nancy Moses, Lynn Nicholas, Brian Pike, Malgorzata Pniewska, Kristen Schmidt, Moya Smith, Robert A. Smith, Simon Roberts, Arthur Tompkins, and James Wynne.

A special thank you to my daughter, Lucy Jackson, who was my first reader and editor. Her insightful opinions and ideas were gratefully appreciated.

Thank you to the team at Palgrave Macmillan, Lina Aboujieb, Emily Wood and Ellie Freedman, for their interest and editing.

And last, but not least, thank you to my family who have encouraged me in my pursuit to write this book.

Author Note

I have endeavoured to fairly represent the artists, dealers, galleries, museums, collectors, professionals, and others involved in matters written about in this book, and to seek permission where possible for use of sensitive content. In some cases, parties were invited to read a draft to confirm details. In other cases the person or organisation did not wish to engage in a dialogue or was deceased.

A Note About Currencies

Currencies have been given in the country where the crime/event took place or in the currency where the media report was filed.

CONTENTS

LIST OF FIGURES

Introduction: Writing Alternative Art Histories

My earlier foray into the murky underbelly world of art crime, *Art Thieves, Fakers & Fraudsters: The New Zealand Story* (2016), surveyed historical and contemporary art crimes committed in New Zealand. Men committed all but one of the crimes presented in my book. The exception was an unnamed British tourist in her mid-seventies, visiting New Zealand in 2013, who brazenly helped herself to a piece of fibre art on exhibition at the Lakes District Museum and Gallery, in the small South Island town of Arrowtown. Captured by the gallery's security cameras, the culprit was picked up the next day by the police, but allegedly she had already disposed of the stolen artwork (or in my opinion, posted it home to Britain).[1] The crime was motivated by personal greed and carried out with aplomb. Other women featured in my book, but as victims or in the form of those who helped curb and mitigate crimes, or who restored damaged works after a crime had occurred—in other words, on the receiving end of art crimes. It was being confronted with my own research that made me question more closely the subject of women, art, and crime. Was the New Zealand situation representative of the Western art world or was it that women were actively involved in committing art crimes, but were never caught? Or was it simply that their stories had not been told?

In 2015 Dr. Noah Charney, an art historian and authority on art crime, threw down the gauntlet for me. He noted in his book, *The Art of Forgery: The Minds, Motives and Methods of Master Forgers.*

1

> There is a decided lack of female forgers in this book; there are female
> accomplices and con men, but I know of no notable female forgers in the
> history of forgery.[2]

I picked up on his comment, taking it as an invitation for further investi-
gation and presentation of art crimes committed by women. Women are
very much underrepresented in the texts about art crime to date. Char-
ney's observation was a challenge (and his gendered use of *con men* raised
my antennae). It made me think and want to cast the net wider than
just art forgery, asking the question: is there a history of women and
art crime and, if so, what is it? Certainly in the last few decades more
women have been actively involved in researching, writing, and educat-
ing about art crime, but what *of* the actual committing of art crimes? If
there is such a history, why haven't women made it into the literature?
Could it be that Charney was right, that there aren't any female forgers
out there (or ones that we know about)? Or perhaps it is that the female
art forger has been too clever and escaped capture. Whatever the answers
were, Charney's provocation set me on a journey, for which I am grateful.
This book is not exhaustive—few books about art crime can be, given the
suspected large numbers of art crimes that go unreported or have incon-
clusive back-stories—but rather a beginning point in trying to present a
more well-rounded balanced history for us to look to in the future.

Art crime falls into three main categories: forgery, vandalism, and theft.
These are broad areas and the study of art crime, including how and why
it is carried out, are complex. This book presents case studies of those
women who destroyed art (*The Lady Destroyers*), mothered art criminals
(*The Mothers of All Art Crimes*), vandalised art (*She Vandals*), conned
artists and clients (*The Art of the Con[wo]man*), stole art (*The Light Fin-
gered*), forged art (*Naming Rights*), and those who used their profes-
sional positions to commit white-collar crimes in galleries, libraries, and
museums (*The Professionals*). *Afterword: Making a Noise About the Silence*
draws my conclusions together about gender and art crime as well as scop-
ing how art crimes are written about and how there is room for opportu-
nity to make change going forward. It also considers conditioning about
how we perceive art crime, gendered language associated with how art
crimes are documented, and how looking specifically at women—a first
of its kind—provides for a greater balance to the ongoing discourse.

This study, as suggested by its title, takes a broad approach rather than just lining up hardened art criminals. Since the 1970s, female art historians have made significant inroads into the documentation of women's art history. The exhibition and accompanying standalone catalogue, *Women Artists: 1550–1950* (1977) by Ann Sutherland Harris and Linda Nochlin, was trailblazing in terms of breaking the silence about the long history of unrecognised women artists.[3] Nochlin's 1988 *Women, Art, and Power and Other Essays* was both insightful and provocative. Whitney Chadwick's 1990 book *Women, Art, and Society*, provided a detailed survey of women artists from the Middle Ages up to the early 1980s. But it was the objective behind Rozsika Parker and Griselda Pollock's 1981 text *Old Mistresses: Women, Art, and Ideology's* thesis that inspired me:

> we are not concerned to prove that women have been great artists or to provide yet another indictment of art history's neglect of women artists. Instead we want to know how, and more significantly, why women's art has been misrepresented and what this treatment of women in art reveals about the ideological basis of the writing and teaching of art history.[4]

As a budding young art historian I found these texts a revelation, adding greatly to the 'story of art' as it had been taught to us according to the male-dominated discipline (both in content and those who delivered it). In many ways, my objective here is similar to those female art historians who went out on an exciting limb.

We know women have committed art crimes, just as there were always women artists at work. The problem is that their stories have been under-represented and silenced by men. Recently published, Dame Mary Beard's *Women & Power: A Manifesto* is one of the smallest yet most empowering books I have ever read. It strikes a chord, discussing female silence, though fortunately Beard is far from silent. Beard's sentiment encouraged me to tell the story of women, art, and crime. Feminist art historians and writers have provided exemplary role models; their commitment to telling under-appreciated art histories has been crucial in challenging the traditional male art history recorded and taught to generations. The 'new art history' as it was called in the 1980s was both refreshing and exciting, but we still have a long way to traverse. I maintain that where there is, and as long as there is, an art history there has been a history of art crime. Art crime is very much part of any art history and, as we know, up until the 1970s art history was not very welcoming of the inclusion of women

artists. We are still making up for lost time, and writing about women, art, and crime is hopefully part of redressing some of the imbalance, and providing the back-stories to our art histories.

Sourcing information about art crime is heavily reliant upon what the media feeds us. Many art crimes are reported in a way that prioritises entertainment value before specific details and due to the length in time cases take in the legal system we don't always receive the complete story. Not specific to gender is the difficulty in obtaining information about art crimes; so often stakeholders, and in particular institutions, avoid answering queries. This can be frustrating, preventing the writer from exploring and offering every possible angle to the reader but from their perspective the reopening of old wounds isn't good publicity. And sometimes the information just isn't available, having been lost over time. For instance, many times I tried unsuccessfully to obtain from the Louvre the title of the Nicolaes Berchem painting that was damaged by Valentine Contrel in 1907. Perhaps they just don't know or don't want to open up old cases. Historically, records kept by institutions aren't as accurate as they are in our digital age. For others, getting asked about art crimes comes as a complete surprise. When I enquired about a portrait of Winston Churchill that was disposed of by President Roosevelt (or by someone else at his request) in 1944, the collections manager of the Franklin D. Roosevelt Presidential Library confirmed it had been disposed of, though she exclaimed surprise, having never heard the story before.

Art crimes have been committed for as long as art has existed, yet the study of art crime is relatively new. Early scholarship soon identified patterns, establishing that thieves and forgers, for instance, fitted a particular 'type'. But this type, criminal profiling, was based on a male construct. To achieve a better understanding of female art criminals we therefore have to look at them within the context of their male counterparts, as there is no model (yet) for the female art criminal. But there are definite characteristics and patterns that have clearly emerged that can be attributed to male art criminals—for they have been studied in more depth. This could be due in part because men have been caught committing crimes or that their art crime activities have involved the Old Masters, of which we are conditioned to believe are more valuable. Generally the art criminals that have been written about—and profiled—are male, of European ethnicity, middle-aged, could be a failed artist or have a modicum of technical artistic skills, and in some cases have experienced a trauma in their life whether it be a broken marriage or a rough upbringing. This could of course say

more about who reports crimes, the criminals that are caught, the priorities of police, and how their stories are told. The art criminals themselves and their biographers have endorsed the profile over time. And though this particular model does not fit the female art criminal, from the case studies presented in this book there are definite similarities when analysing the motivations, specifically for art thieves and art dealers.

Various scholars have tried to justify the 'gentleman thief'—the variety seen in the movies—but in reality they are just thieves with ulterior motives, taking what does not belong to them. Some live in a fantasy world believing that stealing art is a better class of crime, but as art crime expert and Hong Kong senior police inspector Toby Bull comments:

> A specialised fine art thief (if one such even exists) is an uncommon type and, like with the media's portrayal of a Mr Big, is also given something of a top billing in both film and fable. Somehow, these criminals are seen in a different and more empathetic light, loveable rogues or dandy foppish gentleman. The reality could not be further from the truth. Most art thieves are no different to those who partake in the most base and villainous crimes of society.[5]

As more people analyse and write about art crime, a clearer picture of the art criminal has evolved; romantic mythologising has begun to retreat. By adding the female art criminal into the mix, perhaps the myth will be further displaced.

In comparison with other areas of art crime, there is a host of non-fiction accounts about the male art forger. Many art forgers view themselves as clever and talented, delighting in telling of their own journey to the dark side of the art world. Such forgers who have come out and told their story include: Stéphane Breitwieser, Shaun Greenhalgh, Eric Hebborn, Tom Keating, Ken Perenyi, John Myatt, and Han van Meegeren to name but a few. They want to be recognised, trying to claim celebrity status, and make money from selling their stories and thus validating their crimes. The art forger has a common disdain for the cultural elite and art market. Often one of their objectives is to try to make fools out of art professionals. And once they have survived the ordeal of being charged, convicted, and sentenced they manage to resurrect their art fraud career. Shaun Greenhalgh still paints 'forgeries', but they're now made for charity. Wolfgang Beltracchi made a movie about his life as a forger and his

time in prison where he was allowed to continue to paint. Tom Keat-
ing and John Myatt have both had their own television series, showcas-
ing their painting skills. And Karl Sim—New Zealand's first convicted
art criminal—painted large-scale paintings (copies of New Zealand's very
own old master, Charles Frederick Goldie) on the public toilets in his
local town, fulfilling his community service sentence. He went on to co-
write a book, with a journalist, to boast amongst many things that he had
copied no less than fifty New Zealand artists and sold them as authentic
works (though they vary hugely in standard).[6] These works still populate
public and private collections today and Sim's story is mirrored by a host
of others internationally.

Researching and writing about art crime has issues, particular to the
type of content. Distinguishing fact from fiction is the ultimate goal
especially with so much sensationalising around the reporting of art
crimes. Other hurdles include not writing anything libellous and being
stonewalled by those who don't want to talk or provide information.
There is also the problem that so much art remains missing or its own-
ership under dispute, or generally just the many crimes that remain
unsolved. But there is an added hurdle when researching women, art,
and crime—their names. Not as common today as it once was, historically
women took their husband's name when they married. This tradition has
given many females who commit art crimes another option of name to
use and effectively hide behind. Some have found that a return to their
birth name works well, making them less traceable and not attached to
another whose name is perhaps already known to the police and the art
world. Examples found here include Olive Greenhalgh who conveniently
reverted to Olive Roscoe, her birth name, to make her story more cred-
ible when trying to sell her son's (Shaun Greenhalgh) fraudulent works.
Marielle Schwengel took her former husband's name back to become
Marielle Breitweiser (mother of big time art thief Stéphane Breitwieser).
Margaret D. H. Keane, of the 'Big Eyes' fame, was born Peggy Doris
Hawkins. She has also gone by the names of Peggy Ulbrich and M. D. H.
Keane. Today, she is Margaret McGuire. And Australian artist, Elizabeth
Durack (born Elizabeth Durack Clancy) became Eddie Burrup. Perhaps
Elizabeth Durack had a penchant for using a masculine name for in her
1984 essay, 'Australia's Third World', about life on Aboriginal desert set-
tlements, she published under the name of Ted Zakrovsky.[7] Or perhaps
she thought she might be taken more seriously by using a male 'voice'.
On the rampage, and damaging works from prized collections, several

of the British Suffragettes went by completely different names. Maude Kate Smith became Mary Spencer and Freda Graham was officially Grace Marcon. Mary Richardson's alias was Polly Dick. In the media she was referred to as Slasher Mary, the Ripper, and the Slasher.[8] Historically, and especially for politically active women, going by an alias saved their families from embarrassment. For the female art criminal, using another name or alternative options assists in avoiding detection. Anonymity can make for convincing sounding back-stories to artworks and potentially greater sales opportunities. For the researcher though, the more names to deal with (and the different variations in spelling) can be a nightmare.

Unlike their female counterparts, many male art criminals take pride in telling their own story. Memoirs abound, and they proudly use their real names. Many have paid the price for committing art crimes, serving their time and yet, whether embarking on a new life or not, they keep their name. Shaun Greenhalgh and Ken Peryani are good examples, though we might question that purchasing and reading their memoirs, and others of a similar ilk, gives criminals positive reinforcement for their criminal past. Noah Charney also confirms this nuance in relationship to forgery and the media:

> If anything, the media fascination with forgers provides an active incentive for those considering forgery. If the media collectively sternly condemned forgers rather than applauding their exploits, it would be a step in the right direction.[9]

To date, the interdisciplinary study of crimes against art has been examined in a variety of ways: by genre (forgeries, vandalism, theft), by motive (greed, power, profit, politics), by geographical location (specific to countries or civilisations), by type of location (museum, gallery, archaeological site), by medium (paintings, sculptures, rare books, artefacts), by individuals and/or individual events, and by time period (various world wars being a popular one). As diverse as this list appears, for the most part they are male-dominated discourses. Prior to art crime becoming a subject area in its own right, such crimes were captured (or buried) within other genres. For instance, Suffragette Mary Richardson's art vandalism was explored within the history of the British Suffragettes as well as in her autobiography. Clementine Churchill's contribution to the catalogue of art crimes can be found, albeit perfunctory, in her biographies that posit her as the wife of statesman Sir Winston Churchill. And Elizabeth

Durack's confession was announced in the mainstream Australian art journal, *Art Monthly Australia*. And so the art crimes, carried out by women, were scattered and thus didn't offer a comprehensive picture. My aim is to make female-centric art crimes more easily accessible. The women have been organised into groupings that both call on earlier models such as vandalism and theft, and capture them under different umbrellas such as mothers and professionals. This allows for further insights into motives and outcomes, as well as new perspectives on former gendered tropes.

The women featured in this book are only part of what I suspect is a huge catalogue of women involved with art and crime. Those selected were done so for both their scale and diversity of crimes, as well as the motivations behind committing crimes against art. Like those feminist art historians who broke new ground in the 1970s, all new journeys have to have a beginning point. Therefore whether gender has a significant bearing on the types of art crimes committed, or the manner in which they are committed, is at least worthy of interrogation and consideration. For me this book brings together my art historical interests in women and art crime. I hope others enjoy my findings and perhaps can add to the catalogue of case studies presented here to complete an even bigger picture.

Notes

1. Penelope Jackson, *Art Thieves, Fakers & Fraudsters: The New Zealand Story*, Wellington: Awa Press, 2016, p. 162.
2. Noah Charney, *The Art of Forgery: The Minds, Motives and Methods of Master Forgers*, London: Phaidon, 2015, p. 14.
3. Ann Sutherland Harris and Linda Nochlin, *Women Artists 1550–1950*, New York: Alfred A. Knopf and Los Angeles County Museum of Art, 1977.
4. Rozsika Parker and Griselda Pollock, *Old Mistresses: Women, Art, and Ideology*, New York: Pantheon, 1981, p. xvii.
5. Toby Bull, 'Methods of Profit: Rewards, Ransoms and Buy-Backs–Knowing the Rules of Engagement', in *Art Crime and Its Prevention* (ed. Arthur Tompkins), London: Lund Humphries, 2016, pp. 48–49.
6. Karl Sim and Tim Wilson, *Good as Goldie: The Amazing Story of New Zealand's Most Famous Art Forger*, New Zealand: Ariel, 2003.
7. Ted Zakrovsky, 'Australia's Third World', *Quadrant*, April 1984, pp. 38–41.
8. Dario Gamboni, *The Destruction of Art: Iconoclasm and Vandalism Since the French Revolution*, London: Reaktion, p. 96.

9. Noah Charney, *The Art of Forgery: The Minds, Motives and Methods of Master Forgers*, London: Phaidon, 2015, p. 250.

SELECTED BIBLIOGRAPHY

Beard, Mary. *Women & Power: A Manifesto*. London: Profile, 2017.

Bull, Toby. 'Methods of Profit: Rewards, Ransoms and Buy-Backs—Knowing the Rules of Engagement' in *Art Crime and Its Prevention* (ed. Arthur Tompkins). London: Lund Humphries, 2016.

Chadwick, Whitney. *Women, Art, and Society*. London: Thames & Hudson, 1990.

Charney, Noah. *The Art of Forgery: The Minds, Motives and Methods of Master Forgers*. London: Phaidon, 2015.

Greenhalgh, Shaun. *A Forger's Tale*. London: Allen & Unwin, 2017.

Harris, Ann Sutherland and Linda Nochlin. *Women Artists 1550–1950*. New York: Alfred A. Knopf and Los Angeles County Museum of Art, 1977.

Jackson, Penelope. *Art Thieves, Fakers & Fraudsters: The New Zealand Story*. Wellington: Awa Press, 2016.

Nochlin, Linda. *Women, Art, and Power and Other Essays*. London: Thames & Hudson, 1989.

Parker, Rozsika and Griselda Pollock. *Old Mistresses: Women, Art, and Ideology*. New York: Pantheon, 1981.

Perenyi, Ken. *Caveat Emptor: The Secret Life of an American Art Forger*. New York: Pegasus, 2012.

Smith, Dominic. *The Last Painting of Sara de Vos*. Australia: Allen & Unwin, 2016.

Zakrovsky, Ted. 'Australia's Third World', *Quadrant*, April 1984.

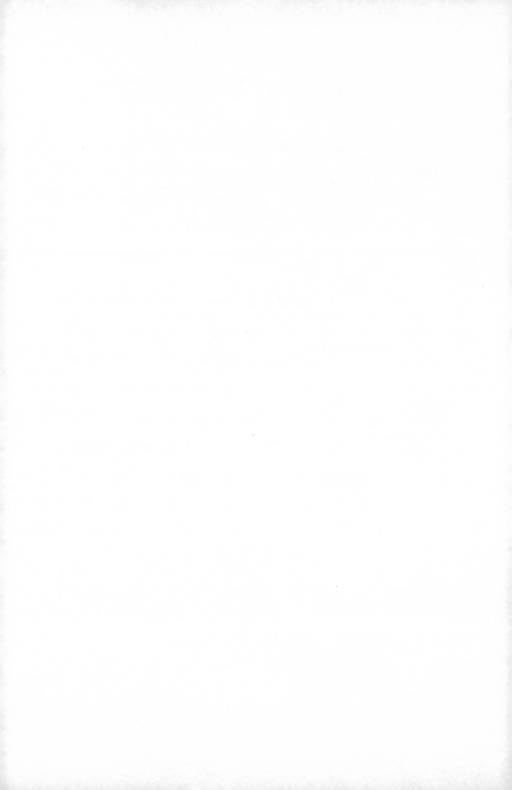

The Lady Destroyers

Lady Clementine Churchill went to great lengths to protect the image of her husband, Sir Winston Churchill. This included destroying images of him. She wasn't the first woman, and won't be the last, to completely destroy a work. Destroying an artwork is the final step; obliterating it rather than vandalising it. When a work is vandalised there is a glimmer of hope that it can be restored to something close to its former state. Furthermore, the intentional destruction of an artwork—as presented in this chapter—is carried out for a variety of known and unknown reasons. Destruction of art, in this context, does not include works destroyed over time by environmental factors or by accident such as a fire or people accidently damaging them. Some works are destroyed very publicly, no secrets barred; others more discreetly, all knowledge kept secret.

The objectives for people destroying art can include: anger, dislike of the artist and/or the image, getting rid of evidence if the art is 'hot' (see the following chapter *The Mothers of All Art Crimes* for extreme examples of this), social protest, warfare, reminders of relationships that have soured, to reduce supply of an artist's repertoire to increase value and therefore increase profit margins. And lastly, perhaps sometimes there is no obvious reason for the destruction of an artwork carried out by someone who has mental instability, or if there is a reason, it's not made public. Artists are also known to destroy their own work on occasion if they feel it is sub-standard or they've changed direction, but this is their prerogative as owners of the artwork. Georgia O'Keeffe (1887–1986) destroyed her own work in a bid for her reputation to remain strong. Allegedly O'Keeffe

© The Author(s) 2020
P. Jackson, *Females in the Frame*,
https://doi.org/10.1007/978-3-030-44692-5_2

also destroyed a large number of her former husband Alfred Stieglitz's (1864–1946), photographic negatives at his request, as he didn't want anyone else to print his images.[1] Again, such decisions made by the artist himself or herself are intentional and legitimate. As my research demonstrates, evidence shows that women who are closely linked, or related, to the artist or subject of the artwork are more likely to destroy it.

JACQUELINE BULLMORE

Researching New Zealand artist Edward Bullmore (1933–1978)—whose work coincidentally introduced me to art crime in New Zealand for 150 of his works are still unaccounted for—I discovered that a couple of his works had been destroyed by his widow, Jacqueline. This was intriguing to me because it seemed at odds with a great love story of two art school students who had married, had a family, only to be torn apart by Edward Bullmore's early death at the age of 45 years. Jacqueline dedicated over a year to cataloguing her husband's work; she was devoted to his memory and legacy, so then why did she destroy two of his works? The works were: a painting, *Man in the Sun* (1962)[2] and a ceramic life-size bust, *Gigliola* (*The Artist's Daughter*) (c.1974).[3] Having curated a major retrospective of Edward Bullmore's work in 2008, I have a reasonable knowledge of his oeuvre and would suggest that *Man in the Sun* was a very significant work (see Fig. 2.1). Importantly, it demonstrates the artist's adaptation and adoption of Surrealist stylistic traits to his work in the early 1960s. Painted in London, against the backdrop of the Cuban Missile Crisis, nuclear warfare was at the forefront of his mind. His fears come through in this work as seen in others from the series titled, *Cuba Crisis*. Equally, the ceramic bust was a rarity—though he had worked in ceramics off and on during his career, he only ever completed one other bust, which was of his elderly mother. The sitter of the now destroyed bust, Gigliola, was 15 years of age at the time the bust was moulded.

In 1990, Jacqueline Bullmore took the year off to catalogue Edward Bullmore's entire collection. She had found the responsibilities of caring for the collection onerous but during this time she made it her focus to document each and every work from those made in his early years at secondary school up to the works left unfinished in his studio when he died. Each work has a catalogue number, with details about size, media, and ownership. This information has been essential to understanding and

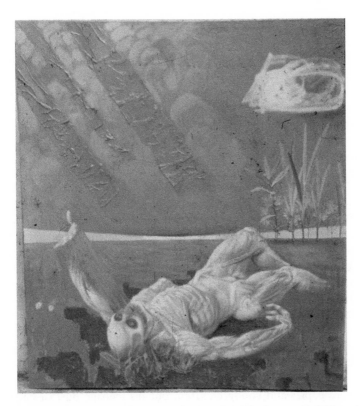

Fig. 2.1 Edward Bullmore, *Man in the Sun* (1962), destroyed. This painting is kindly reproduced with the permission of Marianna Bullmore (*Photographer* Edward Bullmore)

studying the artist's large volume of work. Interestingly, *Man in the Sun* does not appear in the unpublished catalogue raisonné and so we can assume that the work was destroyed prior to the catalogue being completed. It's as if the work never existed. However, *Gigliola* (*The Artist's Daughter*) does feature in the catalogue, though the word 'destroyed' has been added later, perhaps in the late 1990s when Jacqueline Bullmore destroyed it. Jacqueline Bullmore's dedication to the catalogue demonstrated her commitment to her husband's legacy, and yet she destroyed two of his works. It begs the question: why?

Many years on and now an octogenarian, Jacqueline Bullmore cannot contemporaneously offer an explanation around the reasoning behind the destruction of *Man in the Sun*. The image is raw and visibly disturbing; a skeletal corpse lies cast on the ground in a leafy London park, surrounded by soil that is grave-like. The foreshortened figure demonstrates Edward Bullmore's ability as an artist, as does the musculature evidence of his formal art education. Having lost her husband at an early age, death as a theme was perhaps all too raw for Jacqueline Bullmore to live with, and so she burned the painting.

Man in the Sun is apocalyptic and futuristic; during the early 1960s Edward Bullmore was increasingly nervous about the possibility of impending nuclear warfare. In my opinion the image was a game changer in Bullmore's oeuvre. He was on the verge of discovering something new and artistically adventurous. It was this very content that makes it such a significant artwork historically but is also why, perhaps understandably, his widow did not like it. The work would have fitted well in a public collection given Edward Bullmore's experimentation with Surrealism. This would have been a better destiny than the fate bestowed upon it—incineration.

Gigliola (The Artist's Daughter) was destroyed for a different reason. In short, Jacqueline Bullmore and her eldest daughter had fallen out with each other. Emotions ran high and Jacqueline Bullmore smashed the ceramic bust. Edward Bullmore drew and painted their children when they were babies and young children, but his teenage bust of Gigliola is unique to his body of work. Though Jacqueline Bullmore had her own reasons for destroying both these works at the time, it is difficult to accept them. Perhaps *Man in the Sun* reminded Jacqueline Bullmore of Bullmore's own mortality. Too much to bear, she put the work out of sight. Fortunately there is an image of *Man in the Sun* in existence. Sadly, this is not so for *Gigliola (The Artist's Daughter)*, and so we can only wonder what it might have looked like.

This case, and the others discussed in this chapter, raises the question about who, if anyone, has the right to destroy art. The stewardship of collections can be cumbersome and an emotional strain for those who inherit such a responsibility, but consideration needs to be given to the following: the artist's legacy, art history—missing works can skew the history of an artist's body of work—other family members, public reception to an artist's oeuvre, and lastly, the possible value of other works by the artist especially if a destroyed work is one of a series. The two destroyed Edward

Bullmore works can be viewed as selfish acts by the artist's widow, who herself has been the victim of art crime when her brother-in-law who took over the guardianship of the collection in 1991, went on to sell, exchange, and gift many works without handing on the proceeds to Jacqueline Bullmore, leaving her financially strapped. But as in the other examples in this chapter, familial ties are often very much part of the back-story to the destruction of artworks.

Violet Organ and Lucie Bayard

When the prolific American artist Robert Henri (1865–1929) died, he left behind a large volume of work in his studio. Henri belonged to the early twentieth-century New York-based school of painting known as the Ashcan School. He married fellow artist Marjorie Organ (1886–1930) in 1908. Their marriage was one filled with art and travel. One of Henri's students, Lucie Bayard[4] who was the subject of his work, and he of her work, accompanied the couple on two trips to Marjorie's homeland, Ireland. Bayard studied and painted in New York City and Woodstock, New York; her repertoire included shipping scenes, still life, and portraiture. Robert and Marjorie died just a year apart. Childless, their estate was left to Violet Organ,[5] Marjorie's spinster sister. In addition, Organ inherited a small fortune along with Henri's collection of works and took up residence in Henri's former studio. Organ 'determined that she would review the large cache of his unsold paintings and destroy those of "inferior quality"'.[6] Quite how she decided on the quality is not documented. With her artist friend Bayard, the two women set about destroying a huge number of works.[7] Lawyer, Joseph L. Sax, notes that the pair destroyed 550 works in total.[8] However, art crime specialist John Conklin disputes Sax's statistic, himself giving the greater figure of somewhere in the thousands.[9] The remaining works numbered 3450. However big the final count of destroyed works was, it was intentional. Organ, assisted by Bayard, slashed the burned paintings (cut down in size to fit into the fireplace) that did not fit their criteria of superior quality. What makes matters worse for the artist's legacy is the fact that his works were burned in his very own studio. To streamline the process of destruction, Organ had a rubber stamp made with the word DESTROYED emblazoned on it, to label those works destined for the fire.

But the question remains, why were Henri's works destroyed? According to the destroyers, quality control was the reasoning. However, the

answer has more to do with simple supply and demand. Selfishly, if supply is smaller, this increases demand for the deceased artist's work, so that prices increase and thus Organ's potential profits were greater from the sales of her brother-in-law's works. Over time she did gift the occasional work; for example in 1949 she donated a life-size full figure study, *Young Woman in White* (1904) to the National Gallery of Art, Washington, DC.[10] Perhaps such philanthropy, and regularly loaning works for exhibitions, was a way to quash any feelings of guilt around her burning spree.

Organ's intentions were extraordinarily selfish. With her own self-interest at the forefront of her decision she clearly did not contemplate the images that she destroyed. Nor did she consider Henri's oeuvre, their importance to art history, and reception by future audiences. Arguably all artists have bad days. But is that good enough reason for a sister-in-law to dictate posthumously what these were and then destroy a large cache of work? I think not. There is no record of the works that went up in flames but earlier writers have noted a couple of subjects including a portrait of Emma Goldman (1869–1940), the American anarchist, political activist, and writer. There are many photographs of Emma Goldman but no portraits painted during her lifetime. A portrait painter can sometimes depict what the camera cannot and therefore the destruction of Henri's depiction of Emma Goldman is unpardonable. Another destroyed portrait was of American philanthropist and presidential advisor, Bernard Baruch (1870–1965). To have destroyed it must have meant that in Organ's opinion it wasn't Henri's best work, but nevertheless these two examples were of eminent Americans who were very much part of their nation's history.

Organ's objective was selfishly about future proofing her potential income. As a single woman she may have been nervous about her future, but even so, Organ and Bayard have irrevocably changed Henri's contribution to art history.

CLEMENTINE CHURCHILL

Vehemently protective of her husband Sir Winston Churchill (1874–1965), Lady Clementine (1885–1977) was responsible for destroying three images of him. The Graham Sutherland portrait is the best known of the three. The other two destroyed portraits, by Walter Sickert and Paul Maze, though acknowledged by earlier writers, have been glossed

over in the past, in part because there is very little information about their unfortunate destruction.

Sir Winston Churchill took up painting as a hobby in his forties, taking his newfound hobby seriously and aspiring to always improve his works. His interest in art practice saw his book, *Painting as a Pastime*, published in 1948. Churchill took lessons and advice from eminent painters including the renowned English painter, Walter Sickert (1860–1942). Sickert was a prominent member of the Camden Town Group of artists in London and is seen as a transitional artist between Impressionism and Modernism. He already had an established relationship with Clementine Churchill's family dating back to her childhood, when her family lived at Dieppe, France. In 1927 Sickert was introduced to Churchill and from that time on he would give art instruction to Winston Churchill both at Chartwell—the family's country home—and at 10 Downing Street, London. Sickert also went a step further, sending artistic instructions in the post to Winston Churchill. By all accounts, Winston Churchill was a keen student, willing to take advice. Mary Soames (née Churchill), the youngest of the Churchills' five children, noted that the reception rooms at 11 Downing Street were the home to several Sickert sketches.[11]

In the same year that Winston Churchill was introduced to Sickert, Clementine Churchill put her foot through a Sickert sketch, a portrait of Winston Churchill. There are very few details pertaining to this incident. As always with such incidents—as opposed to accidents—we need to ask why would Clementine Churchill do this? Simply, according to Soames, her mother disliked the portrait.[12] This is an early example of Clementine Churchill controlling images of her husband for both present and future generations. The portrait belonged to the Churchills, so arguably she had the right to do with it as she saw fit, but she could have simply stashed it at the back of an unused cupboard. Clementine Churchill must have felt very strongly about the sketch in order to destroy it rather than donate it to a public collection. This strength of opinion would see her go on and destroy two more portraits.

The next work that Clementine Churchill disliked enough to destroy it, was Paul Maze's caricature of Winston Churchill. Paul Lucien Maze (1887–1979) was an Anglo French painter and was particularly well known for his scenes of English events such as yachting at Cowes and

Trooping the Colour. Winston Churchill met Maze in the trenches during World War I. They became firm friends, and their common interest in drawing and painting secured a life-long friendship that was further endorsed when Maze's granddaughter, Jeanne, married Winston Churchill's first cousin once removed.

The caricature by Maze depicted Churchill playing cards, a regular pastime in the Churchill household and there are several versions of this subject by Maze in existence. Soames reported in her biography of Clementine Churchill that her mother had written to her in September 1944 to say that she had organised to have the 'horrible caricature' destroyed.[13]

The Maze work was a charcoal sketch held in the collection at the President's Museum, New York. The catalogue entry reads:

> A charcoal sketch of Winston Churchill playing cards. Inscription on name-plate reads: "This sketch by W.S.C.'s painting teacher was given to F.D.R. by Lord Beaverbrook June 1943."

The year after the sketch was gifted to Roosevelt, Winston and Clementine Churchill attended the Second Quebec Conference during September 1944 and spent some time after as guests of President and Eleanor Roosevelt. On 19 September 1944 President Roosevelt had the sketch withdrawn from the collection, to be destroyed at Clementine Churchill's request. Interestingly the sketch was the property of President Roosevelt and not the Federal Government. The objects that President Roosevelt placed in the Museum Collection during his lifetime, such as the Maze sketch, did not formally belong to the Museum's collection until after his death and the finalisation of his estate. As such, the President possibly believed he had the right to destroy the work. However, some would argue that owning the work does not give anyone the moral right to destroy it, depriving future generations of viewing it. In addition, the work was a gift from Lord Beaverbrook (1879–1964), who during World War II was Winston Churchill's Minister of Aircraft Production. Perhaps as the donor he should have been offered the work back! There are no images of the sketch in existence. Clementine Churchill labelled the work as a caricature, yet this is not mentioned in its catalogue entry above. But if it was a caricature that didn't show Winston Churchill in a good light, then this could be a telling sign of why Clementine Churchill wanted it destroyed.

The demise of the Sickert and Maze portraits provide a good context for the third, and the most significant, work that Clementine organised to have destroyed—Graham Sutherland's 1954 *Portrait of Winston Churchill.* Much has been written about this event and the purpose of discussing it here is to showcase how over time the reports have varied about the circumstances around the portrait's destruction. The true details were kept clandestine for decades.

Graham Sutherland (1903–1980) was chosen to paint Winston Churchill's portrait in 1954, to celebrate Winston Churchill's 80th birthday. A much respected portraitist of the day, Sutherland had painted other important personalities including W. Somerset Maugham and Kenneth Clark. Much of Sutherland's appeal was his ability to render a good likeness to the sitter he was painting. In the case of Churchill, this is where things went awry. The background to the birthday gift is straightforward. The sum of 1000 guineas was raised from members of the House of Commons and the House of Lords to fund the commission of a portrait of Britain's Prime Minister. Between August and November 1954, Sutherland made studies and worked up the final portrait of Winston Churchill; by all accounts the pair got on amicably and even Clementine Churchill was enamoured of Sutherland, thinking him pretty 'wow' to use her own expression, and a most attractive man (she would struggle with how such a handsome man could paint such savage cruel designs!).[14]

On 30 November 1954 Winston Churchill turned 80 years of age. Televised live from Westminster Hall to the nation by the BBC, the ceremony duly took place and Winston Churchill was presented with the portrait (Fig. 2.2).

Those fortunate enough to have television watched as their great statesman unveiled the painting on its curtained easel. In a photograph taken at the birthday event in Westminster Hall we see Winston Churchill standing at the lectern, slightly obscuring Clementine Churchill and the bewigged W. S. Morrison the speaker of the house behind him, about to address his audience. Moments before, Mr. Clement Attlee (leader of the Labour Party and former Prime Minister) seated to Churchill's right presented the portrait to Winston Churchill, who went on to describe the day as the most memorable public occasion of his life. Clearly he was in awe of the generosity and kindness bestowed upon him. He went on to say of the portrait that it was a remarkable example of modern art. In response, the audience laughed. Reading between the lines, and even though he was an artist himself, Winston Churchill was not a modernist, and thus

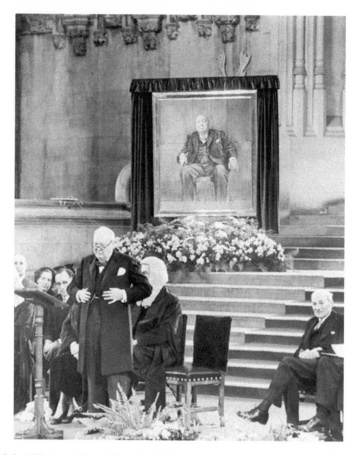

Fig. 2.2 Winston Churchill at his 80th birthday reception being presented with his portrait painted by Graham Sutherland, 30 November 1954, at Westminster Hall (Unknown photographer)

did not warm to the finished portrait that depicted him truthfully. In the background of the photograph Sutherland's portrait is festooned with a floral display and the curtains, moments before had been drawn aside for the big reveal. What is striking about the image is that there is no doubt that the subject of the portrait and the speaker are the very same person; Sutherland's likeness is exemplary. And of course it was this good likeness that Clementine Churchill took exception with. Winston Churchill

looked 80. He looked exhausted. He looked like Winston Churchill. The great orator finished his speech noting that he was nearly at the end of his journey. He went on to live for another decade—but alas his birthday portrait had a much shorter lifespan than its sitter.

Sutherland's portrait depicted an 80-year-old man past his physical prime, slumped in his chair. In July 1953, Winston Churchill had suffered a stroke, he was overweight, and didn't enjoy good health given his penchant for tobacco and alcohol. And this is how Winston Churchill presented to Sutherland; the sitter wasn't depicted as the war leader and Prime Minister of yesteryear—as both Winston and Clementine liked him to be remembered—but rather as the ageing and tired man he was. And so in Clementine Churchill's mind the painting had to go. And go it did. When the birthday celebrations were done and dusted, the portrait was taken to Chartwell, the Churchills' country home, and dealt with. The public never saw Sutherland's original *Portrait of Winston Churchill* again. Over time, there has been much speculation about the portrait's last days. Four different versions of what possibly happened follow, which go some way toward demonstrating the complexities around art crimes, how details are kept under wraps, as well as the enormity of the crime, and how the missing portrait continues to draw ongoing attention to this day.

Account One

In *Looking into Paintings* (1985), Alistair Smith gives a detailed account of Sutherland's portrait from its inception, funding, and demise. Smith notes that word first broke about the painting's destruction via the *Sunday Telegraph* on 12 February 1978, over two decades since its unveiling. Clementine Churchill had died the previous year and it now seemed safe to make an announcement. Importantly, Smith includes a passage from the *Sunday Telegraph* as told by Ted Miles, a retired former employee at Chartwell. He notes:

> *Lady Churchill smashed the painting in the cellars and gave it to me to burn. I watched her do it. Another close member of the family was there too.*[15]

Miles goes on to give more in-depth details:

> I was called to the cellar one day in the autumn of 1955 to help clear out some rubbish. ... Lady Churchill and another member of the family were there in the cellar. They had already put aside a big pile of rubbish. They both reached behind the boiler and pulled out the painting. ... I put it all in the trailer of my tractor and took it down to the incinerator pit behind the house. I tipped it all in and set fire to it immediately.[16]

And for good measure, Ted Miles offers his artistic opinion:

> It was a horrible painting. They never walked past it without expressing their dislike.[17]

This last comment is curious as other accounts inform us that the painting had been banished to the cellar at Chartwell. One questions how often the Churchills were in the cellar and walking past the painting. Is Miles therefore implying that the painting was on exhibition at Chartwell? If it was, it would be surprising that Miles, the gardener, would be a witness to the Churchills' regular contempt of the portrait hanging in the main part of the house.

The painting's destruction, as confirmed by Miles, occurred the year following its debut and, as we know, this wasn't made public until 1978. Smith also makes a pertinent point that the Churchill family declined all requests for loans of the portrait to be exhibited publicly. In addition, they refused all enquiries to photograph the work. The public could therefore not form their own opinion about the portrait. I suspect that many saw it as a public portrait and expected some kind of access to it, either through it being exhibited or viewed in print form. There was another under-lying reason for not releasing images of the portrait and that was to do with Winston Churchill's decline. Clearly the family, and in particular dur-ing her lifetime Clementine Churchill, preferred more youthful images of Winston Churchill to be out there in the public arena.

Furthermore, when the *Sunday Telegraph* made the announcement in 1978, they wanted the story illustrated by a colour image of the portrait. Sourcing an image proved difficult until one taken by war photographer, Larry Burrows (1926–1971), was found.[18] Smith notes that a colour neg-ative is held in the archive at London's National Portrait Gallery, but that there were restrictions placed on its reproduction.[19] However, research now shows that it is inconclusive that the Churchill family placed any

restrictions on the colour negative.[20] Smith was writing in 1985 and since then, with the introduction of the Internet, the image is easily sourced.

Account Two

Fast-forward to 2013 and Rick Gekoski's account of the Sutherland portrait in *Lost, Stolen or Shredded*, provides information about the ownership of the portrait. By his own admission, Gekoski is not a great fan of Sutherland's work but nevertheless offers new insight. Gekoski does not dwell on the actual disappearance of the portrait but makes worthy observations such as the fact that unlike in France, there is no English law to protect an artist from their work being destroyed. He eloquently debates the moral and legal rights pertaining to the destruction of an artwork.

Gekoski agrees that the portrait was destroyed at Clementine Churchill's request and this is interesting in itself. Clearly Winston Churchill wasn't a fan of the work but as an artist himself one might assume he'd have a greater respect for a fellow artist and the public who raised the funds for the commissioning of the portrait.

Speaking to an audience at the National Portrait Gallery, London, Gekoski took a vote about the portrait's destruction. Surprisingly to Gekoski, ninety-seven out of ninety-eight voted in favour that it was wrong of the Churchills to have the painting destroyed. This gave a very clear message. Gekoski agreed with the one audience member who thought Clementine Churchill had the choice to destroy it. And it's important not to lose sight of the fact that as with the Maze portrait, she organised to have the portrait destroyed by another hand. In other words, Clementine didn't dirty her own hands.

Account Three

In 2015, Sonia Purnell's *First Lady: The Life and Wars of Clementine Churchill* included a further revelation. Purnell offers another version of the painting's last hours, in which she introduces Clementine Churchill's private secretary, Grace Hamblin (1908–2002) into the equation. Affectionately known as Hambone by the Churchill children, Hamblin began working at Chartwell in 1932. Knowing how much the Churchills disliked the portrait, Hamblin made an offer to Clementine Churchill which she couldn't refuse. Purnell tells the story:

Grace offered to destroy it, and with the help of her brother sneaked it out of Chartwell 'in the dead of night' and took it by van to his home several miles away, where they lit a bonfire in the back garden out of the sight of passers-by. 'It was a huge thing so I couldn't lift it alone.'.... She threw the painting on the fire and watched it burn, telling Clementine the next morning what she had done.[21]

This information was revealed in a tape recording that had been kept secret until after Hamblin's death. Furthermore Hamblin goes on to note:

'I destroyed it', Grace confessed on the secret tape before her death, 'but Lady C and I decided we would not tell anyone. She was thinking of me.'[22]

Perhaps Hamblin was delusional in thinking Clementine Churchill was concerned about her private secretary's reputation. And so, it would seem that both Miles and Hamblin destroyed the painting, which cannot be right! Their descriptions are different and yet quite definite. The gardener and private secretary were not related. Why both would want to take responsibility for destroying the work is beyond belief unless their loyalty was limitless. But what presents to us is that Clementine Churchill pushed play on the destruction and her conspiracy involved her loyal staff. Hamblin had a long association with the Churchill family and Chartwell. When Chartwell was passed to the National Trust, Hamblin became its inaugural curator.[23] Generally speaking, curators—in this context, the keeper of the collection—protect and respect objects rather than destroy them so it is curious that Hamblin would undertake something as serious as burning the portrait on behalf of her mistress. In 1974, Hamblin acted as secretary to the Churchill Centenary Exhibition, again a clear demonstration of her knowledge and work with the collection. It would appear she was more respectful of her mistress' wishes rather than to the portrait, and what it meant to the nation.

Account Four

It is no surprise that Simon Schama's *The Face of Britain: The Stories Behind the Nation's Portraits* (2015) features *Portrait of Winston Churchill*. Schama's emphasis is more on the actual work and the enormity of Sutherland's task than its fate. He writes eloquently about the

background and the logistics around the commission. Schama under-stands Sutherland's position well, explaining that

> Sutherland later brooded that perhaps he should not have taken on a work that could never meet the expectations of the whole country.[24]

And there you have it in a nutshell. The commission was a tall order and perhaps fraught from the outset. The relationship between sitter, artist, and patron can be a complex one. And given in this instance the sitter was a war hero and statesman made the expectations even higher and more complex. Schama touches on this when he suggests that Winston Churchill and Sutherland had cordial conversations during the sittings and thus a more handsome portrait was expected. However, what Suther-land saw in his sitter was growling bulldoggery.[25] Sutherland said of his task, 'I painted what I saw.' Schama sums up the significance of the por-trait, that only exists in photographs now, by giving the work a sense of art historical perspective. He writes:

> With the exception perhaps of the paintings of the Duke of Wellington by Goya and Thomas Lawrence, Sutherland accomplished the most powerful image of a Great Briton ever executed.[26]

Of the portrait's demise, Schama speculates that it possibly ended up in a bonfire on the lawn at Chartwell but certainly in flames somewhere around the premises.[27]

Each of these accounts offers deeper insight into the Sutherland por-trait. What is not completely clear is how the painting spent its last hours. That is now immaterial for it has gone. Also immaterial now, because the work no longer exists, was its monetary value as opposed to its intrin-sic value to the nation. The commission as we know cost 1000 guineas. In 1978, when its fate was known, Sutherland suggested it would have had a value of at least USD$100,000.[28] By destroying it, the Churchill family retained power over the image. Sutherland was deeply wounded by the portrait's destruction, announcing that it was 'an act of vandalism unequalled in the history of art'. It was worse than vandalism, as there was no way back. But did Clementine Churchill have the right to burn the *Portrait of Sir Winston Churchill*? The Walter Sickert painting was the Churchills' personal property, so arguably she could do what she wanted

with it. The Paul Maze caricature belonged personally to President Roosevelt, not the American people, and at her request he had it destroyed. Again, it came down to personal choice. But the Sutherland was in a different league; artistically and historically more significant on many levels, so morally Clementine Churchill did not have the right to burn it. However, the Churchills' understanding of ownership was straightforward. As Mary Soames noted in her mother's biography, her parents viewed the work as an outright gift and a document prepared and signed on behalf of the Members' Parliamentary Committee gave the Churchills the 'sole and exclusive copyright' of the portrait.[29] However, any number of explanations doesn't excuse the fact that this was made in the spirit of being a very public portrait, launched in a very public manner, and not easily forgotten.

Fortunately for the history of British portraiture, Sutherland's widow Kathleen donated four preparatory sketches, as well as a sketchbook with additional studies of the portrait, to the National Portrait Gallery, London, in 1980.[30] The Gallery's website does not gloss over the fate of the original portrait, noting about the sketches:

> The final controversial portrait, which Churchill said made him look 'half-witted', was later destroyed by his wife and only preparatory sketches survive.[31]

In 1981 a copy of the portrait was made by Albrecht von Leyden (1905–1994). A great admirer of Sutherland's work, von Leyden struggled with the lack of respect shown by the Churchills in their dislike of the painting. This was the inspiration for his copy that took him three months to complete, after rigorous research into the nuances of the work. A decade later, von Leyden gifted the work to London's Carlton Club where Churchill was a member and one of the two dining rooms was named after him. The Club's minutes of 25 February 1992 disclose that Soames had viewed the copy and was content to let the Club act as its future guardian.[32] There is no evidence to support that the portrait has ever been exhibited at the Club and it remains in storage there.[33] In 1979 environmental sand painter, Brian Pike (b. 1963), made a copy of the portrait. Smaller than the original at 70 × 56 centimetres, Pike's copy was made with unconventional materials; the naturally coloured sands were applied by feather brushes to the plywood off-cut, in lieu of canvas. Pike was so disgusted with how Sutherland portrayed Churchill, the man who had led Britain

in its finest hour, that he decided to execute his own version.[34] More recently in 2018, copyists Factum Arte of Madrid made another portrait, for an episode entirely devoted to the portrait for the documentary series, *Mystery of the Lost Paintings*.[35] A photograph on Factum Arte's website shows one of their artists at work reproducing Sutherland's portrait; surrounded by six versions of the image in various sizes it goes part way to show the lengths undertaken to recreate the portrait in order to make it as faithful to the original as possible (see Fig. 2.3). The photograph is cleverly composed; we the viewer are only privy to the back of the unnamed copy artist at work and yet we see six portraits of Winston Churchill. En masse it is a poignant reminder that if the original portrait existed then there would be no need to painstakingly recreate it (or indeed making a documentary about its demise). The photograph further indicates—through the myriad of Sutherland portraits—the thoroughness of Factum Arte. Analysing the swatches of fabric used to sew the trousers Churchill wore for the portrait sitting as well as researching the exact cut

Fig. 2.3 Factum Arte artist making a copy of the Winston Churchill portrait Graham Sutherland 1954, Factum Arte 2017 (*Credit* Factum arte http://www.factum-arte.com/pag/1165/Winston-Churchill)

of his jacket are further examples of the seriousness of their research. And so, the *Portrait of Sir Winston Churchill* has been the topic of many a discourse; indeed it has possibly attracted more [negative] attention for not existing than if Clementine Churchill had just gone along with the original plan which was to 'enjoy' it for Winston Churchill's lifetime and then to have it hung in parliament, at Westminster.

PATRICIA CORNWELL

For the best part of the last two decades, crime writer Patricia Cornwell has researched her claim that serial killer Jack the Ripper was the artist Walter Sickert. We know Sickert as friend, confidante, and art mentor to Sir Winston Churchill but there is a gruesome side to his oeuvre: numerous studies and completed works of corpses, prostitutes, and the sick are to be found amongst his life's work. A good example can be found in the Manchester Art Gallery collection, a painting from 1908 entitled *Jack the Ripper's Bedroom*. Cornwell's findings—and the methodology behind her findings—culminated in two books. The first, published in 2002, *Portrait of a Killer: Jack the Ripper Case Closed*, was followed more recently by *Ripper: The Secret Life of Walter Sickert* (2017). On reflection and by her own volition, Cornwell admits that her earlier book perhaps prematurely used the words *Case Closed* in the title for indeed the case is by no means closed, and perhaps never will be. *Portrait of a Killer* received much criticism not only for her claims about Sickert but by the manner in which Cornwell gathered evidence, which some thought was unfounded. One must give Cornwell her dues for revisiting the subject and addressing issues that were raised out of the first book.

The objective here is not to paraphrase Cornwell's findings, but rather to view her within the context of art crime, for which Cornwell was accused. In short, Cornwell went to great lengths to provide evidence that Sickert was the Ripper. If you only believed what you read in the media then you would catalogue Cornwell as an art criminal, for supposedly she destroyed a painting by Sickert to obtain valuable material to test for his DNA. Fiachra Gibbons of the *Guardian* notes:

> The American crime novelist Patricia Cornwell was last night accused of "monstrous stupidity" for ripping up a canvas to prove that the Victorian painter Walter Sickert was Jack the Ripper.[36]

Gibbons wasn't the only one to make this announcement. Crown Prosecutor Ross Burns claimed:

> She horrified the art world by spending up to $2 million on Sickert's paintings and drawings and ransacking them for DNA, destroying at least one painting in a fruitless search. ... Crime writing often tells the reader as much about the author as it does about the subject, and that is clearly the case here.[37]

Any number of similar responses can be found. The painting 'destroyed', as mentioned above, depicts a view down a path between allotments on the outskirts of Broadstairs—a coastal town 130 kilometres from London on the Isle of Thanet. Sickert lived at Broadstairs from 1934 until 1938, when he relocated to Brighton. *Broadstairs* (*c.*1935–1938) is likely to remain in Cornwell's private collection.[38]

Cornwell was hung, drawn, and quartered in the media for committing this art crime. But where was the evidence for the destroyed painting? All would be revealed in time. In the meantime the alleged destruction did nothing for Cornwell's reputation, and supposedly aligning Sickert with being the Ripper had a negative flow on affect in the monetary value of his work. Auction houses accused Cornwell's claims as devaluing Sickert's work.

Cornwell is a victim of her own success; her status and popularity as a crime writer meant there was a media flurry about her Sickert claim, and thereafter the demise of the painting. In 2017, her second book on the subject puts her readers right on the matter of the alleged painting destruction. She notes:

> This act of vandalism in the name of science or otherwise never happened, and I've been saying this for years. But no one seems to listen. When the Sickert painting in question was transported from London to the Richmond, Virginia, crime labs in 2001, the dry-rotted canvas arrived with a large hole in it. An ABC crew was filming a show on this case, and apparently it was incorrectly assumed the damage to the painting was due to some sort of scientific extraction.[39]

This appears in a coda to her book where she directly addresses criticisms of her earlier work. This response was in part to the criticism, 'I supposedly ripped up a Walter Sickert canvas for no reason.' And in any case the size of the rip was over-sized for the requirements for a DNA test but also

it is pretty much smack bang in the middle of the composition. Surely, if you were to take a sample from a canvas it would be made more discreetly from a corner rather than hacking a great hole in the centre! Plus, conservators do wonderful work these days and a rip of this size is repairable. And thus it is hardly 'destroyed'—especially when you compare it with earlier examples discussed in this chapter.

Perhaps the only real crime here is that the painting wasn't packed well enough to prevent damage and this wouldn't be out of the ordinary. As art underwriter at The Channel Syndicate of special insurer Lloyd's Rupert Onslow notes, 60% of all art claims are works in transit.[40] Artworks are at their most vulnerable when in transit, as *Broadstairs* was.

Crimes of art can damage reputations. Cornwell didn't deliberately damage *Broadstairs* and yet her actions were debated in the media. Word travels quickly in this era of digital platforms and unless one reads her 2017 book you would be hard pushed to know the truth. Cornwell's subsequent book also includes photographic evidence of *Broadstairs* being unwrapped in the lab, with others, when the canvas' tear was revealed. Her reputation, tarnished by the alleged *Broadstairs* destruction, also affected copyright permissions being approved for her 2017 book. Some individuals and organisations decided not to grant her permission.

Sickert, who died in 1942, cannot defend his artistic reputation. Whether he was the Ripper or not is not known at this point in time. Cornwell is not the first to make the link between artist and murderer. As already noted, some believed that Cornwell's speculation affected Sickert's reputation in the salesroom. This is complex to measure as no two paintings or drawings are alike and the market is forever changeable.

It is too late to convict and punish the Ripper, though it would be nice to know once and for all, 'whodunnit'. In a letter dated 2002 Cornwell responded to Therese Lessore's nephew (Therese was Sickert's third wife) who wrote to her about various matters including the alleged destruction of the painting. In it she notes:

> Let me say that it is patently false that I destroyed a Sickert painting. In fact, the painting in question was sold to me ... for some 27,000 [pounds] and flown by private jet back to the U.S. ... What you should know however is that I would not hesitate to "cut up" a Sickert or anything else if it was the only way to expose terrible crime and ensure justice. No work of art is worth as much as a human life.[41]

Given the Ripper is now dead it is difficult for justice to be served. However, the knowledge of his identity might be of some comfort to the descendants of the many women he murdered. And Cornwell is right when she asserts that no work is worth as much as a human life. Value is multi-layered when it comes to art. However, the negativity and sensationalism that ensued when it was made public that Cornwell had allegedly destroyed the painting proves how valued Sickert's work is. In this instance, Cornwell is not an art criminal. Indeed, she was the victim of those who wrongly accused her of destroying art. But once the accusation was out in the public arena there was little escaping it. It was as if she had already been convicted and punished for destroying the work—which she, do not forget, owned. As with most art crime cases, events are played out in the media; online coverage often has little or no editing and can be biased. Proof is essential to conviction, as Cornwell knows only too well, but in this case speculation was rife. There can be no doubt that Cornwell has been indefatigable in her search to prove that Sickert and the Ripper were the same man. But, an art criminal she is not. Unfortunately, many will continue to catalogue her as such if they have not consulted her second book. In the eyes of many, therefore, being an art criminal and/or being accused of being one amount to the same. As for *Broadstairs*, many will rely on Sickert scholar Wendy Baron's notation in her comprehensive book dating from 2006—that brought together fifty years of research and knowledge of the artist—that read 'this painting is said to have been destroyed'. When questioned about Cornwell's Ripper theory, Baron commented, 'Of course it's a novel. Quite an interesting novel, but still a novel.'[42]

Wrongly accused, Cornwell is philanthropic when it comes to Sickert, making this generous gift in 2017:

> I had his paintings hanging in my library in Greenwich, Connecticut, and every time I walked past them, it became too much. I donated about 100 paintings and drawings to Harvard and Yale.[43]

If people thought Cornwell needed to make amends for anything, then surely this gift would suffice.

It seems that Cornwell received as much grief for not destroying Sickert's painting *Broadstairs*, as she would if she had destroyed it, though this is impossible to measure. Once in the media, it takes time and energy to claw back and make people see reason. Significantly, Cornwell presented

evidence to prove her innocence and show that the damaged painting was indeed a victim of bad handling, damaged in transit. The public gets het up about artworks that are destroyed or damaged, especially when they perceive the work as public property or that the subject of the work is a public figure. And perhaps by describing *Broadstairs* as destroyed—as the media did—the event gained more traction than if it had been the lesser crime of vandalism. It's for that reason, the assumption of the painting being destroyed rather than accidently damaged, that it's included in this chapter. In addition to this, Cornwell is a high profile author, with the ability to attract much media attention. Clementine Churchill was also very much in the public eye for decades.

LILY KEMPSON

Across the British Empire portraits of Queen Victoria, the longest serving monarch (up until Queen Elizabeth II superseded her record in 2015), adorned homes and buildings, from the public to the commercial, from schools to churches to hospitals. The Royal College of Surgeons in Ireland was no exception to this practice. In their boardroom at the Royal College's headquarters in St Stephen's Green, Dublin, hung a portrait of Queen Victoria in all her regalia. Commissioned to celebrate her Golden Jubilee (20 June 1887), the oil on canvas was painted by Stephen Catterson Smith RHA (the younger) (1849–1912) and depicts a full-length statuesque po-faced Queen (the exact size is unknown, however the photograph on this book's cover gives an indication of its scale). But in 1916 the portrait was destroyed (see Fig. 2.4).

The College was occupied during the Easter Uprising of 1916 when Irish republicans attempted to end British rule and establish an Irish Republic. The group of rebels was led by Countess Markievicz (1868–1927) and was given strict orders not to damage the premises including the artworks. Three other portraits at the College were damaged, not destroyed. It is significant that the chosen work to be destroyed was of Queen Victoria for it was noted subsequently that her attitude to the Irish was not favourable. During the 1848 rebellion she suggested the Irish should receive a good lesson or 'they will begin it again'. And so Victoria represented what the rebels were fighting against that Easter of 1916. But who ripped the portrait from its heavy gilt frame? Initially, a 14-year-old youth took the blame maintaining that he needed canvas to make puttees for his boots. Well after the event, another possible culprit

Fig. 2.4 Stephen Catterson Smith RHA (the younger), *Portrait of Queen Victoria* (1887), destroyed in 1916. Collection: Royal College of Surgeons, Ireland (Kindly reproduced with their permission)

came forward. Lily Kempson (1897–1996) was a teenage courier for the rebel group who took over the College in a five-day siege.[44] Soon afterwards, fearing that her family's neighbours might alert the authorities to her whereabouts, she fled to America (using her sister's passport) to live

a long and prosperous life, to avoid being charged will her role in the Easter Rising.

Kempson claimed that it was she who had destroyed the portrait of Queen Victoria; Alice McCullough, Kempson's daughter, recalled a conversation in which her mother described the portrait, 'That old witch. I took care of her. I got up there with a knife and just gouged it.'[45] Kempson's granddaughter, Margaret, also remembers being told the story by her grandmother. My only doubt comes down to logistics; Kempson was relatively short at 5'1",[46] so could she have reached high enough to slash the canvas? Examining a photograph taken at the time of its demise, the canvas was ripped from the top of the composition and torn downwards. A dining chair atop a side table would give the vandal the leg-up required, but was it enough? Perhaps Kempson was guilty. We will never categorically know, given there is little evidence left with the exception of oral histories (and the College has no recollection of where the frame ended up). Nearly a century later, in 2013, a fragment of the canvas came up for sale at Whyte's Auctioneers in Dublin. On the reverse of the painted canvas someone had penned 'May 1916 Sinn Fein Rebellion'. This small fragment, measuring just 5 × 12.5 centimetres sold for €300, and barring photographs it is all that is left of Smith's painting. What is a certainty is that the subject of the portrait—a statuesque glorification of the British monarchy—offended the rebels as it stood for everything they opposed.

Each of the women featured in this chapter had different motives for destroying art (or not, in the case of Cornwell). Of course there are also those who have destroyed art unintentionally by accident, including cleaners. For example, in February 2014 a cleaner who was just doing her job at the Sala Murat gallery in Bari, Italy, threw out several items of an installation that to her appeared as rubbish.[47] The work by Naples group, Flip, was titled *Mediating Landscape*; the cleaner mistook the newspaper, cardboard, and biscuit crumbs scattered across the floor, as rubbish.[48] Yet in the big picture, though the work was valued at €10K (which was reimbursed by the cleaner's employer), it was small-scale compared with two women we meet in the next chapter who take destroying art, for a very different reason, to a high level.

NOTES

1. Jon Mann, 'Why These 6 Artists Destroyed Their Own Work', 9 January 2018, https://www.artsy.net/article/artsy-editorial-6-artists-destroyed-art.
2. Edward Bullmore (1933–1978), *Man in the Sun*, 1962, oil and mixed media on cardboard, size unknown, destroyed.
3. Edward Bullmore (1933–1978), *Gigliola (The Artist's Daughter)*, c.1974, ceramic, 30 × 15 × 20 cms, destroyed.
4. Lucie Bayard was born in 1899. Date of death unknown.
5. Violet Organ died in 1959. Date of birth unknown.
6. Joseph L. Sax, *Playing Darts with a Rembrandt: Public and Private Rights in Cultural Treasures*, Ann Arbor: University of Michigan Press, 1999, p. 146.
7. No date is given for when Organ and Bayard destroyed the works.
8. Joseph L. Sax, *Playing Darts with a Rembrandt: Public and Private Rights in Cultural Treasures*, Ann Arbor: University of Michigan Press, 1999, p. 146.
9. John E. Conklin, *Art Crime*, Westport, CT: Praeger, 1994, p. 235.
10. Robert Henri, *Young Woman in White*, oil on canvas, 218.5 × 116.8 cms, National Gallery of Art, Washington, 1949.9.1.
11. From January 1924 to April 1929 the Churchill family lived at 11 Downing Street, London. From June 1940–July 1945 and then again from December 1951–April 1955, the Churchills lived at 10 Downing Street.
12. Mary Soames, *Clementine Churchill: The Biography of a Marriage*, New York: Mariner, 2003, p. 549.
13. Mary Soames, *Clementine Churchill: The Biography of a Marriage*, New York: Mariner, 2003, p. 550.
14. The 1954 Sutherland Portrait, International Churchill Society, 2010, https://winstonchurchill.org/publications/finest-hour/finest-hour-148/the-1954-sutherland-portrait.
15. Alistair Smith, 'The Creation of a Portrait', in *Looking into Paintings* (ed. Elizabeth Deighton), London: Faber and Faber and The Open University, 1985, p. 113.
16. Alistair Smith, 'The Creation of a Portrait', in *Looking into Paintings* (ed. Elizabeth Deighton), London: Faber and Faber and The Open University, 1985, p. 113.
17. Alistair Smith, 'The Creation of a Portrait', in *Looking into Paintings* (ed. Elizabeth Deighton), London: Faber and Faber and The Open University, 1985, p. 114.
18. The photograph was acquired for the National Portrait Gallery's archive around 1978.

19. Alistair Smith, 'The Creation of a Portrait', in *Looking into Paintings* (ed. Elizabeth Deighton), London: Faber and Faber and The Open University, 1985, p. 115.
20. Electronic correspondence with Bryony Millan, National Portrait Gallery, London, 6 June 2017.
21. Sonia Purnell, *First Lady: The Life and Wars of Clementine Churchill*, London: Aurum Press, 2015, p. 341.
22. Sonia Purnell, *First Lady: The Life and Wars of Clementine Churchill*, London: Aurum Press, 2015, p. 341.
23. The upkeep of Chartwell became too much for the Churchill family and in 1946/1947 a group of businessman purchased the home for £50,000. Chartwell was then offered to the National Trust on the condition that Winston and Clementine could reside there for as long as they desired. When Winston died at Chartwell in 1965. Clementine, who never slept another night there after his death, handed the home over to the National Trust.
24. Simon Schama, *The Face of Britain: The Stories Behind the Nation's Portraits*, London: Viking, 2015, p. 21.
25. Simon Schama, *The Face of Britain: The Stories Behind the Nation's Portraits*, London: Viking, 2015, p. 21.
26. Simon Schama, *The Face of Britain: The Stories Behind the Nation's Portraits*, London: Viking, 2015, p. 20.
27. Simon Schama, *The Face of Britain: The Stories Behind the Nation's Portraits*, London: Viking, 2015, p. 21.
28. 'Churchill's Wife Destroyed Portrait They Both Disliked', *New York Times*, 1 December 1978, p. A2.
29. Mary Soames, *Clementine Churchill: The Biography of a Marriage*, New York: Mariner, 2003, p. 550.
30. In addition to the sketches by Graham Sutherland, gifted by Mrs. Kathleen Sutherland to the National Portrait Gallery, one additional sketch (NPG6096) for the *Portrait of Winston Churchill* has been purchased for the collection.
31. https://www.npg.org.uk/collections/search/portrait/mw07208/Winston-Churchill.
32. Aster Crawshaw and Alistair Lexden, 'Homage to a Hero and a Masterpiece: The Destruction and Rebirth of Sutherland's Portrait of Churchill', *The London Magazine*, June/July 2016, London, p. 41.
33. Electronic communication with Frances Jones, Carlton Club, London, 26 June 2018.
34. Electronic communication with Brian Pike, 5 June 2018.
35. http://www.factum-arte.com/ind/553/Mystery-of-the-Lost-Paintings.
36. Fiachra Gibbons, 'Does This Painting by Walter Sickert Reveal the Identity of Jack the Ripper?', *Guardian*, 8 December 2001.

37. Ross Burns, 'Patricia Cornwell: Portrait of a Killer', *New Zealand Herald*, 15 November 2002.
38. Wendy Baron, '770. Broadstairs', in *Sickert: Paintings & Drawings*, New Haven and London: Yale University Press, 2006, p. 558. Patricia Cornwell was contacted to confirm ownership but chose not to respond.
39. Patricia Cornwell. *Ripper: The Secret Life of Walter Sickert*, Seattle: Thomas & Mercer, 2017, p. 493.
40. Dalya Alberge, 'Works of Art: Handle with Care', *The Financial Times*, 18 September 2015, https://www.ft.com/content/b4714a8a-56bd-11e5-9846-de406ccb37f2
41. Patricia Cornwell. *Ripper: The Secret Life of Walter Sickert*, Seattle: Thomas & Mercer, 2017, p. 255.
42. 'Sickert: Paintings and Drawings by Wendy Baron', *Independent*, 14 January 2007.
43. Tom Bryant, 'Jack the Ripper Mystery Finally Solved as Novelist Patricia Cornwell Unmasks the Killer', *The Mirror*, 10 March 2017.
44. Later Lily Kempson McAlerney. Lily married Matthew McAlerney on 20 February 1917 in Seattle, United States of America.
45. See http://lily1916.com/lilys-story.
46. See http://lily1916.com/lilys-story.
47. Piers Eady, 'Cleaner Accidently Destroys Thousands of Pounds' Worth of Modern art by Throwing Exhibition in the Bin', *Irish Mirror*, 20 February 2014.
48. Piers Eady, 'Cleaner Accidently Destroys Thousands of Pounds' Worth of Modern art by Throwing Exhibition in the Bin', *Irish Mirror*, 20 February 2014.

SELECTED BIBLIOGRAPHY

Baron, Wendy. *Sickert: Paintings & Drawings*. New Haven and London: Yale University Press, 2006.
Bryant, Tom. 'Jack the Ripper Mystery Finally Solved as Novelist Patricia Cornwell Unmasks the Killer'. *The Mirror*, 10 March 2017.
Burns, Ross. 'Patricia Cornwell: Portrait of a Killer'. *New Zealand Herald*, 15 November 2002.
Conklin, John. *Art Crime*. Westport, CT: Praeger, 1994.
Cornwell, Patricia. *Portrait of a Killer: Jack the Ripper Case Closed*. New York: G. P. Putnam's Sons, 2002.
Cornwell, Patricia. *Ripper: The Secret Life of Walter Sickert*. Seattle: Thomas & Mercer, 2017.

Crawshaw, Aster and Alistair Lexden. 'Homage to a Hero and a Masterpiece: The Destruction and Rebirth of Sutherland's Portrait of Churchill'. *The London Magazine*, June/July 2016, London.

Gekoski, Rick. *Lost, Stolen or Shredded: Stories of Missing Works of Art and Literature*. London: Profile, 2013.

Gibbons, Fiachra. 'Does This Painting by Walter Sickert Reveal the Identity of Jack the Ripper?' *Guardian*, 8 December 2001.

Jackson, Penelope. *Edward Bullmore: A Surrealist Odyssey*. Tauranga, New Zealand: Tauranga Art Gallery, 2008.

Jackson, Penelope. *Edward Bullmore: A Surrealist Odyssey* (unpublished M.Phil thesis). Brisbane: University of Queensland, 2011.

Lovell, Mary S. *The Churchills: A Family at the Heart of History—From The Duke of Marlborough to Winston Churchill*. London: Little, Brown, 2011.

Mann, Jon. 'Why These 6 Artists Destroyed Their Own Work', 9 January 2018. https://www.artsy.net/article/artsy-editorial-6-artists-destroyed-art.

Purnell, Sonia. *First Lady: The Life and Wars of Clementine Churchill*. London: Aurum Press, 2015.

Sax, Joseph L. *Playing Darts with a Rembrandt: Public and Private Rights in Cultural Treasures*. Ann Arbor: University of Michigan Press, 1999.

Schama, Simon. *The Face of Britain: The Stories Behind the Nation's Portraits*. London: Viking, 2015.

Smith, Alistair. 'The Creation of a Portrait' in *Looking into Paintings* (ed. Elizabeth Deighton). London: Faber and Faber and The Open University, 1985, pp. 85–133.

Soames, Mary. *Clementine Churchill: The Biography of a Marriage*. New York: Mariner, 2003.

Soames, Mary. *Clementine Churchill: The Revised and Updated Biography*. London: Random House, 2011.

The Mothers of All Art Crimes

Olive Greenhalgh, Olga Dogaru and Marielle Schwengel are all convicted art criminals.[1] In a case of blood is thicker than water, they each committed art crimes of extraordinary significant art historical and monetary values. They too are the mothers of high profile art criminals; each woman coming to art crime through a back door provided by their sons' illegal activities. The cases involving their sons Shaun Greenhalgh, Radu Dogaru and Stéphane Breitwieser are well documented and all generated much media hype. Nevertheless, these mothers' art crimes were colossal in scale and warrant showcasing, independently of their sons' crimes. Always searching for motives when studying art crime, here we find the motive was not about the art, or its potential monetary value, but the instinct for mothers to protect their offspring.

Olive Greenhalgh

'Go away or I'll set the dog on you' were the words uttered by feisty Olive Greenhalgh when a reporter knocked on her door looking for answers about the family forgery scam.[2] In 2007 Olive Greenhalgh, an 82-year-old matriarch, received a twelve-month suspended sentence. Her husband George Greenhalgh, Shaun's father, had his sentence deferred on medical grounds and their son Shaun's sentence was just short of five years. The three admitted to conspiracy to defraud and concealing proceeds of a sale. The Greenhalgh case was a high profile one at the time of their being caught and convicted, and Shaun—the couple's forger son—subsequently

© The Author(s) 2020
P. Jackson, *Females in the Frame*,
https://doi.org/10.1007/978-3-030-44692-5_3

enjoyed his time in the media including giving advice about forgeries to
the *Fake or Fortune* (BBC) team[3] as well as writing his autobiography.[4]
For seventeen years Shaun had fashioned forgeries that were then sold
to reputable institutions. In 2005, the Greenhalgh threesome was caught
out by the British Museum over incorrect spelling on a supposed seventh
century BCE Assyrian stone relief that the family offered up for sale.

Shaun Greenhalgh, aged 47 years when he was charged in 2007,
worked from home, where he still lived with his parents. He produced
a wide range of forgeries from L. S. Lowry paintings to Egyptian sculp-
tures. He boasted that he could whip up a J. M. W. Turner painting in
thirty minutes and his infamous *Amarna Princess*, sold in 2003 to the
Bolton Museum in Lancashire for £440K, had taken just three weeks to
complete. The family were successful art criminals, worth an estimated
£850K at the time of their arrest, but their wealth didn't stop them claim-
ing government benefits or living in their Bolton council house. And in
the big picture, their scamming wasn't really about making vast amounts
of money. Shaun Greenhalgh's introverted personality type precluded him
from being the cunning and suave sales person required to pass off the
forgeries to unsuspecting buyers (though there was the occasional suspi-
cious buyer). Fortunately though, both his parents were able to fill this
gap for their flourishing family-based cottage industry.

Olive Greenhalgh was not only the mother and wife in the Green-
halgh household, but she devised the back-stories for the fraudulent art-
works. Much of the Greenhalgh family's success was due to the authentic-
sounding provenance provided when a work was offered up for sale. Hav-
ing good provenance is the key to making a sale and Olive Greenhalgh
was particularly skilled at creating these. Clever and deceitful, from the
outset Olive Greenhalgh maintained that her father had owned a dealer
gallery, providing the perfect foil for establishing the origins of works and
an explanation for the numbers that they produced for the open market
over time. She also invented a story of a great-grandfather who'd made
some astute purchases at auctions and an ancestor who was the cleaner for
the Mayor of Bolton, and had been gifted a painting by Thomas Moran
(1837–1926), an English-born artist whose career took off in America as
a painter of landscapes associated with the Rocky Mountain School. All
this sounded feasible, especially when delivered by a 'little old lady'.

On one occasion, Shaun Greenhalgh's forged pastel on paper work,
supposedly L. S. Lowry's *The Meeting House*, didn't convince the Lowry
Museum staff that it was authentic, and yet the Greenhalghs managed to

sell it to a dealer for £5 K. Olive Greenhalgh provided the provenance for the work—a gift to her on the occasion of her 21st birthday by her gallery-owner father—and she used a name of an artist that her father dealt with to embellish the provenance. In another case in 1994, Olive Greenhalgh used the name Mrs Olive Roscoe (Roscoe was her birth surname) when she had Sotheby's sell the forgery of Gauguin's *The Faun*, on her behalf. Olive Greenhalgh presented a false invoice 'from a Paris art gallery that purportedly showed the piece was sold by the gallery in 1917 to Roderick O'Connor, a known artist friend of Gauguin and an alleged forbear of "Mrs Roscoe"'.[5] This cunning tale of intrigue worked, and on that occasion the Greenhalgh family banked just over £20K. It was this rich web of invented provenances that let the Greenhalgh family to continue their 'cottage industry' over the decades, without being caught. Eventually when their case came to trial, Detective Sergeant Vernon Rapley of London's Metropolitan Police Arts and Antiquities Unit said, 'looking at them now I'm not sure the items would fool anyone, it was the credibility of the provenances that went with them'.[6]

The marketing of Shaun Greenhalgh's fraudulent objects was also integral to the success of the sale and the family's success. Olive Greenhalgh was very much the marketing arm of their business and, along with George managed to deceive museum professionals and major auction houses. They were as clever at marketing their forged artworks as Shaun Greenhalgh was at making them. At their trial Shaun Greenhalgh admitted he was too shy to make the first move when it came to offloading the forgeries. This was his mother's forte. More confident than her son, Olive Greenhalgh set up potential sales meetings by telephone and then George Greenhalgh would clinch the deal. This was all part of the plan: who could refuse an elderly wheelchair-bound returned serviceman, who offered a long-forgotten or newly discovered artwork? George Greenhalgh was extremely talented at showing his fragility and vulnerability.

Olive Greenhalgh played a knowingly active, not passive, role. She was the first point of contact for the majority of sales; and it was the richly construed history about her father's gallery that meant she and the family had a seemingly endless supply of heirlooms to sell. Olive Greenhalgh 'worked' well past retirement age and it was perhaps her age that saw her receive what many thought was a lenient sentence. Olive Greenhalgh enabled the forgery business to co-exist alongside marriage and family life; a risk taker, she actively engaged in the illegal forgery trade and allowed

it to operate in her family home. It was Olive Greenhalgh's skills at fabricating back-stories and initiating meetings with potential buyers that took the cottage industry out into the commercial and professional museum sectors.

OLGA DOGARU

In October 2013, 50-year-old Romanian Olga Dogaru was sentenced to two years imprisonment for handling stolen goods. The goods were seven artworks stolen at 3.20 a.m. on 16 October 2012 from the Kunsthal Museum in Rotterdam, by her ringleader son, Radu Dogaru. The works stolen were:

1. Monet, *Waterloo Bridge, London* (1901)
2. Picasso, *Harlequin Head* (1971)
3. Matisse, *Reading Girl in White and Yellow* (1919)
4. Monet, *Charing Cross Bridge, London* (1901)
5. Gauguin, *Girl in Front of Open Window* (1898)
6. De Haan, *Self Portrait* (1890)
7. Freud, *Woman with Eyes Closed* (2002).

If the works appear to be an odd mix that's because they were selected simply on the basis of where they were hung at the Museum, not on artistic grounds. Radu Dogaru had visited the Museum the day before to check out what was on exhibition. The seven works, valued at millions of Euros and irreplaceable, were located closest to the fire exit door. Radu Dogaru's motive, along with that of his fellow thieves, was based on the cost of living. Having relocated from Romania with their girlfriends they found burgling houses just didn't make them enough. They needed something that was financially more prudent. Making a bad situation worse, these works were on loan to the Kunsthal Museum from the Triton Foundation. None of the works were fitted with security alarms so the theft, completed in less than two minutes, was relatively straightforward, which Radu Dogaru would later boast about.[7] Olga Dogaru not only hid the stolen works but she went on to destroy them, although she

would later retract her statement about the destruction. The works have never been located and in August 2013 Radu Dogaru announced that he had five of the paintings and that Olga Dogaru had only destroyed two.[8] The works remain at large.

In January 2013, following the theft, 28-year-old Radu Dogaru was arrested on suspicion of the art heist, however neither he nor his accomplices were in possession of the stolen works. The evidence was gone. Shortly after the heist the works were taken to the small town of Carcaliu, in eastern Romania. Carcaliu was Radu's Dogaru's hometown and where his mother lived (his father was serving a prison sentence for assault at the time). In a bid to put the police off his scent, Radu Dogaru left the paintings with his mother, Olga Dogaru. She moved the works around in plastic bags and at first buried them in her own garden and then at her sister's garden. From there she relocated them again, with the assistance of Radu Dogaru's 19-year-old girlfriend Natasha Timofei (former high achiever at the village school turned sex worker), to the village cemetery where once again they were buried.

Clearly, Olga Dogaru was nervous about holding onto the works, given they were incriminating evidence that would implicate her son in their theft. But the works didn't stay buried for long as Olga Dogaru had an epiphany: if the works no longer existed they couldn't be used as evidence against her son. On 17 February 2013 Olga Dogaru dug up the masterpieces and returned to her home with the paintings. She lit the heating stove in her bathroom, used to heat water for the bathroom and sauna, and allegedly incinerated the seven works. The following day she cleared out the stove and put the ash in her garden (though other reports note that she gave the ash to a man named Gioni, hoping he would take it to the rubbish tip). The pictures' frames were never located, though it is highly likely the paintings were removed from the frames immediately after the heist in Rotterdam, for ease of transportation in pillowcases to Romania.

Meanwhile, Radu Dogaru also had an epiphany. He thought that if he returned the works he would receive a reduced prison sentence. Though he was clearly in the wrong for the theft, the works were irreplaceable and would be welcomed back by the owners. The loan exhibition, to which the stolen paintings belonged, was a celebration of the twentieth anniversary of the Triton Foundation, set up to protect the 250-strong art collection of Dutch collectors, shipping magnate Willem Cordia and his wife Marijke Cordia-Van der Laan. The sad irony is that they weren't

protected enough given the ease and speed of the art theft. However, Radu Dogaru's good intentions were quickly thwarted when he realised that his mother had destroyed the works.

Olga Dogaru further complicated matters by suggesting that Radu Dogaru had told her to give the works to a person unknown to her. Perhaps she was too afraid about confessing to the incineration of the works. Before her court appearance during August 2013, Olga Dogaru retracted her statement, saying that she didn't burn the works and that she had made up the story due to pressure by the Romanian police. But that conflicted with evidence as forensic proof demonstrated that three or four canvases had been burnt in her stove. And it was likely that the remaining works also went up in smoke, but being works on paper and board, as opposed to canvas, they didn't leave any residue for forensic testing. When the remains in the stove were being tested, and in an effort to protect his mother, Radu Dogaru suggested the nails found belonged to nineteenth-century family icons, which he had a penchant for stealing from locals in Carcaliu. After testing the nails, Romania's National History Museum confirmed they did not belong to nineteenth-century icons.

In October 2013, Radu Dogaru pleaded guilty for his part in the art heist and received six years' imprisonment. Olga Dogaru was given a two-year prison sentence for handling stolen property, for helping a criminal, and for guns and ammunition offences (though prosecutors had suggested twenty years). They and their accomplices were ordered to pay £18.1M to Lloyd's of London, the insurers who had paid out after the theft. Art experts valued the cache of stolen works far higher than this. Radu Dogaru's girlfriend, Natasha Timofei, who assisted Olga Dogaru with burying and relocating the works, was taken into custody in the Netherlands but appears not to have been prosecuted.

The key question is, were the seven stolen works incinerated? The works are listed as missing in the Art Loss Register but as historian Bendor Grosvenor, of *Fake or Fortune* fame suggests, was it all a storyline that literally took the heat off who in fact still holds them?[9] If Olga Dogaru did burn them it was perhaps because she panicked; not wanting her son to go down for the crime and so her best bet, to her reckoning, was to dispose of the evidence. At the time, police were scouring the village looking for the paintings or any information about them. Olga Dogaru's actions destroyed more of our art history; the destruction of art benefits no one and this is why an art thief, realising they cannot on sell a stolen

work, will on occasion simply abandon their booty or hand it in. However, the loss of these valuable works was clearly less important to her than protecting her son. Effectively by protecting him she made the situation worse; not only was she convicted for her part in the crime (if she'd just hidden them or passed them onto someone else or handed them into police, she could have got away without conviction) but also she obliterated seven significant paintings. The bond between a mother and a child can be intensely strong and in a moment of panic Olga Dogaru perhaps made a decision, maybe a knee-jerk one but nevertheless one she thought was right at the time. As the chief prosecutor, Raluca Botea, noted about Olga Dogaru: 'She changes her story all the time depending on how she sees the interests of her son.'[10] Olga Dogaru's unconditional bond with her son probably determined her actions, overriding any competing motivations, moral, artistic, or otherwise.

MARIELLE SCHWENGEL

Marielle Schwengel holds the dubious distinction of destroying the greatest number of old masters in one go. In 2001, Marielle Schwengel, a nurse from Mulhouse in France, destroyed approximately sixty sixteenth- and seventeenth-century paintings and other antiquities—a definitive number is impossible to know.[11] She was subsequently charged with possession of stolen goods and destroying art, and sentenced to eighteen months in prison.

Marielle Schwengel's son, Stéphane Breitwieser, stole the works she destroyed. Obsessive about art and antiquities, but without the means to legally acquire them, he set out to amass a collection by theft. Stéphane Breitwieser's motivation to steal was simply for his own pleasure. In the privacy of his bedroom, along with his accomplice girlfriend Anne-Catherine Kleinklauss, he would enjoy the spoils of his thieving. Best described as a kleptomaniac, and a waiter by trade, Stéphane Breitwieser had champagne taste on beer money. As Edward Dolnick, in *The Rescue Artist*, notes:

> he robbed 179 museums in seven countries. He concentrated on small museums, which tended to be poorly guarded, and small objects, which he could tuck inside his coat.[12]

On his 24th birthday in 1995, he treated himself to Lucas Cranach's (the Elder) *Portrait of Princess Sybille of Cleves, Wife of Johann Friedrich the Magnanimous of Saxony* (1526), stolen from a castle in Baden, Germany, and valued at the time in excess of £4 M (purported to be the work of the highest value that he ever stole) (Fig. 3.1).[13]

He maintained that he would never sell any of the spoils for commercial gain, and prided himself on his connoisseurship. Stéphane Breitwieser's taste was very particular, for instance he never took anything dating from the nineteenth century. Over seven years he accumulated 239 paintings including works by Dürer, Watteau, Boucher, and Cranach.

Stéphane Breitwieser lived at his mother's home, in Mulhouse, Eastern France, close to the Swiss border. The stolen works were kept there and by all accounts he took reasonable care of them, in particular keeping the curtains drawn to avoid excessive ultraviolet light but perhaps this wasn't simply good museum practice but also to keep away any prying eyes away.

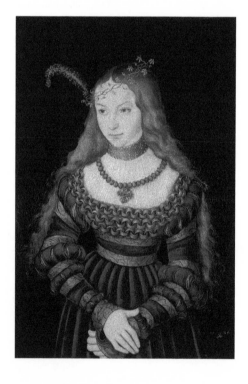

Fig. 3.1 Lucas Cranach (the Elder), *Portrait of Princess Sybille of Cleves, Wife of Johann Friedrich the Magnanimous of Saxony* (1526), stolen from a castle in Baden, Germany, by Stéphane Breitwieser on his 24th birthday in 1995 and allegedly destroyed by his mother, Marielle Schwengel (*Photograph* Alamy)

He'd have paintings that he had removed from their frames re-framed at the local picture framers, who interestingly never twigged the waiter's expensive taste in old masters!

In 2001, aged 30, Stéphane Breitwieser's luck ran out when he was caught red-handed stealing an antique bugle. Things then went horribly wrong for him when his mother found out about her son's larcenous habits and in a fit of anger she began to destroy 'his' collection. Marielle Schwengel's methods of disposal were brutal. She chopped artworks up into small pieces and put them down the kitchen sink's waste disposal unit (this 'domestic' approach fits with the blind eye Marielle Schwengel turned to her son's obsessive stealing, as well as literally tidying up after him), and others were flung into the Rhine-Rhône Canal (approximately 100 kilometres from their home) or put out with the rubbish. Marielle Schwengel's objectives were simply to prevent her son from enjoying the stolen art and, as reported at the time, she told the police that destroying the works enabled her to wipe her house clean of the art.[14] However, she selfishly did not pause to consider who owned the artworks and that by destroying them she was also preventing anyone else from enjoying them ever again. Her decision was finite. Many of the works that washed up on the banks for the River Rhine-Rhône were recognisable but not in an exhibitable state, nor would they ever be. We might consider if Marielle Schwengel's crime was more significant than her son's? Tragically it came down to timing; the international search warrant for Marielle Schwengel's house took nineteen days to materialise, giving her enough time to destroy a substantial portion of her son's beloved collection of stolen goods.

Stéphane Breitwieser initially received a twenty-six-month prison sentence but was sentenced to a further three years in 2013 when police found an additional thirty works stolen by him. Marielle Schwengel was sentenced to an eighteen-month imprisonment and Anne-Catherine Kleinklauss received a six-month prison sentence. The day prior to his sentencing, he tried to commit suicide in his cell. Deeply depressed, Stéphane Breitwieser pleaded for his mother's release before the sentences were handed down, lamenting:

> I feel guilty for my mother. If you send her to prison, you will kill her. ... I apologise for everything. I'll compensate the victims.[15]

Stéphane Breitwieser was trying to protect his mother, yet this doesn't diminish the reality or the enormity of their collective crimes. To compensate the victims on a waiter's wage would be impossible. And like others of his ilk, Stéphane Breitwieser wrote an account about his days of stealing art; in 2006 *Confessions d'un voleur d'art* (Confessions of an Art Thief) was published. Perhaps Stéphane Breitwieser's sentence wasn't harsh enough for in February 2019 he was arrested again for stealing various items including Roman coins from an archaeological museum as well as being caught with €163K in cash stored in buckets, stored at his mother's home![16]

* * *

The three mothers profiled here played the role of *enabler*, assisting in and committing art crimes. Much has been written about this shift, including the argument that physical differences can help explain why men are more inclined to commit crimes—biologically and sociologically it is more natural for women to nurture and care for others and this is at odds with criminal behaviour. (Interestingly both Stéphane Breitwieser's mother and his girlfriend, who effectively assisted his art thieving, were nurses—a vocation associated with caring and nurturing.) However, it is this very attribute that is advantageous to the enabler, for instance, one gets the sense that Radu Dogaru knew his mother would be there if push came to shove. In other words, providing domestic support can enable a male to commit an art crime. Domestic support in this context includes, for example, providing a hiding place for artworks or allowing the family home to be used to make forgeries. And above all else, the enabler is clandestine about the criminal activity. Quite literally, 'Mum's the word'.

Each woman's motivation could be viewed as simply the desire of a mother to protect her adult son. Selfish as this motivation is for the rest of art-loving society, they kept the crimes within the family unit. Instead of curtailing the crimes or helping police convict their sons they protected their sons and so became complicit in the web of art crimes. Each mother *enabled* this to happen. Olive was the team member who established provenance back-stories and set up sales meetings *enabling* Shaun Greenhalgh's practice to flourish for years. Olga Dogaru took the seven stolen works into her home (and other locations such as the cemetery) to *enable* Radu Dogaru (and his associates) to be rid of the evidence. Marielle Schwengel *enabled* Stéphane Breitweisser to fuel his fetish for

illegal collecting by turning a blind eye to all the artworks that were stored in her home. Similarly Olive Greenhalgh chose not to see what her son was up to, as Shaun subsequently admitted he made and sold his first L. S. Lowry forgery aged just 15 years.[17] But aiding and abetting their sons' crimes, and in the process committing their own crimes, was futile. As mothers they paid a price by being convicted, albeit not ending up being sentenced for as long as their sons. Journalist Alex Dymoke noted, 'like much of Breitwieser's collection, the seven masterpieces from the Kunsthal Museum met their end at the hands of an anxious mother'.[18] Dymoke is perhaps too kind; these mothers were not just anxious, they were deceitful and played along with their sons' illegal ways in order to protect them from the law.

These three mothers are art criminals by association. Their sons' art crimes caused them to go on and commit serious art crimes themselves. Perhaps their punishments should have been harsher. Olive Greenhalgh, an octogenarian, received a suspended sentence. Fortunately for her she was not locked up; prison for the elderly is particularly uncomfortable. As an aside, it is worth considering the logistics of 'elderly' prisoners. Studies have proven that elderly inmates require more resources, staff input and time, plus they cannot work effectively in prison employment. The biggest cost for elderly inmates is health-related. When each of the three women under discussion was convicted they were aged 50 years or older, the age that is used to define 'elderly' prisoners in the Western world.[19] And though the three women committed significant crimes the chance of them reoffending (with the exception of Olive who died in 2016) is perhaps relatively low unless their sons give them future cause to. The women got off lightly, for example Marielle Schwengel and Anne-Catherine Kleinklauss were together sentenced to less time that Stéphane Breitweisser. This aside, each was convicted and for Marielle Schwengel and Anne-Catherine Kleinklauss, this surely was the end of their nursing careers.

The case studies presented here created much interest in the media. In particular, the Greenhalgh story fascinated a wide audience, for the family who made a sizeable fortune from art fraud continued to live ordinary lives in a modest semi-detached council house. Once sentenced, a local newspaper, *The Bolton News*, ran an opinion poll in which 65% of participants thought the Greenhalgh's had got off lightly.[20] Such polls cannot be taken too seriously but the very fact that people went to the trouble

to respond is an indication of the level of interest the public took in this case.

Each mother–son relationship was strong, although different. Olive Greenhalgh protected her introverted son from the outside world; he left school without any qualifications aged 16 years. Shaun Greenhalgh's barrister commented during their trial:

> Mr Greenhalgh discovered many years ago he has no style of his own. He had one outlook and that was his garden shed.[21]

Shaun Greenhalgh's bond with his domestic environment, including his mother, was paramount to his existence. He was his parents' caregiver and though often labelled a social recluse, home life protected him from having to deal too much with the outside world (though he certainly appears more confident post-imprisonment). Shaun Greenhalgh is adamantly protective of his late parents in his recent autobiography, protesting that the media made their roles sound more significant than they were.[22] However, they were convicted and charged accordingly. Marielle Schwengel's motivation to destroy the works was initiated by anger, yet the mother–son bond was particularly strong. She and her son doted on each other and as crime reporter Paul French noted:

> She forgave him several youthful police convictions for shoplifting and encouraged his amateur study of art history—he was to combine the two to devastating effect.[23]

That Stéphane Breitwieser attempted suicide—in part through guilt of how he felt about involving his mother—is perhaps a demonstration of their close bond.

Otto Pollak's seminal 1950 text, *The Criminality of Women*, goes some way toward explaining this. He noted that female crimes are underrepresented in statistics for various reasons including women's cunningness and their ability to deceive. The bond of love demonstrated by the three mothers may be unconditional, however this is not the norm when examining the psychology of crime; as historian Chris N. Trueman notes:

> It starts from the belief that women are innately different from men, with a natural desire to be caring and nurturing—both of which tend not to be values that support crime.[24]

In these cases the nurturing could be argued to be the catalyst for supporting [art] crime or exacerbating the situation and making it worse.

Each mother committed these crimes intentionally, though admittedly Olga Dogaru's burning of the Kunsthal works may have been an impulsive reaction. And though Marielle Schwengel expressed anger at her son's criminal activity she still tried to cover up the evidence by destroying it and therefore perverting the course of justice. Stéphane Breitwieser expressed remorse when the realisation that his mother would be imprisoned for her crimes took hold. Nurturing instincts are powerful, and especially for Olive Greenhalgh and Olga Dogaru they came to the fore in being complicit in the criminal circle.

And crime tends to run in families. A 35-year longitudinal study concluded:

> Researchers at Cambridge University's Institute of Criminology found that if children had a convicted parent by the time they were 10 that was the "best predictor" of them becoming criminal and anti-social themselves. The research, published in the journal *Legal and Criminal Psychology*, concluded: "A convicted family member influenced a boy's likelihood of delinquency independently of other important factors such as poor housing, overcrowding and low school attainment."[25]

Common to each of the three cases is that the son was the criminal in the first instance, followed by the parent. This reverse transmission of intergenerational tendencies contrasts with the high rate of offspring who follow in the footsteps of their criminal parents. The Greenhalgh case was very much a family affair; collectively they were known as 'the garden shed gang', referring both to Shaun Greenhalgh's studio and the domestic context in which the family did business. In this context, 'gang' alludes to familial ties. In addition, we see Stéphane Breitwieser and Radu Dogaru involving their girlfriends, and thus de facto family members, as active participants in their art crimes.

The other common element to Olga Dogaru, Olive Greenhalgh, and Marielle Schwengel is that even thought they were convicted we do not really know the full extent of their crimes. There is no way of knowing how many fraudulent works Olive Greenhalgh sold to innocent victims, as Noah Charney notes:

Scotland Yard fears that more than 100 of their forgeries are still out there, mislabelled as originals.[26]

Whether Olga Dogaru burnt all seven stolen works from the Kunsthal Museum is unknown (the frames were never found, and in August 2013 Radu Dogaru tried to cut a deal professing he was still in possession of five works). And was there a full list of the works disposed of by Marielle Schwengel?

Each mother received relatively short prison sentences given the enormity of their crimes and one could question that if the crimes were viewed independently of their sons' crimes, would they have got off as lightly? They are often reported in a way that makes the mothers' crimes appear secondary to their sons', but they committed their own individual crimes. None of the three women were forced into art crime nor were they responsible for decisions made by their adult sons. Both Olive Green-halgh and Olga Dogaru lived their domestic lives within the context of ongoing criminal activity. To a lesser degree Marielle Schwengel also lived within the context of a criminal household, as Stéphane Breitwieser continually brought home art and antiquities to their home. It got to the stage where he had so many artworks he had to rotate them, just as a public art museum does. And yet Marielle Schwengel was not suspicious about the quantity of works, nor their origins. As a mother, I find her ignorance remarkably unbelievable. Clearly Marielle Schwengel had blinkers on and as Stéphane Breitwieser's lawyer Thierry Moser remarked:

This boy is psychologically disturbed, tormented by an obsessive relationship with his divorced mother.[27]

That he describes the adult Stéphane Breitwieser as a 'boy' perhaps goes some way to explain this particular mother–son relationship. Surely the big question has to be why Marielle Schwengel never questioned where these supposed copies of old masters came from? Her apartment's attic provided a safe haven for Stéphane Breitwieser's 'hot' art and yet how was it that Marielle Schwengel never twigged to media reports about missing artworks and antiquities that matched the 'copies' she had in her own home? Or perhaps it was a mother's love for her son that drove her away from doing the right thing. Of the Dogaru theft, Noah Charney succinctly concluded 'This is not the first time that a foolish and ignorant mother has made a son's art theft crime far worse by destroying the stolen art.'[28]

NOTES

1. For simplicity I have used first names where the last name is the same for more than one person.
2. David Pallister and Helen Carter, 'Curtain Falls on Antiques Rogue Show as Last of Family Forgers Convicted', *Guardian*, 29 January 2008.
3. 'Lowry', *Fake or Fortune*, BBC, Episode 1, Series 4, 3 July 2015.
4. Shaun Greenhalgh, *A Forger's Tale*, London: Allen & Unwin, 2017.
5. Thomas D. Bazley, *Crimes of the Art World*, Santa Barbara, CA: Praeger, 2010, p. 81.
6. Mark Jones, 'Comment: Scholarly Research Is Flourishing But Curators' Ability to Judge an Object's Quality Is Not', *The Art Newspaper*, 13 March 2017.
7. ARCA Blog, 'Kunsthal Rotterdam Art Theft: Three Defendants Plead guilty: Radu Dogaru Criticizes Museum's Security', 22 October 2013.
8. Zack Newmark, 'Art Heist Suspect Willing to Surrender to NL Courts', *NL Times*, 13 August 2013.
9. Bendor Grosvenor (ed.), 'Kunsthal Theft Trial (ctd)', *Art History News*, 13 August 2013.
10. Andrew Higgins, 'A Trail of Masterpieces and a Web of Lies, Leading to Anguish', *The New York Times*, 26 July 2013.
11. Lance Charnes, 'Van Gogh Goes to Italy: Oil and Cocaine *Do* Mix', http://www.criminalelement.com/van-gogh-goes-to-italy-oil-and-cocaine-do-mix, 27 October 2016.
12. Edward Dolnick, *The Rescue Artist*, New York: HarperCollins, 2005, p. 144.
13. Oil on panel, 53.3 × 38.1 cms.
14. Jon Henley, 'French Waiter Admits Mass Art Theft', *Guardian*, 23 May 2002.
15. Amelia Gentleman, 'Court Jails Art Thief, Girlfriend and Mother, *Guardian*, 8 January 2005.
16. Sarah Rose Sharp, 'Serial Art Thief, Who Stole Nearly 250 Artworks, Arrested Yet Again', *Hyperallergic*, 14 February 2019.
17. Saiqa Chaudhari, 'Master Forger Shaun Greenhalgh Who Conned Council Out of £400,000 Sells "Lowry" Artworks—This Time Legally!', *The Bolton News*, 22 February 2017.
18. Alex Dymoke, 'The Art of Theft: Why Do Thieves Steal Famous Paintings When They're So Hard to Sell?', www.cityam.com, 28 October 2014.
19. Ronald H. Aday and Jennifer J. Krabill, *Women Aging in Prison*, Boulder, CO: Lynne Rienner, 2011; Azrini Wahidin, *Criminal Justice System: Running Out of Time*, London: Jessica Kingsley, 2004.
20. Zara Ellis, *Master Forgers: The Greenhalgh Family—Does Crime Really Pay?* Cheshire: Book Treasury, 2015, p. 62.

21. David Pallister, 'The Antiques Rogue Show', *Guardian*, 28 January 2008.
22. Shaun Greenhalgh, *A Forger's Tale*, London: Allen & Unwin, 2017.
23. Paul French, 'He Stole $1.4 Billion', *Real Crime*, No. 17, 20 October 2016, pp. 57–61.
24. C. N. Trueman, 'Feminism and Crime', www.historylearningsite.co.uk, 25 May 2015 and 16 August 2016.
25. Roger Todd and Louise Jury, 'Children Follow Convicted Parents into Crime', *Independent*, 27 February 1996.
26. Noah Charney, *The Art of Forgery: The Minds, Motives and Methods of Master Forgers*, London: Phaidon, 2015, p. 108.
27. Tracy McNicoll and Christopher Dickey, 'The Gentleman Thief: A Remarkable Crime Spree Comes to an End: Or Does It?', *Newsweek*, 24 January 2005.
28. Noah Charney, 'Lessons From the History of Art Crime: Art-Burning Mother & Art Loss Register Issues', *The Journal of Art Crime*, Fall 2013, pp. 77–79.

SELECTED BIBLIOGRAPHY

Aday, Ronald H., and Jennifer J. Krabill. *Women Aging in Prison*. Boulder, CO: Lynne Rienner, 2011.

Adler, Freda. *Sisters in Crime: The Rise of the New Female Criminal*. New York: McGraw-Hill, 1975.

Balazs, Edith. 'Romanian Art Thief Offers Works in Return for Dutch Trial'. *Bloomberg*. https://www.bloomberg.com/news/articles/2013-08-13/romanian-art-thief-offers-works-in-return-for-dutch-trial, 13 August 2013.

Bazley,Thomas D. *Crimes of the Art World*. Santa Barbara, CA: Praeger, 2010.

Boughton, Desmond. 'Famous Art and Jewellery Heists'. *J. Safra Sarasin Brokerage Newsletter*, July 2015, pp. 5–6.

Breeuwsma, Gerrit. 'The Rest of the Irreplaceable: A Small Psychology of Art Vandalism'. *Art and Crime*, 1997, pp. 41–53.

Charnes, Lance. 'Van Gogh Goes to Italy: Oil and Cocaine *Do* Mix'. criminalelement.com, 27 October 2016.

Charney, Noah. 'Lessons from the History of Art Crime: Art-Burning Mother & Art Loss Register Issues'. *The Journal of Art Crime*, Fall 2013, pp. 77–79.

Charney, Noah. *The Art of Forgery: The Minds, Motives and Methods of Master Forgers*. London: Phaidon, 2015.

Chaudhari, Saiqa. 'Master Forger Shaun Greenhalgh Who Conned Council Out of £400,000 Sells "Lowry" Artworks: This Time Legally!' *The Bolton News*, 22 February 2017.

Dickey, Christopher and Tracy McNicoll. 'The Gentleman Thief; A Remarkable Crime Spree Comes to an End: Or Does It?' *Newsweek*, 24 January 2005.

Dolnick, Edward. *The Rescue Artist*. New York: HarperCollins, 2005.

Douglas, Susan. 'Susan Douglas Reviews *The Art of Forgery: The Minds, Motives and Methods of Master Forgers*' (Phaidon Press, 2015) by Noah Charney, *Journal of Art Crime*, Fall 2016, pp. 111–112.

Dymoke, Alex. 'The Art of Theft: Why Do Thieves Steal Famous Paintings When They're So Hard to Sell?' www.cityam.com, 28 October 2014.

Ellis, Zara. *Master Forgers: The Greenhalgh Family—Does Crime Really Pay?* Amazon, 2015.

French, Paul. 'He Stole $1.4 Billion', *Real Crime*, No. 17, 20 October 2016, pp. 57–61.

Gentleman, Amelia. 'Court Jails Art Thief, Girlfriend and Mother'. *Guardian*, 8 January 2005.

Greenhalgh, Shaun. *A Forger's Tale*. London: Allen & Unwin, 2017.

Grosvenor, Bendor (ed.). 'Kunsthal Theft Trial (ctd)'. *Art History News*, 13 August 2013.

Higgins, Andrew. 'A Trail of Masterpieces and a Web of Lies, Leading to Anguish'. *The New York Times*, 26 July 2013.

Houpt, Simon. *Museum of the Missing: The History of Art Theft*. New York: Sterling, 2006.

Jones, Mark. 'Comment: Scholarly Research Is Flourishing But Curators' Ability to Judge an Object's Quality Is Not'. *The Art Newspaper*, 13 March 2017.

Jury, Louise and Roger Todd. 'Children Follow Convicted Parents into Crime'. *Independent*, 27 February 1996.

Pallister, David. 'The Antiques Rogue Show'. *Guardian*, 28 January 2008.

Pallister, David and Helen Carter. 'Curtain Falls on Antiques Rogue Show as Last of Family Forgers Convicted'. *Guardian*, 29 January 2008.

Parkin, Simon. 'I Wasn't Cock-a-Hoop That I'd Fooled the Experts: Britain's Master Forger Tells All'. *Guardian*, 27 May 2017.

Pollak, Otto. *The Criminality of Women*. Philadelphia: University of Pennsylvania Press, 1950.

Riding, Alan. 'Your Stolen Art? I Threw Them Away, Dear'. *The New York Times*, 17 May 2002.

Stobie, Erin. 'Artnapping: The Curious World of Art Theft'. *Outlet Magazine*, undated.

Trueman, C. N. 'Feminism and Crime'. www.historylearningsite.co.uk, 25 May 2015 and 16 August 2016.

Wahidin, Azrini. *Criminal Justice System: Running Out of Time*. London: Jessica Kingsley, 2004.

She Vandals

Intentional damage to art is an act of vandalism. Perpetrators either have clear pre-meditated motives for their actions or it can be a spur of the moment opportunity. Artworks can also be damaged unintentionally, such as long term damage due to excessive exposure to ultra violet light, which can slowly destroy a work on paper if not cared for in the correct manner. Accidental damage occurs regularly, such as on 22 January 2010 when a woman attending a class at New York's Metropolitan Museum lost her balance and fell into Picasso's *The Actor* (1905). The oil on canvas sustained a six-inch tear that took three months to repair by the Museum's conservation department. At the time, *The Actor* was valued at USD$130M. The work was returned to exhibition with an additional protective layer, Plexiglass. Fortuitously, as reports noted at the time, the falling woman was not hurt! But this kind of damage is not classed as vandalism. In some cases, art vandalism is committed to draw attention to an individual and/or cause. Sometimes, the cause isn't easily identifiable.

One such example occurred on 7 February 2013 when a 28-year-old woman entered the Galerie du Temps at the Louvre-Lens, an outpost of the Louvre in northern France, and scrawled AE911, measuring 30 cms long, on the right hand corner of Eugene Delacroix's large oil on canvas painting, *Liberty Leading the People* (1830). The unnamed woman used a black permanent marker pen, and as subsequently recounted by the town's mayor Guy Delcourt, reportedly told security personnel that she wanted to put her mark on the painting.[1] The indelible ink was fortunately removable, as it didn't penetrate beyond the painting's surface

© The Author(s) 2020
P. Jackson, *Females in the Frame*,
https://doi.org/10.1007/978-3-030-44692-5_4

varnish. Taking approximately two hours for the ink to be removed, the painting was back on exhibition the following day. Due to the painting's value, the fact that it was being exhibited at a relatively new outpost to the Louvre, and the question around the meaning of the graffiti, the incident was reported widely at the time. However, what happened to the vandal was never made public. There was much speculation as to the meaning behind AE911 with many agreeing that it represented the Architects & Engineers for 9/11 Truth; an American group that supports a conspiracy theory that the World Trade Centre towers collapsed as a result of a controlled demolition. Unemployed, with a masters degree, the vandal allegedly suffered from psychiatric problems and was described as 'unbalanced'.[2] Not one to mince his words, historian Bendor Grosvenor noted his sentiment for the incident: 'usual story; some half-baked nutter looking to publicise something'.[3] It was precisely the 'something' that was never made public. As a result of the incident, the gallery's security was increased.

Digressing slightly, Picasso's *The Actor*, as mentioned above, was glazed with acrylic Plexiglass to mitigate further damage, whether accidental or not. Plexiglass is the favoured glazing choice for major art museums. It is a wonderful material for its anti-reflective quality—there's nothing worse than seeing yourself reflected in an artwork—and how it can protect a work. In addition, it is harder to break than glass and if this does occur it doesn't break into a myriad of shards that can further damage the work. Purists are critical of its use, as viewing fine brushwork up close isn't as easy when a work is glazed with Plexiglass (or any other kind of glazing material for that matter). However, visitor experience and safety of artworks will continue to be a hot topic for museum professionals. The case of art vandal, Susan J. Burns, however proves how Plexiglass saved two significant paintings. On her birthday, 1 April 2011 Burns entered Washington's National Gallery of Art to see the exhibition *Gauguin: Maker of Myth*. She took an instant dislike to Gauguin's *Two Tahitian Women* (1899); leaping at the painting Burns tried to wrench the work from its screws and then proceeded to slam it with her fists. Burns took exception to the bare-breasted women in Gauguin's painting—on loan from the Metropolitan Museum of Art in New York—and she thought the work was 'very homosexual'.[4] Fortunately the painting wasn't damaged and was soon returned to display. The Plexiglass had potentially saved the painting from being damaged. Burns, a schizophrenic, was charged with destruction of property and attempted theft. She pleaded not guilty to

the charges. Just four months later, on 5 August, Burns returned to the Gallery and attacked Matisse's painting, *The Plumed Hat* (1919), valued at USD$2.5M. This time she was also charged for contempt of court as she had been barred from visiting the Gallery following the first act of vandalism. Again, fortunately, the Plexiglass protected painting wasn't damaged though the original frame was, as she'd slammed it against the wall three times. Following a mental observation hearing, Burns who had a criminal record prior to taking to vandalising art, was transferred from prison to St Elizabeth's Hospital, a specialist psychiatric facility in Washington, DC.

Art vandalism has also occurred unintentionally by the hands of those not fully knowledgeable, including by cleaning staff or casual staff brought into work events at museums. On 3 November 1973, two women looking for a container to keep beer cool and to use as a washing up bowl after an event, held at the Leverkusen Art Museum, Germany, chanced upon Josef Beuys' (1921–1986) work *Bathtub* (1960), in a store room inadvertently opened by a museum assistant. The work is a white enamel baby's bathtub on a stand (Beuys was bathed in this tub as a baby),[5] wrapped in fat-soaked gauze and bandages. The women proceeded to use the bathtub for the beer but not before removing the gauze and bandage wrappings.[6] Subsequently, in 1976 the owner of the work sued the town, who was ordered to reimburse the owner.[7] In another case, dating from November 2011, Martin Kippenberger's (1953–1997) sculptural installation, *When It Starts Dripping from the Ceiling* (1987), on exhibition at Germany's Ostwall Museum located at Dortmund, was given a spruce up by the Museum's female cleaner.[8] She removed what she considered to be a pesky beige stain. The stain was intentional and unfortunately the work could not to be returned to its original condition which at the time was valued at €800K.

Institutions and the public are aggrieved when art vandalism occurs, making it very newsworthy. It is difficult to keep such acts out of the media, especially since they are carried out during opening hours in view of the public, in some cases to maximise the effect. The media coverage can be part of the vandal's strategy in drawing attention to their cause, and the more dramatic the act of vandalism, and the more valuable the work in question, then the more sensational the potential coverage. The perpetrator cares little about the damage they have inflicted, but rather whether the damage gets them the desired result. The cases of the female

vandal discussed in this chapter showcase a range of motivations for vandalism, with differing outcomes.

Tomoko Yonezu and the *Mona Lisa*

Leonardo da Vinci's *Mona Lisa* (*c*.1503–1519) is a victim of several art crimes.[9] Perhaps the most notorious and documented crime associated with the *Mona Lisa* is the 1911 theft by an Italian handyman, Vincenzo Peruggia, who escaped with the portrait out of the Musée du Louvre, via the staff door. The irony was that Peruggia was employed to build the glass cabinets to house the most prized works, as the Louvre was going through a period of increasing its security. It took two years to see the painting's safe return and since then she has been the target of vandals on numerous occasions, a couple of which were carried out by women. The most visited museum internationally, in 2016, 7.4 million people visited the Louvre of whom it is estimated 80% go pilgrim-like specifically to see the *Mona Lisa*.[10] With this level of popularity, causing damage—or appearing to cause damage to the 'famous' portrait—has the potential to disappoint many a visitor and hurt the Louvre's visitation numbers. Therefore this small oil painting on poplar panel, a Renaissance portrait of Lisa Gherardini, measuring 77 × 53 centimetres, is a good choice if your intention is to create disruption, gain attention, and ultimately damage one of the world's best-loved and most valuable paintings.

In 1974, the Louvre loaned the *Mona Lisa* to Tokyo's National Museum in Ueno Park in a bid to offer a taste of Western culture to the Japanese public. It was only the second time in 450 years that the painting had been exhibited outside France. The hype was so big for the exhibition, which was scheduled to run for just over two months, that visitors were told there was a time limit per visitor in which to view the portrait. Initially, on the day of its inaugural showing—19 April—it was estimated that visitors would have approximately ten seconds to 'enjoy' the *Mona Lisa*. As the portrait's biographer, Donald Sassoon, wrote, 'This may seem a little rushed, but was perhaps sufficient to enable everyone to feel sanctified by the experience.'[11] As it turned out, only 20,000 people queued to see it on that opening Saturday against the estimated 30,000, yet to keep the crowds moving, and in a bid to give each visitor a fair viewing, no allowances were made for anyone who needed assistance, meaning the disabled, the elderly, and visitors with infants. In other words, you had to be physically fit and able to guarantee a quick look at the *Mona Lisa*.

Tomoko Yonezu, a 25-year-old woman, took issue with this policy. Though 'able' enough to enter the queue, Yonezu suffered from a lame right leg caused by childhood polio. On 20 April when it was her turn to view the *Mona Lisa* she sprayed red paint at the painting's protective case. Fortunately, though there were an estimated twenty to thirty spots of red paint on the casing, the portrait was undamaged. Disgruntled with the Museum's policy, she voiced her concern calling out, 'Down with Mona Lisa! Why don't you let handicapped people in?' A deliberate act of vandalism, the message was effective for it highlighted the unfair policy put in place by the Museum. The policy was not without issue as prior to the *Mona Lisa* being made available for the public to see, there had been a heated debate about the rule and subsequently the Museum decided to schedule one day—10 May—exclusively for physically handicapped visitors, or indeed anyone who could not keep up a steady pace in the queue. Supporting Yonezu in her concerns about the unfair treatment of those who needed assistance were members of the women's liberation group (Uman Ribu) who simultaneously staged a demonstration outside the Museum, with other activists, to show their outrage at the discrimination implemented by the Museum. Yonezu was arrested, detained for a month, and a court battle ensued for the next year. In June 1975, she was convicted of a misdemeanour and made to pay a fine of ¥3k.[12] To this day, Yonezu continues to actively advocate for equality.

'A Russian Woman' and the *Mona Lisa*

More recently the *Mona Lisa* was the target of a terracotta mug-wielding Russian woman. On 2 August 2009, the woman (who remains unnamed) entered the Louvre, purchased a mug from the museum store and made her way to the gallery where the *Mona Lisa* hangs in Room 711, on the first floor of the Denon Wing. She threw the mug, which shattered, at the painting. The protective glass case protected the painting from being harmed. The woman's motivation was her anger at being denied French citizenship. Her act of vandalism inflicted on a much-loved French icon (though it's Italian) would not have enamoured the authorities to reverse their decision to allow her citizenship. Though the Louvre filed a legal complaint about the incident, the woman was released after she underwent psychiatric testing.

These two examples go some way towards showing the risk and lengths vandals will go to in order to make a point, whether it's for a personal or

public cause. That the *Mona Lisa* is an object of beauty is part of their plan. Fortunately, the painting is well secured, especially since its 1911 theft. Since 1960, the *Mona Lisa* can only be viewed through protective glass; this came just four years after it was attacked by acid and sustained damage. In many cases, works that are vandalised can be restored close to their former glory. What can never be changed though is the story, the history of the incident, and of the vandalism. In some cases this adds to the kudos of the work. Viewers are intrigued with stories of vandalism, though as we will see in the majority of cases this information is left off a work's label and the online catalogue, as is the case for the *Mona Lisa*, with the exception of a brief mention about the 1911 theft mentioned in the Louvre's 'The most famous painting in the world' online Focus portal, meaning you have to search for it.[13]

VALENTINE CONTREL AND *POPE PIUS VII IN THE SISTINE CHAPEL*

On 12 September 1907 Valentine Contrel entered the Louvre, mid-afternoon, and headed for the French Neo-Classicist painter, Jean-August-Dominique Ingres' (1780–1867) painting, *Pope Pius VII in the Sistine Chapel* (Fig. 4.1).[14] It is a relatively small oil painting, measuring 700 × 550 mm, depicting a service being conducted by Pope Pius VII. The Louvre's version is a copy made in 1819–1820 of Ingres' earlier 1814 work of the same subject, held in the collection of the National Gallery of Art, Washington. Contrel made a beeline for Ingres' work with a pair of small scissors (well, she was a seamstress!) with the intent of gouging out the eyes of the Pope, a cardinal, and two ecclesiastics. In reality, she struggled with the specifics of the task she had set herself, as the canvas was far tougher than she had envisaged, but nevertheless she was successful at making several lacerations to the canvas, destroying several figures.

Contrel's act of vandalism was not witnessed by anyone so she made her way directly to the nearest police station and confessed to her illegal behaviour. At first the police did not believe her. Subsequently, on viewing the work, they realised Contrel was telling the truth. You see, Contrel's objective was to get caught; her motivation for the crime was to be charged, convicted, and sentenced to prison. Contrel's wish came true.

Before the magistrate, Contrel delivered a long speech of woe, claiming:

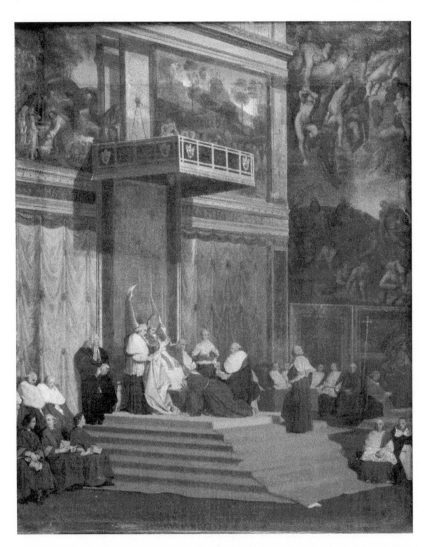

Fig. 4.1 Jean-August-Dominique Ingres, *Pope Pius VII in the Sistine Chapel* (1819–1820). Collection: Louvre, Paris (*Photograph* Alamy)

It is a shame to see so much money invested in dead things like those at the Louvre collections when so many poor devils like myself starve because they cannot find work.[15]

Contrel went on to explain that she worked extremely long days as a seamstress, but couldn't earn enough to cover her rent. For her, ending up in prison would solve her housing problem. Contrel's attack was premeditated and she hoped to be handed down a prison sentence, for as she told a Salvation Army worker, she was fed up with working; she would rather go to prison than be someone's servant.[16]

Ingres' *Pope Pius VII in the Sistine Chapel* was not glazed and in theory easy to vandalise, though it turned out to be harder than she'd initially anticipated. Contrel went about her task unnoticed. There was another woman in the gallery, copying a painting, so absorbed in her activity she didn't notice Contrel's scissor attack. A few other people walked past but she managed to act inconspicuously. In fact, Contrel realised she had to do a sizeable amount of damage in order to be arrested so she didn't want to be stopped prematurely. Clearly some thought had gone into her act of vandalism. When she first arrived at the Louvre, at 3 p.m., there were still too many visitors about so she held off until 4.30 p.m., closer to closing time, before getting to work with her scissors.

One wonders why Contrel specifically chose Ingres' *Pope Pius VII in the Sistine Chapel*. One scholar speculated that the religious subject matter was relevant and catalogued Contrel as an iconoclast. Discussing iconoclasm, art historian Helen E. Scott explains:

Their acts are not so much self-promoting expressions of power, as efforts to take control of their own situations. In the years preceding the First World War, several assaults were undertaken by destitute people in France. The case of Valentine Contrel is a good example.[17]

In her statement to the Magistrate, Contrel made it clear that her demonstration had no grounds in religion. She simply wanted to be looked after by the state. Scott was right about the surge of attacks at the Louvre though. In 1907, Contrel's attack was the Louvre's third in two months.[18] The Louvre took two actions to try to curb further crimes from occurring. Firstly, a greater distance was placed between the viewing public and the artworks and secondly, they 'set more men to look after them'.[19] However, the reality of increasing security was explored at the

time in *The Burlington Magazine*.[20] The suggestion of glazing paintings, and placing stanchions in front of significant works, were both deemed as not 'an entirely effective preventive'. Concern that students of art would be prevented from being able to view works up close was the main reason for the dismissive comment. And as the writer noted, it was 'probably impossible to prevent a desperate person or lunatic from damaging a picture'. More custodians, and one in each 'small' room, were put forward as a possible solution. Well over a century later, public art museums continue to debate the same issues about access to exhibits versus mitigating damage to artworks.[21]

Contrel was one of the 'desperate' people *The Burlington Magazine* spoke of. By all accounts she was an educated woman; bi-lingual (French and English), Contrel had worked as a governess in England before returning to her native France, where she took up work as a seamstress. Contrel had also worked as a Salvation Army officer in both London and Rouen, so knew only too well the plight of the poor. And so she entered the Louvre on 12 September 1907 with a clear objective; her inspiration, as she herself declared, was to imitate an earlier act of vandalism:

> The papers lately mentioned that a man had slashed a Louvre picture. That is what I must do to avenge myself.[22]

In the two months preceding Contrel's attack, two other works were vandalised—Nicolas Poussin's oil on canvas, *Le Déluge* (*c*.1660–1664) and an [unnamed] work by Dutch seventeenth-century artist, Nicolaes Pietersz Berchem (1620–1683). Though unnamed, one can assume it was the oil on canvas acquired in 1816, *Landscape with Elkana and his Wives Anna and Pennina* of 164(7?), as the one other work by the same hand in the Louvre's collection came into the collection after 1907.[23] Alphonse Cousin, wielding a carving knife, slashed *Le Déluge*, a significant work that has subsequently been described as Poussin's most atypical picture. Regarded by many as Poussin's greatest work, very little has been written about the slashing *Le Déluge* was given.[24] The vandal had come upon hard times and was refused financial assistance from his parents so he decided to publicly shame them by being arrested. Cousin's plan worked, for when the story hit the headlines at his parents' hometown, they were justifiably embarrassed.

Despite contemporary reports, such as *The New York Times* who noted *Pope Pius VII in the Sistine Chapel* was damaged beyond all hope of repair,

the painting was restored and hangs today in the Louvre's Sully Wing, in Room 60, Sully Wing.[25] As for Contrel, she got what she wanted; sentenced to six months imprisonment, though it was probably not as long as she had hoped for.[26] But as she told a Salvation Army officer, sentences are increased for bad behaviour! Contrel displayed little remorse for her actions claiming:

> I regret my act because I have learned that the man who painted the picture, like me, also suffered poverty and hardships.[27]

Contrel achieved some notoriety for her act of vandalism and affected change at the Louvre, for it was later in 1907 that the *Mona Lisa* would be glazed, for fear of being vandalised. Contrel's story—in part perhaps due to her long confession justifying her actions—made it into the newspapers worldwide including New Zealand's *The Evening Post*, which was no mean feat for 1907.

Five years later, just before 1 p.m. on 21 July 1912, another seamstress let loose at the Louvre. With red ink in her hand, Frolaine Delarue (Delarue is also known by the names Prolaine Delarre and Delaure Frolaine) smeared ink over the eyes, nose, and mouth of François Boucher's *Portrait of a Young Lady with a Muff* (1749), which was hanging in the Louvre's Lacaze Room.[28] A pair of black and white photographs taken for the newspapers at the time depicts a mugshot of Delarue and an image of the damaged portrait. Though pixillated by current day standards, the image of the damaged work clearly shows the splodge of red ink, albeit in black and white (see Fig. 4.2). Having Delarue's portrait in the news was also about public shaming. As far as images go, the double photograph isn't great, but it's the only known one. In fact, the Louvre had no visual record of this crime until I provided them with this one. And so over a century later, the painting's file was added to.

Some reports say the ink was applied with a paintbrush, others with her hand. When questioned she gave her motivation as:

> I am miserably hungry and have been unable to find work. I often go to the Louvre, and the sight of the young woman in the picture with a happy smile and luxurious clothes maddened me. I decided to mutilate her hateful face in the hope that perhaps after that people would notice me and save me from starving. ... The picture displeased me and I wished to correct what I considered wrong.[29]

Fig. 4.2 Frolaine Delarue with damaged François Boucher's *Portrait of a Young Lady with a Muff* (1749), July 1912 (Unknown photographer. *Source* https://www.presseocean.fr/actualite/faits-divers-la-nantaise-qui-naimait-pas-la-peinture-de-francois-boucher-06-11-2015-174928)

Delarue's handbag also contained a pair of scissors; fortunately she didn't use them on this occasion. Contemporary reports noted that *Portrait of a Young Lady with a Muff* had not suffered extensive damage and was expected to be restored to its former brilliance.[30] It was, but today it remains in storage. The painting, thought to be by the hand of Boucher at the time of the attack, was in 1974 confirmed as having been made in Boucher's workshop, a studio replica of the pastel in the Wildenstein Collection.[31]

From Nantes, 28-year-old Delarue had hit hard times and decided that the red ink would demonstrate that there were other sinners on earth whose faces should become 'red with shame', like hers. After questioning, Delarue was charged with the deterioration of an object used for public decoration and imprisoned at the women's prison, Saint-Lazare, located at Paris's 10th arrondissement.[32]

RINDY SAM AND *PHAEDRUS*

On 19 July 2007 a 30-year-old woman, Rindy Sam, of Cambodian French ethnicity 'kissed' American artist, Cy Twombly's (b. 1928) triptych *Phaedrus* (1977).[33] The work, made up of three white canvas panels and measuring 3 × 2 metres, was on exhibition at the Museum of Contemporary Art in Avignon, France, on loan from its owner, Yvon Lambert. The 'kiss' left a large red indelible blotch on the white canvas, described by some as a smearing of lipstick rather than a tidy lip-shaped kiss.

Sam's justification for this act of vandalism was that she was 'overcome by passion'. Subsequently she was somewhat bewildered that Twombly did not respect her reasoning; Sam thought he'd understand her depth of love and passion for his work, her response she saw as a clear demonstration of her feeling. The museum's curator, Eric Mézil, went as far as accusing Sam of 'raping' *Phaedrus*.[34] The painting's owner Lambert also used the term 'rape' in relation to the vandalism of *Phaedrus*. In a strange turn of events, Sam was liberated by Lambert's rape analogy as it stirred up childhood memories of being abused. She went on to file a complaint for the 'rape of a minor' to an acquaintance of the foster family she had been placed with.[35] Sam was also indignant about the term 'vandalism' being used in relation to her actions, a term she thought more akin to tearing the canvas with knives.[36]

Lipsticks contain fats and chemicals making them notoriously difficult to remove from canvas. Furthermore, lipstick stains well, especially if it is of the bright red variety that Sam favoured (the lipstick was true red satin by Bourjois Rouge Best). Her weapon of choice to vandalise *Phaedrus* was not at all original. Others have preceded her; in 1977, 43-year-old Ruth van Herpen kissed a Jo Baer (b. 1929) white monochrome painting, one of several in the exhibition *Jo Baer 1962–1975*, at the Oxford Museum of Modern Art. Her objective was to cheer up a 'cold painting'.[37] Not only did she leave an impression of her lips but also a long smear line underneath. Van Herpen was charged and ordered to pay USD$1260 towards the restoration of the work that at the time was valued at USD$18K. And in January 2012, at the Art Gallery of New South Wales, Sydney, Australia, a woman kissed John Gibson's (1790–1866) nineteenth-century sculpture *Narcissus* (after 1829). The red lipstick on *Narcissus's* bottom was reported as vandalism. It sounds gendered, but committing a crime against art with lipstick is very feminine; my research failed to find any lipstick-wielding male culprits.

Sam was charged with 'voluntary degradation of a work of art' and ordered to pay damages of €1500 to the owner, €500 to the museum, and a symbolic €1 to Twombly.[38] Sam also had to complete one hundred hours of community service. In her defence, her lawyers, Patrick Gontard and Jean-Michel Ambrosino said Sam's kissing of *Phaedrus*, was an 'act of love'. Agnes Tricoire, lawyer for the plaintiff, noted that Sam's kiss was 'as aggressive as a punch, causing damage that was just as hard to restore'.[39] Many reports about this incident described Sam as an artist, suggesting that she would have more respect another artist's work. But it would seem, according to her, that her passion to add colour to the triptych overwhelmed her and any thought of respect instantly vanished. The extent of the damage to *Phaedrus* meant it couldn't be restored to its former glory, though this was not for the want of trying. Conservators tried thirty different products to try to remove the stain.[40] At the time of Sam's kiss, *Phaedrus* was valued at €1.8M.

Sam is not the only art vandal to be driven by passion. In 2001, artist Jacqueline Crofton threw eggs at Martin Creed's *Work No. 227: The Lights Going On and Off*, on exhibition at the Tate Modern in London. Unlike Sam's outburst of love, Crofton's mission was to make a stand about the state of contemporary art and how artists with 'real creative talent' were held back from major prizes and exhibitions for the likes of Creed whose work was an empty room with two flashing lights. As art historian Helen E. Scott writes:

> The fact that Creed had won the coveted accolade with seemingly minimal effort, while Crofton's laborious work was not rewarded, must have been especially galling for her.[41]

Contemporary art is often controversial; Creed's work was no exception. Reports noted that several visitors walked out of the Tate saying Creed's exhibit was unfit to be considered for the most celebrated prize in the art world.[42] The clean up was swift and the gallery space re-opened promptly. *Work No. 227: The Lights Going On and Off* has been exhibited regularly since it won the Turner Prize in 2001 and in 2013 the Tate acquired it for its collection. At that time, it was valued at £110K.[43] Crofton's punishment for her crime was being barred for life from visiting any of the Tate galleries.

The measure of the outrage and depth of feeling that Sam's kiss caused, was reinforced by the specifically curated exhibition, *I Don't Kiss*.[44] The

exhibition was hosted at the same venue where Twombly's work was vandalised, the Museum of Contemporary Art in Avignon. A group exhibition, made up of over sixty artists, the exhibits included works such as Scottish conceptual artist, Douglas Gordon (b. 1966) who planted a kiss on a plastic skull, as a tool of symbolic defacement (he makes a skull for each year of his life). The lengthy press release explored and contextualised Sam's actions within art vandalism. Exhibition curator Eric Mézil summed up the effect Sam's kiss had on Twombly in the press release for *I Don't Kiss*:

> Cy Twombly was a victim not once but twice. The first instance, by a vulgar kiss placed on one of his canvases exhibited this summer, on an artwork that is kept at our museum. The second time, as the artist ironically told us in September, because from now on, his name shall be known to all French people, but only as the artist who made a white canvas kissed by a woman who calls herself an artist, taking Twombly hostage in a media and judicial scandal.[45]

In 2009 Sam was also ordered to pay for the cost of restoration of *Phaedrus* to the tune of €18,440.[46] In addition she was ordered to pay court costs. And so, what Sam described as part of her own art practice turned out to be a very expensive exercise in order to tick it off her bucket list.

CARMEN TISCH AND *1957-J-NO.2*

Seemingly, both Valentine Contrel and Rindy Sam had very clear intentions when they took to vandalising art. However, it is harder to explain why a Denver woman, Carmen Tisch, aged 36, damaged a large painting by American artist Clyfford Still (1904–1980). On 29 December 2011 at 3.30 p.m. Tisch entered the beautifully appointed, and newly opened, Denver's Clyfford Still Museum.[47] She stopped at the 2870 × 3937 mm oil on canvas painting, *1957-J-No.2* (1957) and scratched and punched at the canvas. After causing this initial damage she then pulled down her pants, slid her buttocks against the canvas before urinating on the floor. Fortunately, her urine missed the canvas.

Before causing any further damage, Tisch was stopped by the Museum security guards and subsequently apprehended by the police. At the time, Tisch was intoxicated and one can only assume that her choice of painting was random. However, the work she chose is particularly significant to

the collection and was one of five listed as a highlight in the media release announcing the grand opening of the purpose-built museum, dedicated to Clyfford Still.[48] The Museum's collection consists of approximately 830 paintings, as well as more than 2300 works on paper, and also sculpture.[49]

Tisch, a tattoo artist, had previous convictions for drink driving and her mother, Mary Thompson, explained on television news that her daughter had battled alcoholism for a long time. Tisch pleaded guilty to criminal mischief (F4) on 17 May 2012. She was sentenced to two years of mental health probation and ordered to undergo alcohol treatment as a condition of her probation.[50]

At the time of the incident, Still's painting, *1957-J-No.2*, from his mid-career period, was valued between USD$30–40M. This is not surprising given Still is considered a giant of American colour field painting. Media reportage noted that the damage was in the vicinity of USD$10K, though the Museum would not confirm this nor whether there was any residual permanent damage. The painting is now restored and installed again. Tisch's action can best be described as a thoughtless and random alcohol-induced act of vandalism.

Cecilia Giménez and *Ecce Homo*

In August 2012 a news story originating from the small Spanish town of Borja went viral. Local amateur artist Cecilia Giménez had 'restored' a fresco titled *Ecce Homo* at her local church, the Sanctuary of Mercy Church. The story was an instant Internet sensation, the reason being that the 'restoration' went horribly wrong and the once-demure twentieth-century Jesus Christ now looked like a freak. For most readers this was pure entertainment, as most news feeds summed up the situation as an elderly woman who botched the restoration of *Ecce Homo*, making the Jesus look monkey-like. However, closer analysis of this case demonstrates a lack of understanding on Giménez's part, how cultural heritage can be devastatingly wrecked, the need for greater controls on restoring works for future generations, and how a disaster has the potential to attract a huge audience.

Elias Garcia Martinez (1858–1934) painted *Ecce Homo* (Behold the Man) in 1930. Martinez, a relatively unknown Spanish artist, undertook his formal art education at the Real Academia de Bellas Artes de San Carlos de Valencia in Barcelona. He went on to teach at the art school in

Zaragoza, where he settled and made his home. Martinez's forte was portrait painting and his 1930 portrait, *Ecce Homo*, is (or was) a sensitively painted image depicting Christ wearing his Crown of Thorns, in the time leading up to his Crucifixion. At the time of the so-called restoration, many media reports suggested that Martinez's *Ecce Homo* was unremarkable artistically, however given the context for which it was painted—a fresco on the wall of this small Catholic Church—and that the local community championed the work, I would suggest its artistic value should not be diminished or relegated to a second-rate painting. The portrait was very much part of the Church's history and collection.

Over time, the painted surface of *Ecce Homo* became unstable; painted directly onto the wall, the fresco suffered from dampness with small specks of paint became separated from the surface. By 2012, the work had a speckled appearance, likened to snowflakes across the portrait. The portrait's condition attracted the attention of Giménez, who decided to restore *Ecce Homo* to look more like she had remembered it from times gone by. Giménez's method involved scraping away large sections of the portrait, replacing them with new paint. Fresco is not an easy medium to work with and its success is heavily reliant on the environmental conditions, such as fluctuations of humidity and dryness. Historically, the great fresco artists have bad days; Michelangelo repainted parts of the Sistine Chapel due to the damp conditions causing the pigment not to adhere (ironically the worst affected areas were on the *Deluge* scene!) Giménez was no stranger to *Ecce Homo*, in fact she had done some earlier restorative work on it, having touched up Jesus' tunic, but she'd never worked on his face before 2012. But Giménez's efforts went horribly wrong. Shortly into the project, the portrait's face began to change unrecognisably. Jesus took on a new monkey-like appearance (see Fig. 4.3).

Giménez, an amateur artist with no formal art education and definitely no training in conservation, paints landscape scenes. Her attempt to restore *Ecce Homo*, though community spirited, was naïve. Giménez's remedial work was stopped before she had completely annihilated the portrait, though this is a matter of opinion given its current state. At the time, there was conjecture about whether she had permission from the local priest to carry out the work or not. Again, a priest without specialist knowledge might assume that it was permissible for Giménez to do such work. Professional conservation was beyond the Church's budget.

There were several outcomes from the damaged *Ecce Homo*. Firstly, the fresco was damaged irreparably. Martinez's descendants are keen to see

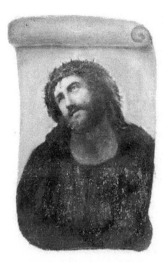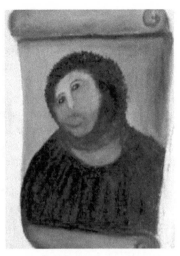

Fig. 4.3 Elias Garcia Martinez's, *Ecce Homo* (1930) (before and after) 're-stored' by Cecilia Giménez in 2012. Collection: Sanctuary of Mercy Church, Borja, Spain (Diocese of Tarazona) (*Photograph* Wikimedia)

the fresco restored closer to its original state; having assessed it, conservators have confirmed this is not possible. And to make matters worse, just prior to the news breaking about Giménez's botched efforts, Martinez's granddaughter had donated funds for *Ecce Homo's* restoration. Giménez got to it first. Martinez's family have also considered having *Ecce Homo* covered up by a photograph of the original work. The future of *Ecce Homo* hangs in the balance.

Secondly, the town of Borja at first expressed anger towards Giménez for spoiling a fresco in their church. However, a couple of years after the event the people of Borja have had a change of heart. Thanks to the international notoriety of the story, thousands of visitors have made the pilgrimage to see *Ecce Homo,* bringing redemption to Borja in the way of giving a much-needed boost to its economy. So popular was Giménez's handiwork, that budget airline Ryanair offered special flight deals to nearby Zaragoza, for those wanting to make the pilgrimage to see *Ecce Homo.* The purists amongst us will question why so many are visiting. We know the answer—to have a laugh and take a 'selfie' with *Ecce Mono* (Behold the Monkey) as Martinez's painting is often now called.

The commercial spin-off has been rewarding. Like other prized art-
works, images of *Ecce Homo* now appear on coffee mugs and tee shirts.
One would hope that funds raised from such merchandising might
go back to the church for the care of the building and its contents.
Giménez—who was initially embarrassed about her work and experienced
weight loss caused through anxiety—was more recently reported as want-
ing a percentage of the royalties on merchandise sales.[51]

Giménez is not the first to try to use an act of art vandalism to procure
monetary advantage, albeit in her case she was going to gift her propor-
tion of the funds to charities of sufferers of muscular atrophy. According
to the *International Business Times*, Giménez is entitled to 49% of prof-
its generated from the merchandising of the restored *Ecce Homo*.[52] In
another case of art vandalism, 90-year-old Hannelore K. visited the Neues
Museum in Nürnberg, Germany, in July 2016 and vandalised a work
by Fluxus artist Arthur Köpcke (1928–1977). The work, titled *Reading
Work Piece* (1977), is an empty crossword and bears the instruction 'In-
sert words'. With ballpoint pen, Hannelore K. filled in the crossword,
inserting words. A retired dentist, Hannelore K. was one of eight retirees
visiting the Museum as part of a writing workshop for seniors. Though
Hannelore K. effectively vandalised the work, she later claimed copyright
on the work. Her attorney argued that she had augmented the work
and therefore was entitled to copyright. Furthermore, when the Museum
restored the work, removing her words, her copyright had been violated
according to her attorney. Hannelore K. believes she enhanced the Fluxus
work and threatened to sue the museum for cleaning off her words. Her
attorney claimed that all the attention around Hannelore K.'s addition
to the work brought the unknown artist more attention![53] Arguably it's
not the kind of attention that the Museum wanted for their well-known
Fluxus artist. At the time of being detained by police, for a half-hour
interview, Hannelore K. was indignant about how she was treated. Yet
as the Museum staff said, they were simply following protocol, which is
necessary for making an insurance claim for any conservation work to be
carried out on the work.

Today, *Ecce Homo* remains in its vandalised state; the case of *Ecce Homo*
raised several issues, including social media's role in sharing this story.
Many mocked Giménez, but hopefully the message not to attempt do-it-
yourself art restoration is somewhat clearer now. At the time, *Ecce Homo*
was viewed as an exemplar of how one should not restore art, and yet
sadly in 2018 Spain sustained another devastating double-whammy of

amateur restoration to add to its list. First was the 'restoration' of San Miguel's *St George* that met with international horror, as well as reviving the story of *Ecce Homo*.

In June 2018 the twelfth-century Romanesque church of San Miguel at Estella in Northern Spain saw one of its prized pieces of wooden sculpture, *St George* dating from the sixteenth century, 'restored' beyond redemption. Over time, the sculpture—St George upon his horse with the slain dragon at its feet—situated in a niche in the church, had deteriorated and was identified as needing conservation. The church's priest, Jose Miguel, commissioned a local woman known only as Carmen, employed at the locally-based Karmacolour Studio as a teacher of handicrafts, to undertake the work. Carmen has no formal training in the delicate and scientific art of conservation. What she did, albeit with good intention, was to try to bring *St George* back to what she considered his former glory. This included filling in the cracks in the wood with plaster and then over-painting the sculpture. Unfortunately, the palette she chose was too bright and not at all in keeping with what would have been close to the original colour scheme. In addition, the paint she used was the wrong type, potentially destroying the original paint. A before and after photograph captured the sculpture's demise. And it was to plain to see how the 'restored' sculpture was instantly likened to a Disney cartoon rather than the church art it was (Fig. 4.4). Again, as with Giménez, the news of Carmen's 'work' went viral. Many likened the new-look *St George* akin to cartoon characters or a fairground carousel horse. *Ecce Homo* was mentioned in every news story about *St George*. Both cases also highlighted the church's inability to identify the difference between amateur restoration and professional conservation. The latter would retain as much of the original artwork as possible and only carry out work that halted further deterioration. But realistically such decisions are often based on the availability of funding. San Miguel's priest was criticised for not having taken professional advice about the restoration of such a significant sculpture. Increasingly, especially for smaller churches, it becomes next to impossible to maintain their collections, providing windows of opportunity for the wannabe amateur conservator.

Four months later, in September 2018, a group of wooden sculptures in a chapel at El Rañadorio, a town with no more than twenty-eight inhabitants, north west of Madrid, was the victim of the handiwork of a local woman wanting to freshen up and improve the fifteenth-century sculptures. Local tobacco shop owner María Luisa Menéndez thought the

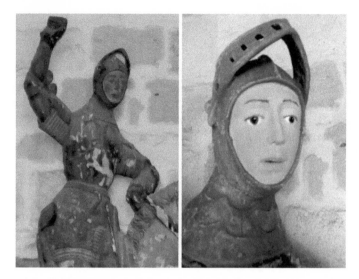

Fig. 4.4 St George and the Dragon 'restored' (before and after), Church of San Miguel, at Estella in Northern Spain, 2018 (*Photographer* Luis Sanz/Flickr)

sculptures looked a bit tired and dull and set to work, with permission from the local priest. Menéndez failed to give consideration to the age of the sculptures, cultural value, or that they had been conserved by professional conservator Luis Suarez Saro during 2002–2003 and funded by local government. The resulting 'restoration' was on equal footing to her sisters in crime, Giménez and Carmen; not only was her choice of palette bright and garish—described by many online as ranging from 'fuschia to lettuce green'—but lacked empathy with the subjects (Virgin and Child with St Anne). The extent of Menéndez's handiwork is best seen when comparing before and after photographs (see Fig. 4.5).

Originally carved from wood, the grain was easily seen and very much part of the work. Menéndez gave no consideration to her choice of palette; the intensity of colour is unfathomable. In addition she made no attempt to vary the tone or shade areas of folded drapery, the result being a very flat bright finish. It's hard not to dwell on the colour scheme given the gravity of the change. The Virgin's nail polish is simply outrageous!

Furthermore, Menéndez painted over paint dating from the fifteenth century, thus compromising the artist's intent and any future preventative conservation. Menéndez used industrial enamel paint, giving permanence

Fig. 4.5 Holy Family wooden sculptures 'restored' (before and after) at El Rañadorio's chapel, Spain, 2018 (Unknown photographer, https://www.independent.co.uk/news/world/europe/spain-church-statues-restored-paint-ranadoiro-asturias-colour-jesus-mary-st-peter-a8529141.html)

to the sculptures; one of the sculptures had never been painted, but it is now. Menéndez admitted to not being a professional artist but she was of the belief that her neighbours liked the new look she had given the sculptures. A few weeks after the story went public it was reported that Menéndez was being sued for failing to preserve historical artefacts. It seems unfathomable that these women had no comprehension, understanding, or appreciation about the age and value of church decorations. What is more, it would seem that the parish priests also lacked such insight. The handiwork of these three Spanish women is perhaps only the tip of an enormous iceberg.

MARY RICHARDSON AND *THE ROKEBY VENUS*

During 1913–1914 several acts of vandalism on art were carried out by a dedicated and fearless group of women, fighting for what they saw as their right—the right to vote. It was a long hard struggle that saw women

imprisoned, ill-treated, force fed, and die, for their strong belief in women's suffrage. Famously, Emily Davison died on 8 June 1913, having run into the oncoming horses at Derby Day on 4 June. King V's horse, Anmer, ridden by Herbert Jones, struck Davison and she died soon after; her name is synonymous with a woman who died for women's suffrage. The events, and legacy, of the Suffragettes has been well documented and for the last century the majority of women have had the choice to vote.

The catalogue of attacks on art committed by the British Suffragettes (see Table 4.1) feature within the generic texts about the Suffrage Movement, but their inclusion in art crime texts are minimal. Many of the institutions to which the works belong play down the role their works had in the long road to suffrage for women in Britain. Some writers avoid using the term 'art crime', instead referring to the actions of the Suffragettes as 'iconoclasm'. Iconoclasm traditionally referenced the destruction of religious icons, or images, to make a political stand. However, the term is used more broadly in referring to those who destroy sacred objects, such as paintings, to challenge the status quo. The status quo of property-owning males to suffrage was certainly challenged in the months that led up to the First World War by the Suffragettes. The 1918 Representation of the People Act advanced suffrage in Britain, though universal voting for all women would not come about until 1928.[54]

The Suffragettes became known for their radical actions as opposed to those women who favoured more constitutional methods, known as Suffragists. Suffragette Mary Wood—who took a meat cleaver to a portrait at London's Royal Academy—justified her actions and summed up the Suffragettes' philosophy:

> I have tried to destroy a valuable painting because I wish to show the public that they have no security for their property nor for their art treasures until woman are given their political freedom.[55]

The Royal Academy, the location of three Suffragette art attacks, was strategic in that it was a very male-dominated organisation. The Academy was founded in 1768 and of the Academy's thirty-four founding members, only two were women. In 1936 another woman joined their ranks.[56] Many, who viewed the notion of militancy as a contradiction to being feminine or indeed against the feminist ideal, scorned the Suffragettes.[57] Their dedication to change the law is well illustrated by looking at individuals such as Mary Richardson. Her story is typical of the lengths a

Table 4.1 List of known works damaged by Suffragettes during 1913–1914

Date of attack	Title of work	Artist	Attacker/s	Type of attack	Location of attack
14 January 1913	*Speaker Finch being held in a chair*	Andrew Carrick Gow	Sylvia Pankhurst	Lump of concrete	Parliament Buildings, Westminster, London
10 March 1914	*The Toilet of Venus (The Rokeby Venus)*	Diego Velázquez	Mary Richardson	Slashed with a butcher's chopper making 5 slashes across nude body	National Gallery, London
3 April 1913	*The Last Watch of Hero*	Lord Frederic Leighton	Annie Briggs, Lillian Forrester, Evelyn Manesta	Glazing smashed with hammer	Manchester City Art Gallery[a,b]
3 April 1913	*Captive Andromache*	Lord Frederic Leighton	Annie Briggs, Lillian Forrester, Evelyn Manesta	Glazing smashed with hammer	Manchester City Art Gallery
3 April 1913	*The Syrinx*	Arthur Hacker	Annie Briggs, Lillian Forrester, Evelyn Manesta	Glazing smashed with hammer	Manchester City Art Gallery
3 April 1913	*Sibylla Delphica*	Edward Burne-Jones	Annie Briggs, Lillian Forrester, Evelyn Manesta	Glazing smashed with hammer	Manchester City Art Gallery

(continued)

Table 4.1 (continued)

Date of attack	Title of work	Artist	Attacker/s	Type of attack	Location of attack
3 April 1913	Paolo and Francesca	George Frederick Watts	Annie Briggs, Lillian Forrester, Evelyn Manesta	Glazing smashed with hammer	Manchester City Art Gallery
3 April 1913	The Last of the Garrison	Briton Rivière	Annie Briggs, Lillian Forrester, Evelyn Manesta	Glazing smashed with hammer	Manchester City Art Gallery
3 April 1913	Birnam Woods [Glen Birnam]	John Everett Millais	Annie Briggs, Lillian Forrester, Evelyn Manesta	Glazing smashed with hammer	Manchester City Art Gallery
3 April 1913	The Prayer	George Frederick Watts	Annie Briggs, Lillian Forrester, Evelyn Manesta	Glazing smashed with hammer	Manchester City Art Gallery
3 April 1913	Portrait of the Hon J L Motley	George Frederick Watts	Annie Briggs, Lillian Forrester, Evelyn Manesta	Glazing smashed with hammer	Manchester City Art Gallery
3 April 1913	A Flood	John Everett Millais	Annie Briggs, Lillian Forrester, Evelyn Manesta	Glazing smashed with hammer	Manchester City Art Gallery

Date of attack	Title of work	Artist	Attacker/s	Type of attack	Location of attack
3 April 1913	When Apples were Golden	John Melhuish Strudwick	Annie Briggs, Lillian Forrester, Evelyn Manesta	Glazing smashed with hammer	Manchester City Art Gallery
3 April 1913	The Shadow of Death	William Holman Hunt	Annie Briggs, Lillian Forrester, Evelyn Manesta	Glazing smashed with hammer	Manchester City Art Gallery
3 April 1913	Astarte Syriaca	Dante Gabriel Rossetti	Annie Briggs, Lillian Forrester, Evelyn Manesta	Glazing smashed with hammer	Manchester City Art Gallery
10 March 1914	The Toilet of Venus (The Rokeby Venus)	Diego Velázquez	Mary Richardson	Slashed with a butcher's chopper making 5 slashes across nude body	National Gallery, London
9 April 1914	Display case, Asiatic Saloon, British Museum (three cups and one saucer damaged)		Mary Stuart (Clara Mary Lambert)[c]	Smashed case and artefacts with hatchet	British Museum, London
4 May 1914	Henry James	John Singer Sargent	Mary Wood	Broke glass, slashed canvas three times with meat cleaver	Royal Academy, London

(continued)

Table 4.1 (continued)

Date of attack	Title of work	Artist	Attacker/s	Type of attack	Location of attack
12 May 1914	Duke of Wellington	Hubert von Herkomer	Gertrude (Mary) Ansell	Slashed with a hatchet	Royal Academy, London
22 May 1914	Primavera	George Clausen	Mary Spencer (Isabel Maude Kate Smith)	Slashed painting in two with butcher's cleaver	Royal Academy, London
22 May 1914	Portrait of a Mathematician	Gentile Bellini	Freda Graham (Grace Marcon)	Defaced with loaded cane	National Gallery, London
22 May 1914	The Death of St Peter	Giovanni Bellini	Freda Graham	Defaced with loaded cane	National Gallery, London
22 May 1914	Martyr	Giovanni Bellini	Freda Graham	Defaced with loaded cane	National Gallery, London
22 May 1914	The Agony in the Garden	Giovanni Bellini	Freda Graham	Defaced with loaded cane	National Gallery, London
22 May 1914	Madonna of the Pomegranate	Giovanni Bellini	Freda Graham	Defaced with loaded cane	National Gallery, London
22 May 1914	Votive picture	School of Giovanni Bellini	Freda Graham	Defaced with loaded cane	National Gallery, London
23 May 1914	Portrait Study of the King for The Royal Family at Buckingham Place (1913)	John Lavery	Maude Edwards	Slashed the painting with a hatchet	Royal Scottish Academy, Edinburgh
23 May 1914	Mummy case		Nellipy Hay, Annie Wheeler	Smashed glass case containing mummy	British Museum

Date of attack	Title of work	Artist	Attacker/s	Type of attack	Location of attack
3 June 1914	Love Wounded	Francesco Bartolozzi	Ivy Bonn	Inflicts irreparable damage with hatchet	Doré Galleries, London
3 June 1914	The Grand Canal, Venice	John Shapland	Ivy Bonn	Inflicts irreparable damage with hatchet	Doré Galleries, London
9 June 1914	Master John Bensley Thornhill	George Romney	Bertha Ryland	Damaged with butcher's cleaver	Birmingham City Art Gallery (on loan)
17 July 1914	Thomas Carlyle	John Everett Millais	Margaret Gibb (Anne Hunt)	Attacked with butcher's cleaver	National Portrait Gallery, London

Earlier commentators did not include the Manchester attacks as they only meant to break the glass. It is believed that three further works were damaged at Liverpool, London's Wallace Collection, and at Manchester's Rusholme Exhibition Buildings. However, details are now lost. In addition damage was inflicted at the British Museum (porcelain exhibits and a mummy case smashed), stained glass windows broken, and other works at private homes damaged or destroyed by arson attacks by Suffragettes

[a]Now Manchester Art Gallery (renamed in 2002 after its major refurbishment)

[b]Some Suffragettes gave false names, these appear first, with their real name in brackets

[c]The intention of the attacks inflicted on the works at Manchester City Art Gallery on 3 April 1913 was to break the glass of the artworks and not damage the pictures (Rowena Fowler, 'Why Did Suffragettes Attack Works of Art?', *Journal of Women's History*, Vol. 2, No. 3, Winter 1991, p. 125)

Suffragette would go to in order to get attention, raising the awareness of the plight of women, non-voters, in Britain.

Mary Raleigh Richardson (1882–1961) was born in England and spent her formative years in Canada. As a teenager she travelled to Paris and Italy, subsequently living in Bloomsbury, London. Richardson (her alias was Polly Dick) was an active member of the Women's Social and Political Union (WSPU), carrying out several acts of violence in accordance with Emmeline Pankhurst's endorsement of the destruction of property to further the cause for women's suffrage. Richardson committed several crimes that included: arson (it's believed that she set fire to The Elms, the home of Rosalind Howard the Countess of Carlisle, a member of the Women's Liberal Federation who supported suffrage for all women but did not approve of the Suffragettes' violent methods), smashed windows at the Home Office, assaulted police, and bombed a railway station. All up, Richardson was arrested nine times and received prison sentences totaling three years. At HM Prison Holloway, Richardson was force fed under new rules legalised by the Cat and Mouse Act of 1913.[58] But Richardson's *pièce de résistance* was attacking Diego Velázquez's *The Rokeby Venus* at London's National Gallery.

Richardson later admitted in her autobiography that she didn't particularly like *The Rokeby Venus*, which made carrying out her plan easier. She wrote to Christabel Pankhurst (1880–1958) to gain approval to attack the painting, which was duly given. Richardson spent her last shillings on an axe (others would later refer to her weapon as a meat cleaver) from the local ironmongers.[59] Her weapon had to be small enough to conceal up her jacket sleeve, which was held in place with a chain of safety pins, for quick release. And so, during her prison leave on 10 March 1914, at 11 a.m., Richardson entered London's National Gallery. The day was a 'free' day at the National Gallery, making it an extra busy one. Richardson scoped the situation in terms of who was in Room 17—both visitors and staff—and where *The Rokeby Venus* was positioned. In fact, she milled about for an hour or so, drawing in her sketchbook (she'd studied fine arts as a young woman) and taking in the movements of people. There were two guards—or detectives as she referred to them—seated in the gallery space and then a third one entered. A ladder was leaning against a wall, as one of the skylights was being repaired. Richardson admitted she felt utterly miserable and clearly the waiting around stressed her out.[60] But at midday one guard took his leave and the other, now more relaxed without his colleague, took to reading his newspaper. Richardson made

her move. Her first blow to the glass broke it, the sound drawing attention. The seated guard initially looked up to the skylight under repair thinking the sound came from there. The guard situated at the gallery's entrance made a dash for her but slipped on the highly polished floor. These security guard glitches gave Richardson time to brandish four more blows to the painting, causing long vertical gashes to Venus' naked back, but very quickly a crowd of guards and visitors surrounded Richardson (see Fig. 4.6). Two German tourists struck Richardson on her neck with their trusty Baedeker travel guides. Richardson was apprehended by the constable on duty in the gallery and taken to the inspector's office, but not before telling visitors:

> Yes, I am a suffragette. You can get another picture, but you cannot get a life, as they are killing Mrs Pankhurst.[61]

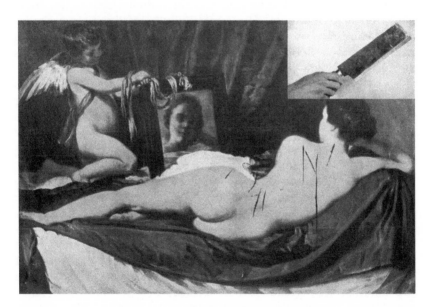

Fig. 4.6 Diego Velázquez, detail of damage inflicted to *The Rokeby Venus* (1647–1651) on 10 March 1914 by Mary Richardson. Collection: National Gallery, London

The police took Richardson away and later returned her to Holloway Prison. As if on holiday, Richardson would subsequently note of her prison accommodation, 'my cell was one overlooking the banqueting hall of the Elizabethan Warwicks'.[62] She was kept up-to-date with public opinion about her latest attack via the woman who cleaned her cell, and social reformer and philanthropist, the Duchess of Bedford, Adeline Mary Russell (1852–1920), who visited her to offer comfort and guidance.[63]

At the time of Richardson's attack, Emmeline Pankhurst (1858–1928) was on a hunger and thirst strike at the same prison, having been arrested at St Andrew's Hall, Glasgow on 9 March. For Richardson, there was no justice in a country that could spend so much on a painting and yet imprison Emmeline Pankhurst, who was trying to lead change for the betterment of women. Richardson's target of *The Rokeby Venus* was significant; to maximise attention she figured that by choosing a work that was beautiful, and so well liked by visitors to the National Gallery, she would gain traction for the cause. *The Rokeby Venus* is an all time favourite for visitors. Hurting *Venus*, hurt the public. Following her attack the National Gallery closed its doors to the general public. The only exception was students. Supposedly this gave the Gallery time to consider how best to go about upping security to prevent more attacks. Considering this was not a one-off Suffragette art crime they had good reason to rethink their security options. Following Richardson's attack, various other art museums closed their doors to unaccompanied women. Photographs of the main troublemakers were also circulated to galleries and museums alerting security staff to potential attackers.

Richardson's choice of *The Rokeby Venus* was strategic. Diego Velázquez (1599–1660) is hailed as the greatest Spanish artist of the seventeenth century. Painted in 1647–1651, the painting was originally titled, *The Toilet of Venus*. It is the only surviving nude painted by Velázquez. At the time of its making, the Spanish Inquisition did not allow for paintings with female naked content and hence the work's art historical significance. *The Rokeby Venus* depicts Venus, the goddess of love admiring her reflection in the mirror held by her son Cupid. As an aside, seeing her reflection is problematic. Known as the 'Venus effect' it would have been impossible for Venus to see herself given the angle of the mirror and her placement. However, the artistic liberty taken by Velázquez tricks the viewer into thinking that Venus can see us. It's these pictorial questions that make the painting complex and engaging for the viewer to this day.

Measuring 1.22 × 1.77 metres, it is believed Velázquez painted it in Italy where he was possibly influenced by other works of female nudes such as those by Titian and Giorgione. Spaniards actively collected paintings of nudes by foreign artists but didn't encourage such subject matter for their own artists. *The Rokeby Venus* was kept out of the public eye until the twentieth century when it had been hung in the homes of Spanish courtiers. In 1813, *The Rokeby Venus* came to England and in 1814 was acquired by politician John Bacon Sawrey Morritt for his collection at Rokeby Park in Yorkshire (where it was given its new title). It hung in the lavish Rokeby Hall above a fireplace. During the 1857, the painting was a popular work in the *Manchester Art Treasures* exhibition that boasted 16,000 works on exhibition and saw 1.3 million visitors. Morritt sold the painting but its place at Rokeby Park is not forgotten as William Alan Menzies (1865–1929) made a copy of the work and fitted it into the original's frame. Today the copy hangs in the saloon at Rokeby Park. In 1906 the original work was acquired for the National Gallery, London, at the cost of £45K. The funds were raised by the National Art Collections Fund; at the time of Richardson's attack, the amount paid for the work was stressed in reports, possibly making it seem worse given the fundraising effort, including the King's financial support.[64] At the time of Richardson's attack *The Rokeby Venus* had been on display at the National Gallery for less than a decade.

That Richardson chose a female nude to attack is relevant; not only was the decision to do with the work as an object of beauty but it was also about who and how the painting was viewed. The 'male gaze', a term now commonly used, was first coined in 1975 by feminist film theorist Laura Mulvey.[65] Richardson was a trailblazer for using *The Rokeby Venus* as a representative work for all female nudes, to vent her disapproval at the way men ogled over the nude Venus. Richardson, a former fine arts student prior to working as a journalist, perhaps knew too well how gendered art education was, especially the centuries-old tradition of favouring the female nude model over male models.

Richardson pleaded guilty to the charge of malicious damage sustained to *The Rokeby Venus* and was sentenced to eighteen-month's imprisonment with hard labour, though she only served a few weeks and was then transferred to a nursing home to convalesce (she had a heart condition). As art crime writer John Conklin notes, there appeared to be discrepancies when it came to sentencing Suffragettes:

Vandalism of an important painting by the British suffragettes in 1914 could only be punished by a maximum jail sentence of six months; the penalty could have been three times greater had a window been broken.[66]

Members of the public offered opinions, via newspapers of the day, about how the art-attacking Suffragettes should be dealt with; one suggested death and another thought the vandals should be sent permanently to Western Australia.[67]

The *Rokeby Venus* was temporarily taken off display and repaired. Today it hangs in Room 30 at the National Gallery. Two portraits, also by Velázquez, flank it: to the left, *Philip IV of Spain* (c.1656) and to the right, *Portrait of Archbishop Fernando de Valdes* (1640–1645). Room 30 is dedicated to Spanish seventeenth-century art, of which there are seven works by Velázquez. Today viewers can still make out the faint scars left behind after the work's conservation treatment. *The Rokeby Venus* is glazed with laminated glass; if breakage occurs the resin layer bonding the two sheets of glass together keeps the shards in place preventing them from piercing the canvas. There is however no evidence on the label, or audio tour, that Richardson attacked the work. At the time of writing, the National Gallery supplied me with a copy of *The Rokeby Venus'* accompanying label as well as the audio tour script. Neither make mention of Richardson's planned and brazen attack.

The National Gallery has traditionally excluded information pertaining to Richardson's attack in didactic information, however during 2018 curatorial staff and guest speakers such as classicist Mary Beard, acknowledged that the attack added to the complexity of the painting's history and that mention should be made in light of the country celebrating a century since the passing of the 1918 Representation of the People Act. Furthermore, the National Gallery is not the only museum to exclude information about Suffragette attacks.

Bertha Ryland, also a member of the WSPU, wielding a meat cleaver slashed George Romney's full-length portrait of *Master Thornhill* (the portrait is now referred to as *John Thornhill (1773–1841) as a Boy*)[68] on 9 June 1914, at the Birmingham Museum and Art Gallery. The portrait sustained three large gashes in the lower area about the subject's legs and feet. Like *The Rokeby Venus*, Ryland's attack was deliberate and she demonstrated little remorse. And perhaps what makes the attack even worse is that the portrait belonged to a private collector. *Master Thornhill* was on loan from Mrs. C. P. Lane (Bertha D'Albiac du Boulay) of

Donhead Hall in Shaftsbury, England. Following its restoration in 1919, the portrait was sold. In 1961 it was gifted to the Museum of Fine Arts in Boston. The Museum's website is most informative, providing detailed information about the work (subject and style) as well as a full description of its provenance.[69] However, it fails to make mention of its brush with the Suffragette movement. Birmingham curator Nicola Gauld suggests:

> There is still an unease in telling the history of the feminist struggle and the actions of militant suffragettes, and a perception in some galleries and collections that the messiness of politics must not taint the beauty of art.[70]

Arguably by including such 'messiness' in the form of a more transparent narrative makes for a truer account and richer history of a work; providing such information assists in contextualising the work within a very specific historical period.

George Clausen's (1852–1944) painting of a young female nude, *Primavera* (1914), was attacked while on exhibition at the Royal Academy by Suffragette Mary Spencer (her real name was Isabel Maude Kate Smith [1881–1977]). A century on, in 2014, the auction house Christies was selling the work and to their credit the story of its attack was provided in the catalogue.[71] Perhaps *Primavera*'s colourful past added to its significance and value, for it sold in excess of the estimate (£50–80K), for £92,500.

Suffragette Anne Hunt (her real name was Margaret Skirving Gibb [1877–1954]) was also forward thinking, yet of a different ilk from Richardson. Hunt took a butcher's cleaver to Millais' *Portrait of Thomas Carlyle*, at London's National Portrait Gallery. At her trial she proclaimed:

> This picture will be of added value and of great historical importance because it has been honoured by the attention of a Militant.[72]

Hunt was onto something. As viewers we are sponges for information and often (sadly) spend more time reading labels of works on exhibition, than looking closely at the actual artwork. Information about a work's colourful history is of interest; as enquiring viewers we should be asking why specific works were targeted and what was the overarching objective behind such attacks. For instance, of all the portraits on display at the National Portrait Gallery, Hunt chose Millais' unfinished portrait of *Thomas Carlyle* (1877), the founder of the Gallery. This is significant for it

shows premeditation and forethought into a sitter of note. The extended catalogue entry about this work, written in 1973, appears in full on the Gallery's website. It makes no mention of Hunt's attack. However, the shorter label, displayed next to the work, includes the attack.

The National Portrait Gallery made specific mention of Hunt's attack and how it related to another exhibition within the Gallery, demonstrating a more transparent and fuller history of the work. This is commendable and perhaps represents a shift in attitude by galleries and museums to share such histories. Carlyle's portrait was repaired; the victim of a battle fought by women across the nation, but his scars are still visible today and perhaps are a poignant reminder of the lengths women went to in order to obtain suffrage, many of whom were scarred by their valiant efforts.

The attack on art by the Suffragettes was an organised campaign carried out by several women to hurt the nation's collections. All but one attack, on two works, took place in public art museums. Carried out by Ivy Bonn (also referred to as Ivy Bon) this exception occurred on 3 June 1914 at London's Doré Gallery, a New Bond Street art dealer. As described in the newspaper the following day:

> A young woman smashed two pictures in the Dore Gallery, New Bond Street, one being Bartolozzi's "Love Wounded," which is of almost priceless value, and the other Chapland's [*sic*] "Grand Canal, Venice," which is of minor value. An attendant named Bourlet, seized the woman, who badly wounded him with a hatchet.[73]

At the time of the attack, Bonn was on prison release for hunger striking. The two works were irreparable. Whether this was Bonn's intention or not is unknown but she was certainly on a mission leaving a note with the message:

> To stop this you must give us justice. We have been too ladylike in the past. Now we are going to fight.[74]

The Shapland and Bartolozzi were completely destroyed, and though this chapter is focused on vandalism, this case demonstrates that in that moment of thrusting the hatchet at an artwork it is possibly difficult to know how far to go to damage the work, make the point, or completely destroy it. Bonn clearly went too far. Perhaps too, from a contemporary perspective, conservators nowadays are more expert at making

repairs. Both works at the Doré Gallery were works on paper—the Bartolozzi an etching (some reports said it was a drawing) and the Shapland a watercolour—and therefore glazed. As often is the case, the broken glass pierced the paper damaging the work beyond repair. Bonn's choice of an Italian landscape is also at odds with her fellow Suffragettes' choice of subjects to attack. As an aside, apart from her Doré Gallery rampage there is very little information available about Bonn. It is highly likely that Bonn was not her true identity, as her name does not appear in any other connection with the Suffragette militancy.[75]

Each of the artworks attacked by the Suffragettes during 1913–1914 were the work of male artists and depicted prominent men or female nudes (with the exception of Shapland's Venetian scene). Admittedly, that the artworks attacked were works by men would not have been hard to orchestrate, given the proportion of works by female artists in public art galleries in Britain at the time was extremely low. When Richardson attacked *The Rokeby Venus*, just 0.54% of works in the National Gallery's collection were by women artists.[76] At the adjacent National Portrait Gallery, as at the 10 March 1914, only 3.5% of the collection was works made by female artists. A century on, this hasn't changed significantly. In July 2018, the National Gallery announced the acquisition of Artemisia Gentileschi's *Self Portrait as Saint Catherine of Alexandria* (*c.*1615–1617). This is an exceptionally fine addition to their collection but the downside of the announcement and media hype was the reminder that of the 2300-plus works in the collection, only twenty-one are the work of women artists.[77]

The Suffragettes were militant and came to each of their attacks well prepared. The tools used such as butcher's cleavers and hatchets were very masculine for the time. The male portrait subjects were all prominent men who had held powerful positions and were well known to the public. They included: the Duke of Wellington, King George V, Henry James, and Thomas Carlyle. Long before the main programme of the attacks took place in 1914, a 'Votes for Women' suffrage poster was stuck on the glass of Solomon J. Solomon's *Portrait of Rt. Hon. H. H. Asquith, Prime Minister*, at the Royal Academy in June 1909.[78] And though the poster did not damage the work per se the intent behind the action was very clear for Asquith was opposed to votes for women. Interestingly, there is some confusion over how the work was damaged. The portrait's current catalogue information, provided by its present owner, the National Liberal Club, notes that 'Votes for Women' was scrawled across it in violet ink

(rather than having a poster stuck to it).[79] The shade of ink was certainly an official Suffragette colour. Fortunately the portrait came through the ordeal unscathed. Today the unglazed work hangs at the National Liberal Club, at their London location at 1 Whitehall Place, Westminster.

Whether the damage inflicted on art by the Suffragettes assisted in obtaining franchise is impossible to measure. One would like to think so given the harm they caused. Some were not particularly endeared to support the Suffragette cause on the grounds of how they went about making themselves heard. The Great War effectively put a halt to further damage.

Mary Richardson went on to live a long and full life. In 1932 she joined the British Union of Fascists, likening their actions to those of the Suffragettes though she left after a couple of years, on the grounds that she did not approve of their policy about women. In 1953 Richardson's autobiography, *Laugh a Defiance*, was published.

From random acts, such as American Lindy Lou Layman's intoxicated rampage on her date night that went awry in December 2017 in which she damaged USD$300K worth of art (including an original Andy Warhol), to the organised vandalism carried out by British Suffragettes, vandalism of art is an ongoing problem.[81] Looking back, the Suffragettes' cause is easy to get caught up in; empathy abounds, we respect them individually and collectively as heroines, with reminders in the form of significant anniversary celebrations. A century on from the British Suffragettes mobilisation to destroy property (and art), one can take the moral high ground and say they were ill-advised wilful women who threatened significant pieces of art, but one would like to think that their illegal actions assisted in obtaining women's suffrage. Quite how long and how far they would have gone without the Great War's intervention is impossible to know. But as the attacker of George Clausen's *Primavera*, Mary Spencer suggested at her trial, she attacked art over human life, for she respected the latter more.[82]

The publicity and inconvenience created by the Suffragettes' protests were, as Christabel Pankhurst said, the main reasons for pursing this line of protest.[83] And yet the Pankhursts must have had some appreciation for the art their fellow Suffragettes attacked for Christabel's sister, Sylvia Pankhurst (1882–1960) was an artist in her own right. Having attended the Manchester School of Art and London's Royal College of Art, Sylvia produced works including a series about her 1907 tour of industrial environments. The works depict women working in harsh conditions. In late

2018 the Tate Britain announced the acquisition of four watercolours from the series.

The Suffragettes were politically motivated and art will continue to be vandalised in an effort to affect change, whether for political, social, or economic reasons. In 2016, just days after Britain's Brexit referendum vote, artist Yasmeen Sabri's (b. 1992) work, *Walk A Mile In Her Veil*, was vandalised. The work, comprising a burka over a metal frame was made to 'promote tolerance and understanding'.[84] However, the message was lost on intoxicated 70-year-old Brexit supporter Mikkaela Haze, who walked into South Kensington's Royal College of Art, cider bottle in hand, and attacked Sabri's installation. She shouted, 'we voted to take our country back' and 'Saudi Arabia go home'.[85] Haze pleaded guilty, admitted racially aggravated criminal damage and was given a nine-week prison term suspended for twelve months and ordered to undertake rehabilitation for her drinking problem. It took Sabri months to repair her sculpture before it could be exhibited at another London venue, Somerset House. And so from the organised to the naïve to the drunkards, attacks on art have the capacity to give artworks notoriety, all due to the damage inflicted upon them. Often we learn of a work because of the damage sustained and the circumstances around the event; some organisations keep quiet about a work's history of vandalism, whereas others flaunt the story, for example, if it makes for a good story for a tour guide. *Ecce Homo* is an extreme case; a relatively unknown painting has become famous for all the wrong reasons. As is often the case, a work's value changes once damaged and a devalued work can bump up the value of similar works by the same artist, as they become more desirable and there are fewer of such a high quality available. For women, historically their motivations can differ from their male counterparts when it comes to art vandalism, but the end result, for the artworks and their owners and audiences, unfortunately remains irrevocably the same.

NOTES

1. Pascal Rossignol, 'Graffiti Removed from Delacroix's Liberty … Vandal "Unbalanced"', *rbi*, 9 February 2013.
2. Marie-Laure Michel, '"Unbalanced" Woman Vandalises Famed Eugene Delacroix Painting at the Louvre in Lens', artdaily.org, 9 February 2013.
3. Bendor Grosvenor, 'Delacroix Attacked in Louvre Lens', *Art History News*, 8 February 2013.

4. 'This Is Very Homosexual ... I Think It Should Be Burned!': Woman Attacks $80 Million Gauguin Painting of Topless Women at the National Gallery', *Daily Mail*, 5 April 2011.
5. Dario Gamboni, *The Destruction of Art: Iconoclasm and Vandalism Since the French Revolution*, London: Reaktion, 1997, p. 301.
6. Amanda Foreman, 'When Works of Art Come Apart', *The Wall Street Journal*, 25 August 2016.
7. Dario Gamboni, *The Destruction of Art: Iconoclasm and Vandalism Since the French Revolution*. London: Reaktion, 1997, p. 301.
8. Holly Fox, 'Cleaning Lady Destroys Contemporary Sculpture with Her Scrubbing', *Deutsche Welle*, 4 November 2011.
9. The *Mona Lisa's* full title is *Mona Lisa: Portrait of Lisa Gherardini, Wife of Francesco del Giocondo*. The portrait was acquired by François I in 1518 and joined the Louvre's collection in 1797.
10. Alan Riding, 'In Louvre, New Room with View of "Mona Lisa"', *The New York Times*, 6 April 2005.
11. Donald Sassoon, *Mona Lisa: The History of the World's Most Famous Painting*, London: HarperCollins, 2002, p. 248.
12. Setsu Shigematsu, *Scream from the Shadows: The Women's Liberation Movement in Japan*, Minneapolis: University of Minnesota Press, 2012, p. 99.
13. See https://focus.louvre.fr/en/mona-lisa/understand/most-famous-painting-world.
14. Valentine's last name is spelt various ways: Contrel, Cantral, and Cantrel. The former is the most commonly used spelling.
15. 'Girl Demolishes Louvre Painting', *The New York Times*, 22 September 1907.
16. Steven Goss, 'A Partial Guide to the Tools of Art Vandalism', *Cabinet Magazine*, Issue 3, Summer 2001, p. 6.
17. Helen E. Scott, 'Wholly Uninteresting?: The Motives Behind Acts of Iconoclasm', in *Perspectives on Power: An Inter-Disciplinary Approach*, Newcastle Upon Tyne: Cambridge Scholars, 2010, p. 30.
18. *The Ogdenburg Journal*, New York, 4 October 1907, p. 1.
19. *The Evening Post*, Vol. LXXIV, Issue 96, 19 October 1907, New Zealand.
20. 'Art in France', *The Burlington Magazine for Connoisseurs*, Vol. 12, No. 55, October 1907, pp. 56–58.
21. See Penelope Jackson, 'Legacy and Longevity: Protection of Objects from our Past for Our Future', in *Art Crime and Its Prevention* (ed. Arthur Tompkins), London: Lund Humphries, 2016, pp. 99–109.
22. 'Girl Demolishes Louvre Painting: Remarkable Statement of Vandal on the Philosophy of Maintaining Art Museums with Poverty Rampant', *The New York Times*, 22 September 1907.
23. The Louvre could not confirm this information.

24. Richard Verdi, 'Poussin's "Deluge": The Aftermath', *The Burlington Magazine*, Vol. 123, No. 940, July 1981, pp. 388–401.
25. 'Girl Demolishes Louvre Painting: Remarkable Statement of Vandal on the Philosophy of Maintaining Art Museums with Poverty Rampant', *The New York Times*, 22 September 1907.
26. 'Fear for Louvre Pictures, Despondent Girl's Act in Slashing One May Have Imitators', *The New York Times*, 6 October 1907.
27. 'Fear for Louvre Pictures, Despondent Girl's Act in Slashing One May Have Imitators', *The New York Times*, 6 October 1907.
28. From the workshop of François Boucher (1703–1770), *Portrait of a Young Lady with a Muff* (MI 1026), 1749, oil on canvas mounted on cardboard, Louvre, Paris.
29. Steven Goss, 'A Partial Guide to the Tools of Art Vandalism', *Cabinet Magazine*, 2001, http://www.cabinetmagazine.org/issues/3/toolsofartvandalism.php.
30. 'Vandalisme au Louvre', *L'Impartial Journal Quotidien et Feuille D'Annonces*, 22 July 1912.
31. Electronic communication from Guillaume Faroult, Musée du Louvre, 12 July 2018.
32. *Le Petit Parisien*, 23 July 1912, https://gallica.bnf.fr/ark:/12148/bpt6k5644062.texte.langFR.
33. Some references give her name as Sam Rindy.
34. 'One Is Art, One Is Vandalism: But Which One?', *The Scotsman*, 10 October 2007.
35. Corinne Boyer, 'The Woman Who Had Kissed a Painting Has No Regrets', *La Croix*, 1 May 2009.
36. Corinne Boyer, 'The Woman Who Had Kissed a Painting Has No Regrets', *La Croix*, 1 May 2009.
37. Steven Goss, 'A Guide to Art Vandalism Tools: Their History and Their Use', *Cabinet Magazine*, Issue 3, 2001.
38. http://news.bbc.co.uk/go/pr/fr/-/2/hi/entertainment/7098707.stm.
39. 'One Is Art, One Is Vandalism: But Which One?', *The Scotsman*, 10 October 2007.
40. http://news.bbc.co.uk/go/pr/fr/-/2/hi/entertainment/7098707.stm.
41. Helen E. Scott, *Confronting Nightmares: Responding to Iconoclasm in Western Museums and Art Galleries*, unpublished PhD thesis, University of St Andrews, Scotland, Vol. 1: Text, 2009, p. 50.
42. Nigel Reynolds, 'Turner Prize Won by Man Who Turns Lights Off', *The Telegraph*, 10 December 2001.
43. Nick Clark, 'Tate Acquires Martin Creed's Controversial Turner Prize-Winning Piece Work No. 227', *Independent*, 2 September 2013.
44. The exhibition ran from 27 October 2007 to 13 January 2008.

45. Press Release, *I Don't Kiss*, Collection Lambert en Avignon, France (27 October 2007–20 January 2008), http://www.collectionlambert.fr/en/event/57/i-don-t-kiss.html.
46. Henri Robert, 'With a kiss', *Top 5 Ways to Fuck Up an Artwork*, 21 December 2015.
47. The Clyfford Still Museum, Denver, Colorado, opened to the public on 18 November 2011.
48. The Clyfford Still Museum media release, 15 November 2011, notes: 1957-J-No. 2 (PH-401)—This 9-by-13-foot mural features Still's iconic red, black, and white forms that seem to be simultaneously drawing towards each other and breaking apart. Like many artists working in New York at this time, this painting is indicative of Still's use of scale to create immersive environments for the viewer.
49. https://clyffordstillmuseum.org/about-the-collection.
50. Denver District Attorney, Mitchell R. Morrissey, District Attorney–Second Judicial District, News Release, 31 May 2012.
51. Barry Neild, 'Ecce Homo "Restorer" Wants a Slice of the Royalties', *Guardian*, 20 September 2012.
52. Umberto Bacchi, 'Clumsy Restorer Cecilia Giménez Who Botched Spanish *Ecce Homo* Fresco Demands Royalties for Tourist Boom', *International Business Times*, 2 July 2014.
53. Chris J. Holland, '90 Year Old Claims Copyright in "Vandalised" Artwork', *Copyright Queries*, 22 August 2016, https://blogs.ucl.ac.uk/copyright/2016/08/22/90-year-old-claims-copyright-in-vandalised-artwork.
54. The Act extended the franchise in parliamentary elections, also known as the right to vote, to men aged 21 and over, whether or not they owned property, and to women aged 30 and over who resided in the constituency or occupied land or premises with a rateable value above £5, or whose husbands did. At the same time, it extended the local government franchise to include women aged 21 and over on the same terms as men. https://en.wikipedia.org/wiki/Representation_of_the_People_Act_1918.
55. John Conklin, *Art Crime*, Westport, CT: Praeger, 1994, p. 246.
56. Laura Knight (1877–1970) (née Johnson) was create a Dame in 1929 and in 1936 was the first women to be elected to full membership of the Royal Academy, since its inception, in 1936. Mary Moser and Angelica Kauffman were founding members.
57. Helen E. Scott, 'Their Campaign of Wanton Attacks', Suffragette Iconoclasm in British Museums and Galleries during 1914, *The Museum Review*, Vol. 1, No. 1, 2016, p. 5.
58. As suffragette historian June Purvis notes, 'The government responded to the hunger strike by introducing, in October of the same year, forcible feeding. Then in April 1913, the Prisoners' Temporary Discharge for Ill

Health Act, a hunger striker or "mouse" could be released into the community on a special licence for a specified period of time until she was well enough to be re-arrested by the authorities or "Cat" and serve her full sentence.' 'Viewpoint: A Lost Dimension? The Political Education of Women in the Suffragette Movement in Edwardian Britain', in *A Feminist Critique of Education: 15 Years of Gender Education* (eds. Christine Skelton and Becky Francis), Abingdon: Routledge, 2005, pp. 189–197.

59. Mary R. Richardson, *Laugh a Defiance*, London: George Weidenfeld & Nicholson, 1953, p. 166.

60. Mary R. Richardson, *Laugh a Defiance*, London: George Weidenfeld & Nicholson, 1953, p. 167.

61. 'National Gallery Outrage', *The Times*, 11 March 1914, pp. 9–10.

62. Mary R. Richardson, *Laugh a Defiance*, London: George Weidenfeld & Nicholson, 1953, p. 170.

63. As an aside, in 1919 the Duchess of Bedford instigated a Committee of Enquiry into the medical care at Holloway Prison. The results saw an overhaul of staffing with more women in senior positions as well as better conditions for pregnant prisoners.

64. Rowena Fowler, 'Why Did Suffragettes Attack Works of Art?', *Journal of Women's History*, Vol. 2, No. 3, Winter 1991, p. 112.

65. See, Laura Mulvey, 'Visual Pleasure and Narrative Cinema', *Screen*, Vol. 16, Issue 3, October 1975, pp. 6–18.

66. John Conklin, *Art Crime*, Westport, CT: Praeger, 1994, pp. 95, 275.

67. Rowena Fowler, 'Why Did Suffragettes Attack Works of Art?', *Journal of Women's History*, Vol. 2, No. 3, Winter 1991, p. 113.

68. Oil on canvas, painted *c.*1784–1785.

69. http://www.mfa.org/collections/object/john-thornhill-1773%E2%80% 931841-as-a-boy-33700.

70. Nicola Gauld, 'Attacking Art: Militant Suffragism in Birmingham', *History Workshop Journal*, 20 September 2016, http://www.historyworkshoporg. uk/attacking-art-militant-suffragism-in-birmingham.

71. Lot 95, Victorian, Pre Raphaelite and British Impressionist Art, 17 June 2014, Christies, London.

72. Bryony Millan, *The Great War in Portraits: Suffragette Action*, London: National Portrait Gallery, https://www.npg.org.uk/whatson/ firstworldwarcentenary/explore/gallery-stories/suffragette-action.

73. 'Picture-Smashing: Attendant Badly Wounded', *The Sydney Morning Herald*, 5 June 1914, p. 9.

74. Colleen Denney, *The Visual Culture of Women's Activism in London, Paris and Beyond: An Analytical Art History, 1860 to the Present*, Jefferson, NC: McFarland, 2018, p. 165.

75. Miranda Garrett and Zoë Thomas (eds.), *Suffrage and the Arts: Visual Culture, Politics and Enterprise*, London: Bloomsbury, 2019, p. 192.

76. Electronic communication with Malgorzata Pniewska, National Gallery, London, 24 July 2018.
77. Eileen Kinsella, 'London's National Gallery (Finally) Buys a Painting by Artemisia Gentileschi, Pioneering Female Artist of the Italian Renaissance', *artnet news*, 6 July 2018.
78. The portrait is oil on canvas and at the time of its inaugural showing in 1909 it was glazed.
79. Electronic communication with Simon Roberts, National Liberal Club, London, 11 July 2018.
80. On 8 October 2018 Lindy Lou Layman was charged with First Degree Felony. She was given a pre-trial intervention and will reappear in court on 7 October 2020 [Cause No. 1574832, The State of Texas vs. Lindy Lou Layman].
81. Rowena Fowler, 'Why Did Suffragettes Attack Works of Art?', *Journal of Women's History*, Vol. 2, No. 3, Winter 1991, p. 120.
82. Nicola Gauld. 'Attacking Art: Militant Suffragism in Birmingham', *History Workshop Journal*, 20 September 2016, p. 3, http://www.historyworkshoporg.uk/attacking-art-militant-suffragism-in-birmingham.
83. Sophia Sleigh, 'I Don't Feel Welcome Now', says student after Burka sculpture destroyed by woman launching post-Brexit rant, *Evening Standard*, 21 July 2016.
84. Martin Robinson, 'Drunk Brexit Supporter Screamed "We Voted to Take Our Country Back!" as She Destroyed Royal College of Art Hijab Sculpture Days After EU Vote', *The Daily Mail*, 19 July 2016.
85. Harley Tamplin, 'Brexit Voter Spared Jail After Destroying Burka Sculpture in Art Gallery', *Metro*, 15 November 2016.

SELECTED BIBLIOGRAPHY

'Art in France'. *The Burlington Magazine for Connoisseurs*, Vol. 12, No. 55, October 1907, pp. 56–58.
Bacchi, Umberto. 'Clumsy Restorer Cecilia Giménez Who Botched Spanish *Ecce Homo* Fresco Demands Royalties for Tourist Boom'. *International Business Times*, 2 July 2014.
Charney, Noah (ed.). *Art and Crime: Exploring the Dark Side of the Art World*. Santa Barbara, CA: Praeger, 2009.
Clark, Nick. 'Tate Acquires Martin Creed's Controversial Turner Prize-Winning Piece Work No. 227'. *Independent*, 2 September 2013.
Conklin, John. *Art Crime*. Westport, CT: Praeger, 1994.
'Fear For Louvre Pictures: Despondent Girl's Act in Slashing One May Have Imitators'. *The New York Times*, 6 October 1907.

Fowler, Rowena. 'Why Did Suffragettes Attack Works of Art?'. *Journal of Women's History*, Vol. 2, No. 3, Winter 1991.

Gamboni, Dario. *The Destruction of Art: Iconoclasm and Vandalism Since the French Revolution*. London: Reaktion, 1997.

Gauld, Nicola. 'Attacking Art: Militant Suffragism in Birmingham'. *History Workshop Journal*, 20 September 2016, pp. 3–7. http://www.historyworkshop.org.uk/attacking-art-militant-suffragism-in-birmingham/.

'Girl Demolishes Louvre Painting'. *The New York Times*, 22 September 1907.

Goss, Steven. 'A Partial Guide to the Tools of Art Vandalism'. *Cabinet Magazine*, Issue 3, Summer 2001.

Holland, Chris J. '90 Year Old Claims Copyright in "Vandalised" Artwork'. *Copyright Queries*, 22 August 2016.

Kinsella, Eileen. 'London's National Gallery (Finally) Buys a Painting by Artemisia Gentileschi, Pioneering Female Artist of the Italian Renaissance'. artnet news, 6 July 2018.

Le Petit Parisien, 23 July 1912.

London Times, 11 March 1914.

Manchester Guardian, 23 May 1914.

'Militant Makes Savage Attack'. *The Ogden Standard*, Utah, 3 June 1914, p. 8.

Millan, Bryony. *The Great War in Portraits: Suffragette Action*. London: National Portrait Gallery. https://www.npg.org.uk/whatson/firstworldwarcentenary/explore/gallery-stories/suffragette-action.

Mulvey, Laura. 'Visual Pleasure and Narrative Cinema' in *Film Theory and Criticism: Introductory Readings* (eds. Leo Braudy and Marshall Cohen). New York: Oxford University Press, 1999, pp. 833–844.

New York Times, 22 September 1907.

New York Times. 'Fear for Louvre Pictures, Despondent Girl's Act in Slashing One May Have Imitators', 6 October 1907.

'One Is Art, One Is Vandalism: But Which One?'. *The Scotsman*, 10 October 2007.

'Picture-Smashing: Attendant Badly Wounded'. *The Sydney Morning Herald*, 5 June 1914, p. 9.

Rachlin, Harvey. *Scandals, Vandals, and Da Vincis: A Gallery of Remarkable Art Tales*. New York: Penguin, 2007.

Reynolds, Nigel. 'Turner Prize Won by Man Who Turns Lights Off'. *The Telegraph*, 10 December 2001.

Richardson, Mary. *Laugh a Defiance*. London: G. Weidenfeld & Nicolson, 1953.

Riding, Alan. 'Your Stolen Art? I Threw Them Away, Dear'. *The New York Times*, 17 May 2002.

Sasson, Donald. *Mona Lisa: The History of the World's Most Famous Painting*. London: HarperCollins, 2002.

Scott, Helen E. '"Wholly Uninteresting"? The Motives Behind Acts of Iconoclasm' in *Perspectives on Power: An Inter-Disciplinary Approach*. Newcastle Upon Tyne: Cambridge Scholars, 2010.

Scott, Helen E. 'Their Campaign of Wanton Attacks: Suffragette Lconoclasm in British Museums and Galleries During 1914'. *The Museum Review*, Vol. 1, No. 1, 2016.

Shigematsu, Setsu. *Scream from the Shadows: The Women's Liberation Movement in Japan*. Minnesota: University of Minnesota Press, 2012.

Skelton, Christine, and Becky Francis (eds.). 'Viewpoint: A Lost Dimension? The Political Education of Women in the Suffragette Movement in Edwardian Britain' in *A Feminist Critique of Education: 15 Years of Gender Education*. Abingdon-on-Thames: Routledge, 2005.

The Evening Post, Volume LXXIV, Issue 96, 19 October 1907, New Zealand.

The Ogdenburg Journal, 4 October 1907, p. 1, New York.

'Vandalisme au Louvre'. *L'Impartial Journal Quotidien et Feuille D'Annonces*, 22 July 1912.

The Art of the Con[wo]man

Dealers are integral to the art market. Their role is to exhibit contemporary and historical art to sell; to support their artists through exhibitions, commissions, and opportunities such as being represented at art fairs; to source works for clients; publish catalogues; and to market and publicise an artist's work. The professional dealer is knowledgeable and specialises in specific areas of art. In doing so, they build up clientele and represent artists working in similar areas, for example, contemporary photography or indigenous art. Many artists are simply not interested in driving the commercial aspect of their practice, or don't have the skill base or would rather spend their time and energy creatively, so they leave this to a dealer. This ostensibly gives the dealer the exclusive rights to exhibit and sell their work, although occasionally more than one dealer will represent an artist across different locations. Dealers make their living from the commission they receive from sales of works. It is therefore in their best interest to be motivated in seeking legal legitimate sales. However, this is where a dealer can fall down, by short-changing their artists and clients.

The success of a dealer's business is the quality of their relationship, based on trust, with artists and clients who will in turn often become very loyal to their dealer. However, there are numerous examples where this trust, or honesty, is tested to the maximum. Dealers, with the upper hand of knowledge, can act deceitfully in a bid to potentially increase their income; money is made from selling-on fraudulent works, switching works, encouraging the making and selling of fraudulent works, crafting provenance, and not passing on the proceeds from sales to the seller

© The Author(s) 2020
P. Jackson, *Females in the Frame*,
https://doi.org/10.1007/978-3-030-44692-5_5

and/or artist. Dealers are in a unique position that at times is exploited for financial gain. Fortunately, some get caught out but others don't. It is impossible to measure such clandestine and deceitful practices. Convicted dealers pay the ultimate price, a loss of reputation. Unfortunately, an artist's reputation can also be compromised and put at risk when caught up in dodgy dealings. Dealers can either operate from commercial premises, usually a gallery, as well as independently, from their home or online. The latter has the added advantages of lower overhead costs and the ability to go 'off-line' if necessary. Male dealers dominated the commercial art sector long before it became a profession taken up by women. For this reason, this chapter looks at case studies that have occurred in relatively recent times.

MARY BOONE

For years, actor Alec Baldwin coveted the work of American painter, Ross Bleckner (b. 1949). In 2010, with one Bleckner already in his collection, Baldwin decided he wanted to acquire the painting *Sea and Mirror* (1996). The large oil on canvas (213 × 182 centimetres) depicts a myriad of beautiful shimmering shapes, akin to sea anemones, executed in a luminous and bright lustre. The work had previously come up at auction in November 2007, at Sothebys' Contemporary Art Day sale in New York. *Sea and Mirror* was estimated to sell for USD$70–80K, and sold for USD$121K.[1] The painting's provenance was listed as the property of a private Swiss collector who had acquired it from the Gagosian Gallery, Los Angeles. The painting was exhibited in Hamburg and Zurich the year after it was painted.[2] *Sea and Mirror* had a pedigree provenance. Bleckner is a leading contemporary American artist who notably is the youngest artist ever to have the honour of a retrospective at the Guggenheim in New York.[3] Thus Bleckner's work is highly valuable and collectable, and clearly greatly desired by Baldwin.

Baldwin approached New York art dealer Mary Boone in his bid to acquire *Sea and Mirror*. Boone was in her mid-twenties in 1977 when she established her gallery in New York and has over the following decades represented major artists such as Barbara Kruger, Jean-Michel Basquiat, Joseph Beuys, and since 1979, Ross Bleckner. As good as her word, Boone agreed to source *Sea and Mirror* for Baldwin. And she did. The pair agreed on a price tag of USD$190K for the painting, including

Boone's finder's fee of USD$15K. *Sea and Mirror* was duly delivered to Baldwin.

Like any new owner should, Baldwin checked the painting over thoroughly; on the canvas' verso the work's inventory number, 7449, was recorded. This matched the 1996 painting to a tee. But for Baldwin, the palette was not quite how he remembered it. Additionally, the painting smelt of new fresh paint (evidence of this would come out later in email correspondence about prematurely aging the work and ensuring the paint was dry). Boone offered an explanation for the colour change; allegedly the previous owner was a heavy smoker, so Bleckner removed the canvas from its stretcher and cleaned it as a courtesy to Baldwin.[4] And though Baldwin accepted this explanation at the time—partly due to his fondness for the artist and the work, he didn't want to think it wasn't true—some six years later he broached the subject with friends. They too thought it slightly odd and so Baldwin sought advice from Sotheby's who confirmed, by comparing it against the original in the auction catalogue, that Baldwin did not own the 1996 *Sea and Mirror* painting that he had commissioned Boone to source on his behalf. So, what painting did Baldwin own?

The truth emerged; Boone had failed to convince *Sea and Mirror*'s owner to sell it. Boone then approached Bleckner and requested he make another version of the painting and backdate it to 1996. Baldwin subsequently referred to the new painting as a 'copy' but Boone's lawyer Ted Poretz noted that the work was an original by Bleckner. It was, it just wasn't the work that Baldwin had requested to purchase and hand over USD$190K for. As an aside, the terminology used throughout the reporting of this case varied. Baldwin referred to his *Sea and Mirror* as a copy. Susan Lehman of *The New Yorker* magazine refers to it as a reproduction.[5] It was in fact an original authentic Bleckner, for the artist had painted it himself. But it wasn't the painting that Baldwin thought he had purchased, or rather, been sold by Boone. In addition, it was not painted in 1996 even though it was dated 1996, and its inventory number could not have been 7449, given you can't have two paintings with the same inventory number.

Baldwin was conned. Boone clearly saw a window of opportunity to keep her client happy, and in doing so make her artist some money and bank her commission. Unfortunately for Boone, Baldwin called her bluff. Baldwin was later criticised for taking so long to act on his hunch, but

perhaps it was his adoration for the artwork—and the artist's oeuvre—that prevented him from pressing for the truth. The time between purchase and discovering the truth doesn't alter Boone's dishonest practice. Baldwin tried to file a criminal case against Boone but the Manhattan District Attorney's office said this couldn't be done. Boone, perhaps not wanting the case to be dragged through the courts for obvious reasons, offered Baldwin his money back with interest. Finding this unacceptable, on 12 September 2016 Baldwin filed papers with the New York Supreme Court against Boone for selling him a different version of *Sea and Mirror*. The case was settled pre-trial. Baldwin received a seven-figure sum from Boone of which he planned to donate half to re-build the Sag Harbor Cinema in the Hamptons that was heavily destroyed by fire in December 2016.[6] Baldwin also got to keep his *Sea and Mirror*, though it is reportedly crated and stored in his basement ready for a lecture tour about art fraud![7] In addition, Baldwin got to commission a new work from Bleckner, who apologised for his part in the scam.

In a bid to please her famous actor client, Boone had let her guard down. Dishonesty cost her; greed and the desire to please can prevent a dealer from acting professionally. During the 1980s Boone was criticised for having some of her artists make works that were inferior in order to supply market demands.[8] Today Boone, now in her mid-sixties, continues to represent major contemporary artists as well as selling works on the secondary market; in 2018 Boone pleaded guilty to two counts of tax evasion and early 2019 saw her sentenced to thirty months imprisonment and 180 hours of community service mentoring New York schoolchildren in a visual arts programme. In March 2019, Boone announced that she would be closing her New York gallery on 27 April 2019. Her plan, once her sentence is served, is to re-launch herself back into the New York art world.[9]

What is unusual in the *Sea and Mirror* case, compared with other cases discussed in this chapter, is that Boone involved the artist in the scam, and thus unfairly compromised his reputation. Boone claimed that she had advised Baldwin from the outset that he was receiving a different version of *Sea and Mirror*. He denied this and without a formal written agreement it is difficult to prove either way. As attorney Kate Lucas writes, 'careful contracting prior to consummating an art transaction can mitigate the risk of a contentious and costly litigation later'.[10] With the exception of the charity, there were no real winners in this case; Baldwin would have ultimately preferred the original painting he had so admired, for as

journalist Susan Lehman noted, like many lawsuits, this one began as a love story.[11]

ANN FREEDMAN AND GLAFIRA ROSALES

On 28 November 2011 New York's dealer gallery, the Knoedler Gallery, closed its doors. Its sudden closure shocked its clients and the visual arts community. Established in 1846, the Knoedler, with branches in Paris and London, prided itself on dealing in top of the range artists such as Raphael and Vermeer before changing tack in the 1970s to focus on contemporary American art. In 1994 the Knoedler appointed a new director, Ann Freedman, of whom art theft detective Virginia Curry notes:

> she had no formal education or scholarship whatsoever in fine art or the history of art. She had started her climb in the New York gallery trade as a receptionist at another gallery and then moved to Knoedler as a salesperson.[12]

Freedman's lack of formal visual arts education didn't bode well for the future.

Soon after taking up her new role, Freedman began to sell works by major American artists on consignment from Glafira Rosales, a Long Island dealer, who sourced the works from the David Herbert Collection. Over time, the Knoedler Gallery acquired approximately sixty works from Rosales to on-sell. Allegedly, Rosales acquired the works from a Mr. X. Junior, of Filipino descent, who had inherited an astounding collection of American abstract expressionist works. The works, though sparsely documented, sold for millions of dollars. The Knoedler's mark-ups were extraordinary. For example, the Knoedler paid Rosales USD$4.5M for a Rothko, only for Knoedler to on-sell it to a Las Vegas casino owner for USD$7M. Both Freedman, on behalf of Knoedler, and Rosales were riding high on their catalogue of success. And the works just kept on arriving at the Knoedler Gallery. But in reality, there was no Mr. X. Junior; Rosales was acquiring the works in order to meet demand, for the Knoedler and others, from a Chinese immigrant artist, Pei-Shen Qian.

Rosales chanced upon the sidewalk artist, Pei-Shen Qian, one day and so began their business relationship in which he made good copies for Rosales. Qian arrived in New York in 1981 from China and though he tried to establish himself as an artist, the reality was that he couldn't.

He found however he could make a livelihood from making copies of works by significant artists. In turn, Rosales paid him a paltry fee, especially given how much she was charging the Knoedler. By all accounts they were good copies, as no one suspected for quite some time (apart from when he misspelled 'Pollok'). What would eventually catch Freedman and Rosales out was the lack of documentation for Qian's works, yet for fourteen years they got away with brushing off requests for documentation, as well as relying on falsely ageing some of Qian's paintings with tea and the dirt out of a vacuum cleaner. Rosales also provided false or incomplete provenances. Trust is central to the dealer–client relationship and interestingly Freedman, perhaps in a bid to show how convinced she was that the works were authentic, added to her personal collection from Rosales' cache. She purchased a Rothko, a Motherwell, and a Pollock, later claiming, 'I was a believer'.[13] Sceptics might view this as a ruse, all part of her strategy, for the question often asked is, did Freedman know the Rosales works were fraudulent?

In 2007 London hedge fund manager Pierre Lagrange paid USD$17M for Pollock's *Untitled* (1950). Lagrange asked Freedman repeatedly for the painting's documentation; when it failed to materialise he took steps to authenticate it himself. Forensic testing categorically gave the painting's date of manufacture in the 1970s; the yellow pigment tested was not available until the 1970s. Having died in 1956, Pollock was not the artist of *Untitled* (1950). Qian was. Lagrange demanded his USD$17M be returned by the Knoedler Gallery on 27 November 2011, giving them forty-eight hours notice to pay up. The next day, the Knoedler Gallery closed up shop. As Noah Charney explains, the Knoedler 'did not have enough money left to reimburse any more claimants, or the resources to pay for a lengthy legal fight'.[14]

Following Legrange's discovery, Knoedler clients Domenico and Eleanore De Sole questioned the authenticity of their Rothko, *Untitled* (1956), purchased in 2004 for USD$8.4M. Their interest was piqued when the supposed provenance of their Rothko sounded very similar to Legrange's Pollock. Both works had supposedly belonged to an anonymous Swiss collector who had been assisted in acquiring works by deceased art advisor, David Herbert. Alarm bells rang for the De Soles who in 2011 hired art conservator James Martin to test their Rothko. His findings were conclusive. *Untitled* was made with a water-based polyvinyl acetate as a base, which he described as the kind of product you'd find if you went to the hardware store Home Depot for primer. Furthermore,

this was not a material that Rothko used, nor did he paint on white backgrounds at the time when *Untitled* was allegedly painted in the mid-1950s.[15]

The De Soles case went to trial in early 2016. On 10 February 2016 Freedman settled with the De Soles for an undisclosed sum, though they were suing her for USD$25M. The De Soles were happy at last that the truth was established. And though the trial became very public, Domenico De Sole noted that even though Martin's report confirmed that the Rothko was a fake, Freedman continued to maintain it was authentic. As he said, if she truly believed it to be authentic she could have taken the painting and refunded the De Soles their original USD$8.3M, selling it on to make a handsome profit. For his part in it, Domenico De Sole said he would have walked away in exchange for a refund. However, Freedman wasn't forthcoming with an offer and so she was sued.[16] To give some context to the enormity of the deceit, Freedman took a 773% profit on behalf of the Knoedler for *Untitled* when she sold it to the De Soles in 2004.

Freedman left the Knoedler Gallery in 2009, the same year the FBI began to investigate the gallery's sales. When the Knoedler closed, it claimed it was due to an unrelated business decision. What would ensue over the next decade were several cases of civil litigation. In 2012, Rosales aged 57 years, pleaded guilty to charges of fraud, conspiracy, money laundering, and tax evasion. She was ordered to pay USD$81M in damages to the victims of her operation. Her co-conspirators—Jose Carlos Bergantiños Dias and his brother Jesus Angel—fled to Spain. Qian, facing criminal charges, fled to China. There were ten lawsuits against Freedman, which caused the collapse of the Knoedler Gallery. In 2011 Freedman opened her own dealer gallery, called FreemanArt on Manhattan's Upper East Side.

Combined, this group left behind them a trail of deceit, devastation, and fraudulent works. As an aside, at least twenty-three other works offered up by Rosales were sold through Manhattan dealer, Julian Weissman. At the time of writing there were still two lawsuits against the Knoedler, but not Freedman. Of the established forty works sold from Knoedlers, not all have re-surfaced. In other words, there are still forgeries at large that will be on-sold, knowingly and unknowingly, to other victims. Freedman presented herself on occasion as the victim, claiming she did not realise the works were fraudulent.[17] However, her time at the Knoedler was very lucrative. It was reported that Freedman made about

USD$10.4M from the sale of Rosales' works as a result of profit sharing, on top of her base salary of about USD$300K per annum. By April 2008, Freedman's cut was 30% of Knoedler's operating income.[18]

The scam lasted for fourteen years; three of the 'group' absconded leaving Freedman and Rosales to face the music. The closure of the Knoedler Gallery will go down in history as a 'chilling event for scholars, dealers and collectors alike'.[19] Unfortunately, the damage created by the multi-million dollar scam spearheaded by two women will continue well into the future given both the longevity and scale of their operation. Again, as with other cases it was the scientific testing that would prove definitively the authenticity of works.

ANGELA HAMBLIN

The Internet is a double-edged sword when it comes to art crime. It can greatly assist in preventing and solving art crimes, but conversely it is a haven for those wanting to sell art. Many purchases are made online, sight unseen on a small screen. In addition, few purchasers carry out due diligence. For the deceitful seller, such sales are money for old rope, especially if the work isn't authentic and has been acquired by the vendor at little cost (and from my experience, if the questions around provenance get too tough the seller removes the item from auction). One such devious seller—an online dealer—was Angela Catherine Hamblin. In 2007, 58-year-old Hamblin was charged with mail fraud in connection with her scheme to sell fake works of art on the online auction site, eBay, and through private transactions.

The four works that made up her charge were:

1. Milton Avery, *Summer Table, Gloucester*, oil on canvas
2. Juan Gris, a Cubist still life and collage and thick paper
3. Franz Kline, oil on Masonite
4. J. M. W. Turner, *The Ryder Water, with a distant view of Ambleside and the Langdale Fells* (a watercolour on blue paper described by Hamblin as 'original').

Milton Avery (1885–1965) was an eminent American modern painter; represented in major international collections, Avery's work is highly prized. Hamblin offered *Summer Table, Gloucester*, up for sale on eBay, and so began the chain of events that would ultimately see her downfall. Joseph Kinney, a North Carolina dealer, acquired the painting from Hamblin for USD$65K. He then sold it on to ACA Galleries Inc. for USD$200K. The purchaser, Jeffrey Bergen, inspected the work personally prior to the purchase being finalised. A short time later however, the Milton and Sally Avery Arts Foundation examined *Summer Table, Gloucester*, and conclusively determined that it was not a genuine Avery work.[20] Needless to say, ACA Galleries requested that Kinney rescind the sale. He did not. ACA Galleries sued Kinney, arguing that Kinney had misrepresented the painting's authenticity. The court disagreed and ruled in favour of the defendant, Kinney. According to the court, ACA Galleries had the opportunity prior to purchase to have the painting authenticated. Conclusively, Hamblin's eBay sale went on to cause further havoc for future sellers and buyers.

Hamblin provided documentation about works for potential buyers. For instance, she maintained that her great-grandfather purchased the Gris in 1932 from the ballet choreographer, George Balanchine.[21] Her claims included that she, and her husband, were the legal owners of the 'authentic' works of art by Gris, Turner, and Kline.[22] Furthermore, Hamblin described the Turner as an original watercolour.[23] Other claims included that she, or her husband, had inherited the paintings from deceased relatives, and that one of the paintings was from a now-deceased seller.[24] Such provenance details appeared on the face of it convincing, but in reality were lies. Hamblin took an estimated USD$410K in proceeds from the sales.[25]

At the time of Hamblin's arrest in 2007, media reports suggested that she could face up to twenty years imprisonment if found guilty.[26] Clearly Hamblin had deliberately gone about selling the forgeries knowingly, along with falsifying provenance documentations. On 14 July 2009 Hamblin pleaded guilty to two counts of mail fraud and one of wire fraud.[27] She was ordered to pay restitution of USD$65K to Jeffrey Bergen of ACA Galleries.[28] Hamblin also received a one-year sentence to be served at Danbury Women's Camp, Connecticut, followed by three years supervision. However, Hamblin failed to serve her sentence, effectively becoming a fugitive.[29]

CLAIRE EATZ

Selling art on consignment is common on the secondary art market. Sometimes, as with the Knoedler/Rosales case, there is an extra layer of dealers involved or it can be simply a direct arrangement between owner (consignor) and dealer. In short, the dealer who does not own the work and the commission they make is the difference between the price the work sold for, and the fixed set amount that the dealer and owner have agreed upon. However, when the dealer does not pass on the fixed amount (or any amount for that matter) from the sale, it is a case of consignment fraud. Selling art by consignment can be lucrative, especially if the dealer operates from their home as Claire Eatz did, without the cost of overheads that a commercial gallery space can incur.

Claire Eatz (1921–2013) owned and operated the Rothschild Gallery from her home at Bridgewater, New Jersey, during the early 1980s. Today she is remembered as a habitual liar,[30] having committed consignment fraud on several occasions. Selling on consignment, like other forms of art dealing, relies on mutual trust between client and dealer. Art crime writer John Conklin described Eatz's practice:

> Eatz cultivated trust with her sweet grandmotherly image, by providing references from reputable dealers, and by acting honestly in some transactions.[31]

Her strategic combination of 'good cop, bad cop' won clients and possible sales of valuable artworks that included a Monet and a Martin Johnson Heade. In reality, Eatz repeatedly strung together a pack of lies to fob off her clients and consignor. Put simply, Eatz sold works and kept the proceeds, using the funds on at least one occasion to offset debts she owed to another gallery, or sold works twice over. She had excuses that she used repeatedly such as the funds hadn't arrived in her bank account as the purchaser was ill or away on holiday. Eatz invented deaths in the family of a purchaser, again a delaying tactic to pay up. On other occasions she reportedly sent the cheque by registered mail, but the envelope was empty with the exception of a blank piece of paper.

Eatz's *pièce de résistance* was a scheme best described as double dipping. She would sell the same artwork twice over and then accept the work back again to sell on consignment. Such cases are messy and complex. For the buyers of the work—apart from the fact that there were

two owners without either of them knowing it—there is a fundamental question of who has title for the work. Furthermore, down the track the artwork's provenance is tarnished by such illegal irregularities of ownership. But Eatz persevered with her money-making scheme until her arrest on 12 March 1985 for the interstate transportation of Martin Johnson Heade's 1889 painting, *A Cora's Shear-Tail with a Single Orchid*, measuring 30.5 × 45.5 cm and valued at USD$150K.

Martin Johnson Heade (1819–1904), originally from Pennsylvania but very much an itinerant artist, painted a variety of subjects but is perhaps best remembered today for his detailed tropical rain forest nature studies set amongst misty backgrounds; somewhat romantic in style, his works are exquisite renderings particularly of orchids and hummingbirds. *A Cora's Shear-Tail with a Single Orchid* depicts a Peruvian shear-tail hummingbird (Thaumastura cora) with a single Cattleya labiata orchid. Heade is viewed as a peripheral member of the Hudson River School of painting and his works can fetch well in excess of USD$1M, though you can pick up any number of hand-painted reproductions online for a song!

In November 1982, Sally Turner of Sally Turner Gallery in Phoenix gave four paintings to Eatz to sell on consignment including Heade's *Cora's Shear-Tail with a Single Orchid*. Three years later, Sally Turner had not received any payments for the works. To her knowledge, the Heade had sold as she'd received, by certified post, an envelope containing a blank piece of paper, pretending to be a cheque.

Eatz had sold the Heade painting to New York's Hirschl & Adler Galleries. However, prior to the sale Eatz had committed to selling it, in December 1982, to another New York gallery, the Alexander Gallery, for USD$42,500. Eatz used these funds to pay off a debt with the Knoedler Gallery. And so, a picture emerges of money laundering.

In May 1983 Hirschl & Adler Galleries—who believed they owned the Heade—consigned it back to Eatz who maintained she had a buyer for it. The value was now put at USD$250K. Payment from the alleged sale was not forthcoming to Hirschl & Adler, who by mid-June 1983 decided to take legal action. Eatz then returned the painting to Sally Turner, the original consignor. Hirschl & Adler were out of pocket and went on to sue Sally Turner, and her daughter Renee Andre who had taken delivery of the Heade painting from Eatz on behalf of her mother. Eatz escaped being named as a defendant in the case, having filed for bankruptcy.

The events surrounding the Heade painting are complicated and involve several agencies; Eatz played buyers and sellers off against each

other. With the intention to make money Eatz was taking a moral holiday; she was convicted of fraud for transportation of the Heade painting from New York to New Jersey on 20 May 1983, after receiving it on consignment from Hirschl & Adler. Eatz was acquitted of the count involving transportation of the Heade New Jersey to New York on 9 December 1983 when she sold it to Alexander Gallery.[32]

Cora's Shear-Tail with a Single Orchid was not Eatz's only consignment sales art crime. Aged 64 years, in 1985 Eatz was convicted of five counts of consignment fraud. She was sentenced to six years imprisonment for one count of fraud and made to pay restitution—as much as her assets would allow—to her victims.[33] In addition, she was placed on probation for six years for a suspended prison sentence for the other four counts.[34] In October 1985 Eatz was sent to the Federal Correctional Institute in Lexington, Kentucky. According to the artist's catalogue raisonné published in 2000, the owners at that time of *Cora's Shear-Tail with a Single Orchid*, were major American art collectors, Denise and Andrew Saul.[35]

Germaine Curvers

Germaine Marguerite Marie François Toussaint Curvers' legacy is one of an art dealer who left behind a trail of deceit. Many private and public Australian collections are now populated with fraudulent works that Curvers sold to them (and possibly further afield than Australia). For over two decades, the Belgian-born Australian émigré dealer ran a lucrative trade in art produced by some of the biggest names and best-loved Australian artists such as Sidney Nolan, Arthur Boyd, and Brett Whiteley, as well as more internationally renowned artists like Pollock and Picasso.

Curvers fell into art dealing out of a necessity to downsize her personal collection that filled the bed and breakfast establishment she ran in Sydney. She began to sell the collection off from her Paddington Street, Windsor Gallery. Reports described Curvers as having a presence—'large, cigarette-smoking, champagne-drinking'—that few could forget.[36] With profit margins at times reaching 2000 per cent, Curvers made a decent living from selling art; she had a good eye for what sold well and met this demand by commissioning copies to be made by William Blundell (b. 1947), a furniture dealer and copy artist.

Blundell, who was also conveniently based in Sydney, was a prolific copyist who claimed to be able to make twenty Brett Whiteley works

an hour.[37] Brett Whiteley (1939–1992) was a foremost Australian artist whose vibrantly distinctive work is highly regarded and prized by collectors. Blundell's prolificacy worked well for Curvers who commissioned him to make works to order for her, paying him a small sum for each one. And this is where it gets interesting. According to Blundell, he sold his works to Curvers on the grounds that they were wall coverings, for decoration, nothing more. Curvers would then frame the works—often using recycled vintage frames—in an effort to make them appear more authentic. Famously, when the scam came to light after Curvers' death on 15 April 1997, Blundell cleverly referred to his artworks as 'innuendoes' or 'decorative pieces'. Copying of art, or making art in the style of an artist, is not illegal. However, the passing off of such works as authentic originals is illegal. Given his intent was not to sell the innuendoes as originals, he was not convicted of any wrongdoing. In addition, what ultimately helped the court case from Blundell's perspective was that Curvers was now deceased, so they only had his word. Blundell admitted to painting at least 162 innuendoes in court, but denied he knew Curvers' intention was to on-sell them as originals.

Within the context of this study, it is Curvers who is under scrutiny. She was successful in her dealings; Curvers made good profits from Blundell's works. Her success was due to her ability to fool collectors and professionals alike. Curvers even fooled her husband, who especially in the early days of her dealing, thought the works were authentic. Curvers' strong and flamboyant personality made her adept at selling, and evidence produced during the court case showed her to be an astute businesswoman; over a decade she paid Blundell—always by cash or cash cheque—only about AUD$40K, typically AUD$100 to AUD$200 per painting.[38]

At the time that Curvers was operating her racket, Australia was enjoying financially buoyant times. In 1988 The Australian Art Sales Digest recorded sales of AUD$38,474,000.[39] By the mid-1990s the bottom had fallen out of the market (just under AUD$7M in 1995). Curver's timing had been impeccable for a hungry market that she happily supplied. But on occasions Curvers sailed close to the wind. In 1994 she sold eleven Whiteleys to a Sydney doctor for AUD$30K. They were subsequently found to be forgeries. The police became involved and Curvers refunded her client in full. Always a step ahead, Curvers announced that she had purchased the Whiteleys in good faith, and so no charges were laid. Curvers took a cavalier attitude to dealing and as Blundell would

note after her death, 'she had no regard for the dealers and so-called experts'.[40]

Perhaps what is different about this case study is that the forger was known, which is relatively unusual, and Blundell would go on to admit to making the innuendoes quite openly because he believed they weren't actually forgeries. Unfortunately for collectors, his admission highlighted that there were hundreds, possibly thousands, of his works still in collections or for sale on the secondary market. Not everyone was totally convinced of Blundell's painting abilities though; Stuart Purves,[41] a Melbourne art expert was enraged during the court case, calling the Whiteleys 'appalling fakes'.[42] 'Of a Picasso' he noted it was also appalling, of kindergarten standard, done by someone who should give up. Furthermore, Purves went on to describe the Monet in the same manner.[43]

Curvers' illegal activity only became public knowledge after her death. A long and litigious dispute followed over her estate. Fortunately for the art market, going forward, Curvers' widower, John Curvers, contested her will in which many Blundell innuendoes were exposed.[44] Eventually, in 2002, Justice James Burchett ruled that the collection was jointly owned by Germaine and John and would be split accordingly. At the time, it was reported that the works in question made up the greatest collection of fakes in Australian history.[45] Blundell's works continue to sell in Australia, though some are now more honestly titled, for instance paintings recorded online in The Australian Arts Sales Digest have titles such as *Impression After Gruner*[46] and *A Little Innuendo*. Curvers didn't show any remorse for her actions; according to Blundell, who visited her on her deathbed, she noted that her biggest mistake in all of this was that she had sold too many works and should have charged more![47]

TATIANA KHAN

In 2006 Tatiana Khan, a West Hollywood art dealer, sold a Picasso pastel drawing titled *The Woman in the Blue Hat* (*La Femme Au Chapeau Bleu*) (1902), to Victor Sands for USD$2M. At the time, Khan was in her late sixties and owned and operated the Chateau Allegré Gallery in Los Angeles. With the proceeds from the sale she acquired a Willem de Kooning work valued at USD$720K and gave Jack Kavanaugh, who had advised Victor Sands to acquire the Picasso pastel drawing, USD$800K as a kickback (though he would go on to say it was a loan).[48] All was well until in 2009 the owners of the Picasso contacted Dr Enrique Mallen,

a Picasso expert and director on the Online Picasso Project, responsible for documenting thousands of Picasso works, for his opinion about their drawing. Mallen categorically came to the conclusion that the drawing was not by the hand of Picasso and he suggested that the FBI investigate further.

At the time of sale, Khan had told her client that the USD$2M price tag was very reasonable and that she was able to let it go for less than its market value as it came from the Malcolm Forbes Estate, who was allegedly keen to keep the sale quiet. Supposedly, the true market value was more in the region of USD$5M. As art crime writer and director of security for the Isabella Stewart Gardner Museum, Anthony Amore would note as an aside, when Khan was subsequently investigated by the FBI she stated that she

> obtained the pastel from a woman named Rusica Sakic Porter around 2005. According to Khan, Porter was an aesthetician she had met when one of her gallery employees visited Porter for a facial across the street from Chateau Allegre. As is the case in many provenance scams, Khan used war to explain the artwork's dicey history, saying that Porter's family purchased the work before the Bosnian War. Khan told [Special Agent Linda] English that Porter borrowed $40,000 from her and gave her the Picasso as collateral for the loan.[49]

The truth revealed that the pastel drawing was a century newer than Khan led her clients to believe; in 2006 Khan had commissioned a duplicate pastel drawing of the original from art restorer and interior decorator, Maria Apelo Cruz who was very able at duplicating artworks.[50] In one report about Canadian-born Filipina Cruz, she boasted that she could paint almost anything in any style including Old Master paintings.[51] Cruz duly made the drawing thinking that she was assisting Khan's clients who had supposedly had their original Picasso drawing stolen. Khan had ostensibly decided to have a copy made to trick the thief. Cruz would later realise this was a ruse to get her to make the drawing. Khan had the duplicate made under false pretences, falsified the works' provenance, and then went on to sell a copy knowingly as an authentic Picasso.

In 2010, following investigation, Khan pleaded guilty in the Los Angeles federal court to fraud, making false statements to the FBI, and witness tampering. Khan admitted to telling Cruz to lie to the FBI; Cruz was told by Khan to admit to doing the restoration work for Khan, but not

to copying art. Khan, aged 70 years by this time, was sentenced to five months probation, the return of USD$2M to the purchaser, forfeiture of the Willem de Kooning work, and 2500 hours of community service. Arguably, Khan got off lightly given the maximum possible sentence is twenty-five years (some reports even suggested forty-five years) in a federal prison.[52] Khan's web of deceit, and inconsistencies of provenance, came forty years into her career as an art dealer, a fact that her attorney thought would help her in court. It didn't.

Petra Kujau

Konrad Kujau (1938–2000) was a German illustrator and forger. His claim to fame was making and selling the fraudulent Hitler Diaries. Outed in 1983, Kujau was convicted of forgery and embezzlement, and subsequently served a four-and-a-half year prison sentence. On his release, Kujau made a living from painting copies of works by artists such as Leonardo da Vinci, Gauguin, and Monet amongst others. Notoriety gained from his Hitler Diaries gave him an element of kudos and a market for his copies. Having served his time, Konrad Kujau was transparent about his foray into copy art—not claiming them to be authentic—in fact he labelled them as 'original Kujau forgeries'. And they sold well; the late 1980s saw his paintings sell in the region of €3.5K each. For Konrad Kujau this must have been a nice little earner, especially since he gained his following from committing fraud in the first place.

Though Konrad Kujau died in 2000, there continued to be a ready supply of his works available on the open market, of which many sold online. A few years later in 2006, one of his former students questioned the abundance of his works for sale and that's when Petra Kujau was caught red-handed. In the 1980s, Konrad Kujau employed an assistant for his gallery, a singer called Petra Kujau. She later claimed to be Konrad Kujau's great-niece and saw an opportunity to continue selling Kujau's 'original' forgeries. Except they weren't Kujau's copies; sourcing paintings cheaply from Asian art factories, she would add Konrad Kujau's signature, and then sell them as his. In short, Petra Kujau was selling forged copies relying on Konrad Kujau's name to attract sales. All up, along with her unnamed 56-year-old male accomplice, she sold approximately 300 works, worth €300K.

At the age of 51 years, in 2010 Petra Kujau was convicted at Dresden after a two-year trial. She was handed down a two-year suspended

sentence, fined, and given 180 hours of community service to be served at a kindergarten. During the court case she changed her supposed relationship to Konrad Kujau from being his great-niece to being distantly related to him. Petra Kujau was clearly confused about her relationship with Konrad Kujau as she'd also claimed to be his granddaughter, however she was only twenty years his junior. *The Sydney Morning Herald* eloquently referred to her, as Konrad Kujau's 'faux niece'.[53] At the time of Petra Kujau's conviction, Judge Joachim Kubista noted 'art forgeries are nothing unusual, but the further falsification of the forger is really rather unusual'.[54]

Criminals can turn over a new leaf and change their ways and for the unsuspecting it would seem, on the face of it, that Petra Kujau did exactly that. For in 2016 an exhibition titled *Petra Kujau: The Paintings* was hosted at the National Gallery in San Francisco. Reinventing herself, this time she exhibited as a painter of works that originated in the works by major artists such as Franz Marc and Vincent van Gogh. The exhibition displayed over 300 works, which is no mean feat for any artist, and was hailed as a major retrospective of her oeuvre. The Gallery described her as one of the most important female artists of the last century, yet it is hard to forget, and forgive her former illegal activity. It seemed that Petra Kujau re-launched her career; interestingly she was still confused about her relationship to Konrad Kujau.

In the Gallery's marketing spin it noted that Petra Kujau was the great granddaughter of Konrad Kujau! Petra Kujau may have emancipated from dodgy art dealer to artist but there still seemed to be anomalies about her family connection, if any, to the infamous Konrad Kujau. In addition, a retrospective usually supposes that the artist has had a long and/or significant career and yet Petra Kujau does not seem to fit either criterion. But there's a twist to this fairy tale change of lifestyle—the National Gallery of San Francisco does not exist. Indeed the entire exhibition was a ruse, a fabrication, an online hoax. It seemed too good to be true. The exhibition, along with another in which Olga Daguru curated an exhibition of works from the Kunsthal Museum of Rotterdam (where her son stole works from) is a kind of performance art. The online reviewer picked up that Petra Kujau had a criminal past but for the uninitiated, the exhibition appeared plausible.

* * *

For the most part, the case studies discussed in this chapter have occurred in the last half-century. Prior to World War II, the female art dealer was relatively scarce.[55] With its rise, an established pattern of criminal activity has also occurred. It is also perhaps indicative of how crimes are reported and how such reports have become readily available and accessible on the Internet. The art dealers profiled here were selected to showcase the variety of types of art dealing, from consignment sales, selling of forged copies, dealing in innuendoes, taking on a false identity, and selling the wrong painting. However, there are common elements to each. Firstly, the convicted dealers knowingly committed these crimes in a bid to make money. Greed is central to each of the crimes. Secondly, each dealer abused the trust of his or her clients. Furthermore, few if any, show remorse for their convictions. That innocent victims were duped does not seem to outwardly affect the dealer. And some have used their misdemeanours to try to further their careers. Lastly, common to each of the eight dealers is their ages. All of them were middle-aged, or older, when convicted. And this raises the question of why jeopardise years of building up a reputation only to destroy it with illegal activities? Perhaps some had been working the system for longer than was later revealed. Again, it comes back to greed and hoping their clients would not question their integrity. Clearly, some dealers think they are invincible; in recent decades new ways of dealing in art—and fraudulent art—has been made possible with online technology. Unfortunately, too many collectors purchase art unseen—or rather, only viewed on a screen. For the dishonest dealer, no matter what their gender, this has been a boon as they can enjoy a level of anonymity. And lastly, common to each dealer here is the fact that they all got caught. Whether they carried out their sentences though, is another matter.

Dealers such as the women discussed here give dealers a bad name. For that reason we have seen a shift in role and terminology in recent decades. The title, 'gallerist', is now used more commonly by some instead of dealer, as it has more positive and inclusive connotations. The change in terminology extends to 'sourcing and placing' art, rather than the more commercial, 'buying and sellling'. The gallerist sees themselves more in the role of promoting and protecting their artists (and clients). They take a more altruistic approach to their artists, advocacy, and programme of exhibitions, as opposed to straight profiteering straight from sales. And it is perhaps because of the bad reputations that some art dealers have that this new title has emerged. Dishonest dealers are in the minority and

we must not lose sight of the decent dealer who supports their artists through artistic and economic highs and lows.

Dealers are at the chalk face of the secondary art market and though some may turn a blind eye to a work that isn't quite right, others take their role very seriously and act accordingly. One such dealer is Australian, Lauraine Diggins, who has been part of the art market scene since 1974, owning and operating a gallery in Caulfield, Melbourne, for decades. In 1998, a Queensland dealer, Leigh Murphy, sold Diggins three paintings. The works, by well-known nineteenth-century Australian artists, were: Tom Roberts', *Track to the Harbour, Cremorne* (1899), Arthur Streeton's, *Banksias Bend Over the Bay* (1927), and Arthur Streeton's *Garden Island and the Harbour* (1890s), a work that was devised from a sketch made by the artist from Sydney's Wooloomooloo Bay. Diggins took one other work, Girolami Nerli's *Shipping at Melbourne Wharf* (1888?), on consignment. The works duly featured in the Gallery's nineteenth- and twentieth-century Australian Painting, Sculpture and Decorative Arts exhibition and accompanying catalogue held from May to June in 1998. The Nerli was later returned to Murphy, at his request, and prior to any scientific testing taking place.

Diggins, to her credit, wasn't comfortable with Streeton's *Banksias Bend Over the Bay* and so had the late artist's grandson, Oliver Streeton, look at the work to be on the safe side. He thought it was a Streeton. However, it was revealed soon afterwards, by curator Geoffrey Smith of the National Gallery of Victoria, that the painting's provenance possibly fitted another work, which was in London at the time. The three works were subsequently tested and at first thought to be authentic by the conservator, however at a big cost to Diggins, further testing using the Raman technique (a non-destructive method of testing the type and age of paints used, enabling a conservator to draw conclusions about a work's authenticity), proved that the paint and varnish used in their making did not date from the time in which they were supposedly painted. As journalist Martin Daly would report, 'The forgeries were too good to fault without analysis.'[56] And they were good forgeries. In addition, the works appeared to have good provenance including genuine gallery stickers on the verso. Someone had gone to quite an effort to make them look like the genuine article. That someone, the forger, has never been identified. It wasn't until the Raman testing was undertaken that the results were conclusive. Diggins immediately refunded the purchase money to the purchasers; personally she lost in excess of AUD$300K as there was

no comeback from Leigh Murphy. At the time that the story broke in Australia in early 1999, Murphy had conveniently disappeared.

Though Diggins was out of pocket, this did not deter her from her mission to break the cycle of sales of fraudulent works. She would later tell Australian television Four Corners—'I am not prepared to perpetuate this type of behaviour.'[57] Diggins noted that she hoped the industry would change and that disappointingly she had received very little support for notifying the public of her find. Other dealers kept their heads down and didn't support her going public. It was the public and Diggins' clients that praised her for taking such a vocal stance; Diggins would subsequently receive approximately 200 letters of support. As a dealer, she went to great lengths to ensure that the three works she had exhibited, with the potential to sell in good faith, would always be labelled as fraudulent. In early 1999, Diggins sent a three-page letter to her entire database outlining the unfortunate situation.[58] She reassured clients that she guaranteed the authenticity of all sales. Diggins explained in detail how the unfortunate saga had played out. What she stressed was that going forward these works must not reappear, as authentic works, on the market ever again. She asked her clients to adhere stickers over the catalogue numbers 9, 10, and 12. The wording read, 'Amendment: At the time of publishing Lauraine Diggins Fine Art believed the following work was genuine as catalogued. We no longer guarantee the authenticity of Catalogue No. 9' (and 10 and 12). Exhibition catalogues become permanent records held by libraries, auctioneers, and collectors, becoming crucial for provenance and due diligence research. If the information is not corrected then potentially more fraudulent sales can follow.

Two decades later, the paintings are still in Diggins' possession for safekeeping and are clearly labelled in her gallery's catalogue database as being fraudulent. Furthermore, and to her credit, Diggins donated AUD$25K to the University of Melbourne for the establishment of their database for artworks with 'problematic attributions'. The three paintings' true value now is to those learning about forgeries and one day will be gifted to the University of Melbourne for the purposes of study. The unregulated art market industry is still populated with dealers who don't see any wrong in making money from fraudulent art. Time and time again, when discussing art and crime, we return to the notion of monetary value (as opposed to artistic, cultural, or sentimental). Diggins was upstanding in her pursuit in bringing fraudulent art to the public's attention; ignorance can be bliss

for the forger, dealer, and collector. Having studied and written extensively about art forgery, Noah Charney offers this insight: 'it is best in the interest of all involved to believe that the art in question is exactly what they hope it to be'.[59] Only occasionally does the bubble burst.

NOTES

1. Lot 551, Contemporary Art Day, 15 November 2007, Sotheby's, New York.
2. Illustrated in colour in Bice Curiger (ed.), *Birth of the Cool: American Painting from Georgia O'Keeffe to Christopher Wool*, Ostfildern: Cantz, 1997, p. 34.
3. Ross Bleckner's retrospective was held at the Solomon R. Guggenheim Museum, New York, in 1995.
4. Susan Lehman, 'Alec Baldwin's Legal Tussle Over a Painting', *The New Yorker*, 20 November 2017.
5. Susan Lehman, 'Alec Baldwin's Legal Tussle Over a Painting', *The New Yorker*, 20 November 2017.
6. On 8 November 2017 Baldwin tweeted the news that his foundation would no longer be donating to the Sag Harbor Cinema but rather another East End arts-related charity.
7. Susan Lehman, 'Alec Baldwin's Legal Tussle Over a Painting', *The New Yorker*, 20 November 2017.
8. Nancy Haas, 'Stirring Up the Art World Again,' *The New York Times*, 5 March 2000.
9. Nadja Sayej, '"I Feel Like a Pariah": How Art Dealer Mary Boone Fell from Grace', *Guardian*, 21 March 2019.
10. Kate Lucas, 'The Devil's in the Details in Lawsuit Between Alec Baldwin and Mary Boone', Grossman LLP *Art Law Blog*, 2017.
11. Susan Lehman, 'Alec Baldwin's Legal Tussle Over a Painting', *The New Yorker*, 20 November 2017.
12. Virginia Curry, 'Art Crime and Law Enforcement: Villains, Thieves and Scoundrels', in *Art Crime and Its Prevention* (ed. Arthur Tompkins), London: Lund Humphries, 2016, p. 131.
13. James Panero, '"I Am the Central Victim": Art Dealer Ann Freedman on Selling $63 Million in Fake Paintings', *New York Magazine*, 27 August 2013.
14. Noah Charney, *The Art of Forgery: The Minds, Motives and Methods of Master Forgers*, London: Phaidon, 2015, p. 162.
15. Cait Munro and Sarah Cascome, 'Conservator Found Rothko Painting in Knoedler Trail to be a "Deliberate Fake"', *artnet news*, 4 February 2016.
16. Eileen Kinsella, 'Domenico De Sole Speaks About the Knoedler Fraud Trial', *artnet news*, 17 February 2016.

17. Henri Neuendorf, 'Former Knoedler Director Ann Freedman Says She Was the "Perfect Mark"', Art and Law, *artnet news*, 18 April 2016.
18. These figures were presented to the jury. M. H. Miller, 'Ann Freedman Settles with the De Soles in Knoedler Trial Over $8.3m Fake Rothko', *artnet news*, 2 July 2016.
19. Colette Loll, 'Art, Anxiety and the Online Marketplace', in *Art Crime and Its Prevention* (ed. Arthur Tompkins), London: Lund Humphries, 2016, p. 66.
20. Don Zaretsky, 'Forgery Arrest', *The Art Law Blog*, 11 October 2007.
21. 'Woman Arrested for Selling Forged Milton Avery Painting', by Joseph Goldstein, *The New York Sun*, 11 October 2007.
22. United States District Court Southern District of New York versus Angela Hamblin, Defendant, Case 1:07-cr-01191-LAP, document 1, filed 18 December 2007, p. 4.
23. United States District Court Southern District of New York versus Angela Hamblin, Defendant, Case 1:07-cr-01191-LAP, document 1, filed 18 December 2007, p. 2.
24. United States Attorney Southern District of New York, 'Massachusetts Woman Charged with Selling Fake Works of Art', 10 October 2007.
25. United States District Court Southern District of New York versus Angela Hamblin, Defendant, Case 1:07-cr-01191-LAP, document 1, filed 18 December 2007, p. 5.
26. Joseph Goldstein, 'Woman Arrested for Selling Forged Milton Avery Painting', *The Sun*, New York, 11 October 2007.
27. Mail and wire fraud is any intentional fraudulent scheme not to provide honest services via mail or wire communication.
28. Indictment US District Court, Southern District of New York, USA v. Angela Hamblin, filed 14 February 2011. Criminal Monetary Penalties Case Number: 1:07CR01191-01 LAP.
29. Indictment US District Court, Southern District of New York, USA v. Angela Hamblin, filed 14 February 2011 and electronic communication with former FBI agent, James Wynne, 2 May 2018.
30. Lynn Stowell Pearson, 'Arrest of Claire Eatz', *IFAR Reports*, Vol. 6, No. 4, May–June 1985, p. 4.
31. John, Conklin, *Art Crime*, Westport, CT: Praeger, 1994, p. 95.
32. Lynn Stowell Pearson, 'Art Dealer Claire Eatz Convicted of Fraud and Sentenced to Six Years in Jail', *IFAR Reports*, Vol. 6, No. 8–9, October–November 1985, p. 7.
33. John, Conklin, *Art Crime*, Westport, CT: Praeger, 1994, p. 95.
34. Lynn Stowell Pearson, 'Art Dealer Claire Eatz Convicted of Fraud and Sentenced to Six Years in Jail', *IFAR Reports*, Vol. 6, No. 8–9, October–November 1985, p. 6.

35. Theodore E. Stebbins Jr. (ed.), *The Life and Work of Martin Johnson Heade: A Critical Analysis and Catalogue Raisonné*, New York: Yale University Press, 2000, figure 606, p. 349.
36. James Morton and Susanna Lobez, *King of Stings: The Greatest Swindles from Downunder*, Melbourne University Publishing, 2011, p. 246.
37. James Morton and Susanna Lobez, *King of Stings: The Greatest Swindles from Downunder*, Melbourne University Publishing, 2011, p. 247.
38. Ben Hills, 'A Brush with Fame, Spectrum', *Sydney Morning Herald*, 18 July 1998, p. 1.
39. Robyn Sloggett, 'Art Fraud: Does It Matter?' *Museums Australia Magazine*, Vol. 17, No. 1, August 2008, p. 12.
40. Ben Hills, 'A Brush with Fame, Spectrum', *Sydney Morning Herald*, 18 July 1998, p. 1.
41. Stuart Purves is a second-generation art dealer specialising in historical and contemporary Australian art. In 2006 he was awarded The Order of Australia (AM) for his contribution to the arts.
42. Ben Hills, 'A Brush with Fame, Spectrum', *Sydney Morning Herald*, 18 July 1998, p. 1.
43. Ben Hills, 'A Brush with Fame, Spectrum', *Sydney Morning Herald*, 18 July 1998, p. 2.
44. A few days prior to her death Germaine Curvers changed her will to exclude her family and appointed William Blundell as executor. See James Morton and Susanna Lobez, *King of Stings: The Greatest Swindles From Downunder*, Melbourne University Publishing, 2011 for more details, p. 247.
45. Ben Hills, 'Judge Gives Go-Ahead to Sell 1000 Fake Paintings', *Sydney Morning Herald*, 23 May 2002.
46. Elioth Gruner (1882–1939) was a significant Australian artist of landscapes and pastoral scenes.
47. Ben Hills, 'A Brush with Fame, Spectrum', *Sydney Morning Herald*, 18 July 1998, p. 1.
48. Michael Cieply, 'Media Executive's Father Ordered to Pay $250,000 in Suit Over Fake Picasso', *The New York Times*, 25 May 2012.
49. Anthony M. Amore. *The Art of the Con*. New York: St. Martin's Griffin, 2015, p. 169.
50. To see an image of the forged work visit, https://www.flickr.com/photos/artimageslibrary/4267045785/in/photostream.
51. www.positivelyfilipino.com.
52. Press Release Index Release No. 10-078, 27 April 2010.
53. Kate Connolly, 'Forger's Faux Niece Convicted', *The Sydney Morning Herald*, 12 September 2010.
54. Kate Connolly, 'Art Dealer Convicted of Forging Forger's Forgeries', *Guardian*, 10 September 2010.

55. See 'The Art of Shopping: Dealing in the USA' (chapter 15) in Philip Hook, *Rogue's Gallery: A History of Art and Its Dealers*, London: Profile, 2017.
56. Martin Daly, 'A True Picture Emerges of Australia's Artful Dodgers', *Sunday Age*, 21 February 1999, p. 12.
57. James Morton and Susanna Lobez, *King of Stings: The Greatest Swindles From Downunder*, Melbourne University Publishing, 2011, p. 246.
58. Lauraine Diggins Fine Art file, State Library of Victoria, Melbourne, Australia.
59. Noah, Charney (ed.), *Art and Crime: Exploring the Dark Side of the Art World*. Santa Barbara, CA: Praeger, 2009, p. 109.

Selected Bibliography

Amore, Anthony M. *The Art of the Con*. New York: St. Martin's Griffin, 2015.

Charney, Noah (ed). *Art and Crime: Exploring the Dark Side of the Art World*. Santa Barbara, CA: Praeger, 2009.

Conklin, John. *Art Crime*. Westport, CT: Praeger, 1994.

Connolly, Kate. 'Art Dealer Convicted of Forging Forger's Forgeries'. *Guardian*, 10 September 2010.

Connolly, Kate. 'Forger's Faux Niece Convicted'. *The Sydney Morning Herald*, 12 September 2010.

Curiger, Bice (ed). *Birth of the Cool: Amerikanische Malerei*. Zurich: Kunsthaus, 1997.

Curry, Virginia. 'Art Crime and Law Enforcement: Villains, Thieves and Scoundrels' in *Art Crime and Its Prevention* (ed. Arthur Tompkins). London: Lund Humphries, 2016.

Goldstein, Joseph. 'Woman Arrested for Selling Forged Milton Avery Painting'. *The New York Sun*, 11 October 2007.

Haas, Nancy. 'Stirring Up the Art World Again'. *The New York Times*, 5 March 2000.

Hills, Ben. 'A Brush with Fame, Spectrum'. *Sydney Morning Herald*, 18 July 1998.

Hills, Ben. 'Judge Gives Go-Ahead to Sell 1000 Fake Paintings'. *Sydney Morning Herald*, 23 May 2002.

Hook, Philip. *Rogues' Gallery: A History of Art and Its Dealers*. London: Profile, 2017.

Kinsella, Eileen. 'Domenico De Sole Speaks About the Knoedler Fraud Trial'. *artnet*, 17 February 2016.

Lehman, Susan. 'Alec Baldwin's Legal Tussle Over a Painting'. *The New Yorker*, 20 November 2017.

Miller, M. H. 'Ann Freedman Settles with the De Soles in Knoedler Trial over $8.3m Fake Rothko'. *Artnews*, 2 July 2016.

Morton, James and Susanna Lobez. *King of Stings: The Greatest Swindles From Downunder*. Melbourne: Melbourne University Publishing, 2011.

Munro, Cait and Sarah Cascome. 'Conservator Found Rothko Painting in Knoedler Trail to Be a "Deliberate Fake"'. *artnet*, 4 February 2016.

Panero, James. '"I Am the Central Victim": Art Dealer Ann Freedman on Selling $63 Million in Fake Paintings'. *New York Magazine*, 27 August 2013.

Pearson, Lynn Stowell. 'Arrest of Claire Eatz'. *IFAR Reports*, Vol. 6, No. 4, May–June 1985.

Pearson, Lynn Stowell. 'Art Dealer Claire Eatz Convicted of Fraud and Sentenced to Six Years in Jail'. *IFAR Reports*, Vol. 6, No. 8–9, October–November 1985.

Sloggett, Robyn. 'Art Fraud: Does It Matter?' *Museums Australia Magazine*, Vol. 17, No. 1, August 2008.

The Light Fingered

For as long as art has been made, it has been stolen. It is impossible to measure the extent of art theft, given it often goes unreported, and how it is reported in the media depends on the work, the fame of the artist, and how sensational the actual theft was. What we do know about art theft is that as long as there are those motivated to steal art it will continue to occur. The lack of security, suitable opportunities to steal, and those willing to acquire 'hot' art, has the potential to make art theft a growth industry. The motivations and methods for the female art thief may vary, but the end result is fundamentally the same, art is intentionally stolen and there will be victims. Art theft can be categorised into three types: larceny, burglary, and robbery. Larceny involves the taking of property without force, violence, or fraud. Burglary is the unlawful entry to commit a theft but not necessarily a forced entry. And lastly, robbery involves the use of force and/or violence to take artworks from the custody of people, frightening the victim/s of that robbery. What also needs to be considered is the motivation for theft. An art-motivated criminal steals for personal gain; simply, they cannot live without a particular piece/s of art. Given they adore the work, they are more likely to care for it, avoiding damaging it when they steal it. Additionally, since it is for their personal viewing they usually work alone. The second type of art thief finds motivation in profit: simply put, they are interested in selling the stolen artwork/s for cash, or goods and services.

In the early 1990s, criminologist John Conklin noted that there had been little research carried out about art thieves in part because few such

© The Author(s) 2020
P. Jackson, *Females in the Frame*,
https://doi.org/10.1007/978-3-030-44692-5_6

thieves had been identified, arrested, convicted, and imprisoned.[1] His words remain pretty true to this day. However, since the 1990s, books such as Matthew Hart's *The Irish Game* and Sandy Nairne's *Art Theft*, offer greater insight into art theft and the art thief. In part, the research and publications about art crime carried out in the last decade or so not only present the major issues around art crime but also hopefully have created a greater awareness about curbing art crime, including security against theft of art. But what of the women art thieves, who are they, and are their motivations any different from their male counterparts?

In some instances the male and female art thief operate together; 'husband and wife' teams have worked in tandem to successfully steal art. An early reported example is that of a Parisian couple, Paul and Amelie Decuypere. Married in 1849, they stole from furnished houses they rented, absconding with the contents, including art. They had a catalogue of crimes to their names (and they went by a variety of names including Amelie and Paul Thuillier, Antoine Thuillier, Amelia Decuypere, and Louise Claudine Margaret) including a religious themed painting they stole from a museum in Amsterdam. The painting was valued at £2K in the mid-nineteenth century, making it equivalent to approximately £90K now. According to the records, Amelia (as the Home Office and Prison Commission records refer to her) was convicted of larceny in a dwelling house for stealing several paintings, a coffee pot, two clocks, and a pair of blankets (three counts).[2] There was no court trial. Amelia was also responsible for at least another dozen offences. While in England, the couple were tried in absentia in Paris, convicted of swindling and fraudulent bankruptcy, and sentenced to ten and twenty years hard labour respectively. Historian Lucy Williams describes Amelia in *Wayward Women: Female Offending in Victorian England*: 'Amelie was a fine art thief, a notorious fraudster, an offender across Europe.'[3] Unfortunately, there are no details about the paintings stolen, or whether they were ever recovered. However, the law did eventually catch up with Amelia and Paul. Amelia served five of a six-year sentence, and was paroled in 1864 from England's Fulham Prison. Paul was sent to Coldbath Fields Prison, Clerkenwell, London. Having worked closely as criminals they were separated for their prison sentences.

Another case involving the work of a couple, concerned Willem de Kooning's painting *Woman-Ochre* (1954–1955). This is a remarkable story as the work was recovered, demonstrating that stolen art is occasionally recovered. *Woman-Ochre* was a key work in the collection of the

University of Arizona's Museum of Art in Tucson. On 29 November 1985 a couple brazenly stole it. The art heist was described:

> The museum had just opened when a man and a woman walked in. They were the sole visitors. The woman, described as being in her mid-50s with shoulder-length reddish and blond hair, distracted the security guard by making small-talk while the man, who appeared to be in his 20s and wore a moustache and glasses, cut the painting from the large frame, leaving the edges of the canvas attached.[4]

From the description at the time of the de Kooning theft, it was clear that the woman's role in the heist was that of a decoy. Thirty-one years later a New Mexico antique storeowner, David Van Auker, unwittingly acquired the de Kooning painting in an estate lot for which he paid USD$2K. A few of his customers enquired if the work was authentic. A search on the Internet soon revealed to Van Auker that it could well be the stolen work. And it was. Valued at USD$160M at the time of its return in 2017, the Museum staff were simply overwhelmed to have the painting back. No one has been charged for the theft though there was a suggestion that an elderly couple, Jerry and Rita Alter, from whom Van Auker made the purchase, were the original thieves. Until recently there was no evidence to support the notion.

Jerry Alter died in 2012 and Rita Alter in 2017. From all appearances, they were a quiet law-abiding couple; Jerry was a musician and teacher and Rita, a speech pathologist. Since their deaths, and the recovery of the de Kooning, questions were raised about how this couple, with a moderate income, managed to support their passion for travel (they visited 140 countries and all seven continents). Added to this, at the time of their deaths they had in excess of USD$1M in their bank accounts. In 2018, a family photograph emerged and could be the key to confirming the suggestion that perhaps the Alters were the thieves of the de Kooning painting. The photograph depicts the couple on holiday at Tucson in Arizona taken the day before the robbery, clearly placing them at the right place and very close to the right time.[5] The coincidence seems too good not to be true. At the time of writing, the FBI was still investigating the de Kooning theft, and though it is over three decades since the *Woman-Ochre* was taken, more pieces to the puzzle of its disappearance and reappearance continue to come to light. For instance, it is curious that the painting was hung behind the door of the couple's bedroom.

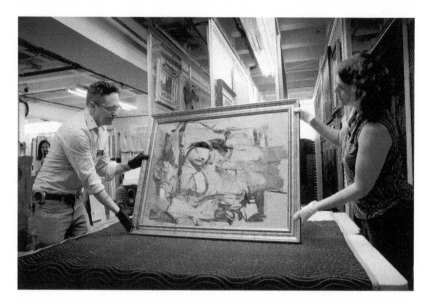

Fig. 6.1 The University of Arizona Museum of Art staff Kristen Schmidt (Registrar) and Nathan Saxton (Senior Exhibition Specialist) with Willem de Kooning's *Woman-Ochre* (1954–1955) on its return to the University's collection in 2018 (*Photographer* Bob Demers, University of Arizona News)

This suggests a private-viewing-only policy and a desire to keep the painting from others seeing it and ultimately asking questions. Furthermore, the assumption can be made that the Alters knew the value of the work, as they had a blackout curtain on the facing bedroom window to protect the painting from any ultraviolet light.

The New Mexico Manzanita Ridge Furniture and Antiques of Silver City store notified the Museum staff of their finding; a series of cracks across the canvas consistent with it being rolled up indicated that this was the missing de Kooning. It was known that the canvas was cut from its stretcher, which meant the measurements of the found canvas had to be an exact match. They were. What is special about this case is that the de Kooning was returned to the University of Arizona's Museum of Art, the staff truly humbled by the goodwill gesture of the antique dealers (see Fig. 6.1).

Working together as a couple can be a good strategy for committing art crimes; often the woman acts as a decoy while the man removes the artwork. However, many women work alone in their pursuit to steal art; without an arrest the true objective or motivation for a theft cannot be realised. In some instances the intent is very clear though, for example in August 2017, Spanish police arrested a 67-year-old unnamed British woman accused of stealing a painting from a private collector in Mallorca. The painting was by American artist Jean-Michel Basquiat (1960–1988), acquired by the collector directly from the artist's father. Basquiat works are highly desirable; in 2017 a Japanese billionaire paid USD$110.5M for *Untitled* (1982). According to the thief, she stole the work to force the collector, her employer, to pay her €30K that was owed to her for wages in arrears. And so, her motivation was purely monetary. Whether she received the funds is not known. A sting in the tale for the Basquiat owner however was that once the theft and recovery was made public, the work's authenticity was questioned. The reason given was the over-use of abundant text on the painting, more so than Basquiat ordinarily employed.[6] And so, even though the painting was recovered, its authenticity is now in the public arena because of the theft, jeopardising future potential sales of the work. No collector wants this kind of publicity.

Opportunists steal art simply because they can, often without thinking through any of the long term and subsequent consequences. Irish general practitioner Dr Jill Purce is a good case in point. Purce confessed to stealing a large portrait of Steve McQueen from a Belfast hotel. At just over 180 cms in height, the one-off specially commissioned print proved logistically too large to move and so Purce sought assistance from a friend, another woman, also in her sixties, to remove the painting from the hotel in the early evening of 16 October, 2016. Surveillance footage captured the heist including the pair walking down the street carrying the large portrait right past the police station. However, the women had difficulties getting the portrait into their getaway vehicle, at which point they abandoned the heist. The work was soon located and returned to the hotel. The Bullitt Hotel, where the portrait was stolen from, had only opened its doors for the first time the day before. Located in Belfast, the hotel was named after the 1968 thriller movie, *Bullitt*, starring Steve McQueen. Shortly after the heist Purce regretted her actions; in what appears a moment of weakness, and as she said, 'I think I did it maybe because I could do it, it was a bit like The Thomas Crown Affair.'[7] Purce admitted to being a huge Steve McQueen fan; the irony being

that Steve McQueen starred in the original movie, *The Thomas Crown Affair*. The print, commissioned from Slovakian artist Kamil Vojnar, by the hotel's owner, was valued at £15K. However, the damage to Purce's reputation was not worth this moment of weakness. The media played on the fact that she was a well-respected general practitioner, and wouldn't be remembered for her years of service to her patients and community but rather for what was labelled as The Great Escape.[8] The fact remains though that Purce, and her unnamed accomplice, stole the work and then abandoned it on the street. The final outcome, for the artwork, could have been far worse than the slight damage it sustained. Purce's dalliance into art theft was a spur of the moment kind of decision whereas the following cases, discussed in more detail, demonstrate bigger and more targeted strategies for art theft.

VILMA BAUTISTA AND MONET'S *LE BASSIN AUX NYMPHÉAS*

Imelda Marcos' (b. 1929) name is synonymous with shoes. Famous for her shoe collection, she amassed thousands of pairs. A large number of those shoes can be seen today at the Shoe Museum in Marikina, Philippines. However, shoes were not her only area of collecting; with her husband, President Ferdinand Marcos, the couple acquired a significant art collection, with paintings by some of the great masters. One work, Monet's *Le Bassin aux Nymphéas* (1899) came into the Marcos' collection in March 1977 when Imelda purchased nine paintings totalling USD$2.9M from Marlborough Fine Art, London.

The most expensive work was the Monet, costing USD$791,800. The funds to purchase the cache of works came from a Swiss bank account, called the Trinidad Foundation. In 1986 the Swiss froze these funds on the grounds that the money had been misappropriated by the Marcos' and belonged to the Republic of the Philippines.

Marcos was the president of the Philippines from 1965 to 1986, with his reign coming to an abrupt end in 1986 with allegations of mass cheating, political turmoil, and human rights abuses, which led to the People Power Revolution removing him from power in February 1986.[9] The Marcos' were accused of plundering the country's treasury and many would argue that the art collection was purchased with public funds and therefore was not a personal collection. Marcos died in 1989 and in 1990 Imelda was acquitted, by a Manhattan federal jury, of stealing more than

$USD200M. Her defence argued that she didn't know the money had been obtained illegally. A lawyer for Imelda told reporters:

> The real issue in the trial is whether there was any indication Mrs. Marcos knew the funds she used were illicitly obtained. ... There was not one iota of evidence on this point.[10]

For the two decades from 1990, the whereabouts of the art collection remained a mystery. However, in 2011 Cyrus Vance Jr, a Manhattan District Attorney, seized fifty-two of the paintings from Vilma Bautista's Long Island and Manhattan residences. A further two paintings were surrendered by Bautista's former attorneys. Bautista, a former employee of Imelda's, was employed as a Foreign Service Officer assigned to the Philippine Mission to the United Nations in New York from early 1966 up until 1986. During this time she also acted as Imelda's unofficial private secretary and personal shopper.

At the time of the Marcos' fall from grace, the New York residences (a townhouse on 66th Street and an apartment on the 43rd floor of the Olympic Tower at 641 Fifth Avenue) were stripped of valuable items including the artworks, which Bautista took. Bautista kept quiet about the collection until 2009 when she decided to sell one of the prize pieces, Monet's 1899 painting from the Water Lily series titled *Le Bassin aux Nymphéas* (also known as *Japanese Footbridge Over the Waterlily Pond at Giverny*). However, the deal fell through when Bautista was unable to satisfy the potential buyer, the Acquavella Galleries of Manhattan, with an up-to-date 'authorisation to sell' letter from Imelda, arguing an earlier letter dating from 1991 was too old.

To appreciate the value of *Le Bassin aux Nymphéas*, both in monetary and art historical terms, it's worth considering the painting's origins. In 1883 Monet and his family relocated to Giverny, 72 kilometres northwest of Paris. From that time up to his death in 1926, Monet gardened and painted. He was an obsessive gardener, continuously extending and tweaking his garden. The garden provided an endless source of subject matter, and as the light shifted and palette changed, he painted. There are approximately 250 images of water lilies. In *Le Bassin aux Nymphéas* Monet depicted his beloved water lily garden and bridge in lilac tones. Though he painted the same subject over and over, each is different according to the light and colour of the moment. *Le Bassin aux Nymphéas*, similarly sized with the others in the series, measures

890 × 920 millimetres; painting directly from nature, the canvases were easily transportable outside as the light changed. Monet applied the oil paint to his canvas thickly, giving *Le Bassin aux Nymphéas* a three-dimensional quality and lustre that is typical of Monet's oeuvre. This work is an early example of the series, which he only began in 1899. When the Marcos Monet hit the headlines there was much interest from the media and public alike, not only for how did the Marcos' pay for the work but that *Le Bassin aux Nymphéas* was a quintessential Monet, much revered by followers of Impressionism.

On 14 September 2010 Bautista brokered a deal to sell the Monet with the London art dealers, Hazlitt, Gooden & Fox, who in turn sold it to the then Swiss-based hedge fund manager Englishman, Alan Howard. Howard's art advisor viewed the work prior to making the purchase and even though Howard was aware that the Marcos' were prior owners, he was assured that it was safe to acquire, and did so for the sum of USD$43M. Bautista provided a Certificate of Authority signed by Imelda, dated 21 June 1991. The Certificate stated that Bautista was Imelda's authorised representative to offer and negotiate the sale of the work. Interestingly, in 1991 Imelda had provided Bautista with a number of Certificates in which the details could be added in at the time of a sale. After various costs and payments were made, Bautista was left with the remaining USD$15M. However, Bautista's income tax return filed for the 2010 year did not reflect the income from the Monet sale, having given her annual income as a paltry USD$11K. Bautista's dishonesty caught up with her.[11] In 2012, Bautista was convicted on charges of conspiracy to commit grand larceny, possession of stolen property, and tax fraud after illegally attempting to sell another painting, Sisley's *Langland Bay* (1887). Over the next few years she would appeal her case.

The new owner of the Monet, Alan Howard, was left in a precarious position. Having shelled out a vast sum for the work he didn't want to lose it if it was proven that Bautista was not the legal owner and therefore didn't have the right to sell the work. In an effort to show his goodwill, and clear himself of any further legal dispute over the painting's ownership, Howard donated USD$10M to the Filipino people in exchange for a legal release on any claims regarding the painting. The Monet acquisition opened up old wounds though; over three decades have passed since the Marcos' were forced from the palace and yet the billions of dollars it is alleged that the Marcos' stole from the Filipino people are yet to be recovered. In 1986, the Philippine Commission on Good Government

(PCGG) was formed in a bid to try to reclaim some of the wealth that had been taken. The PCGG launched a campaign to reclaim the art collection calling it 'Where's the Art?' with the press release making special mention of Monet's *L'Église et La Seine à Vétheuil* (1881) and Sisley's *Langland Bay*, providing further evidence of the scope of the collection, and the atrocity of how it was formed. Sadly though, the Monet case highlighted the injustices of the Marcos' regime, as well as being just one work of at least 200 within the art collection. The court ruling was a staggering ninety-three page document in the case of the District Attorney of New York County versus The Republic of the Philippines, et al.[12]

The question remains, which of the two women was the art thief here? Imelda loved to spend, amassing her art collection with money from the Philippines, not her personal funds. Many would argue that the art collection should be returned to the Philippines. Bautista, who held the works for twenty years at her home, was both greedy and devious. She sold the Monet, and tried to sell others, for personal gain. Bautista didn't act alone in her pursuit to secure sales. Bautista seconded her nephews Chaiyot Jansen Navalaksana and Pongsak Navalaksana to assist in plotting the sale of four paintings on the Asian black market. They were also involved in the Monet sale and after it went through, Bautista gave them a USD$5M commission to share. Their email correspondence provided good evidence of the precarious position they found themselves in during the time of the potential sale. Fleeing to Bangkok, they avoided being charged.

Like two peas in a pod, Imelda and Bautista are both thieves. As Supreme Court Judge Renee White noted, 'The evidence clearly shows Miss Bautista stole property from the Philippines government and Imelda Marcos.'[13] On 8 October 2012 Bautista was charged with having illegally conspired to possess and sell valuable works of art acquired by Imelda during her husband's presidency, keep the proceeds for herself, and hide those proceeds from New York State tax authorities and others.[14]

In another example of her collecting greed, Imelda failed in her 2015 legal battle to see the return of her jewellery collection, which was confiscated in 1986 at the time of her husband's ousting. It was reported:

> The court found that the jewels could not have been bought by Ferdinand Marcos on his government salary of a few thousand dollars. This, the court said, was sufficient to presume they were unlawfully acquired.[15]

And it is with this line of thinking that one can assume the art collection was also purchased from the public, not private, purse. Sadly, while Imelda shopped en masse, a large proportion of the Philippines population lived in abject poverty. It is this injustice that is still being fought today by people such as Robert Swift, a Human Rights lawyer representing 10,000 victims of the Marcos regime. In early November 2018 Imelda was found guilty of seven counts of graft (the unscrupulous use of a politician's authority for personal gain), with the potential sentence of decades of imprisonment. The conviction also disqualifies Imelda from holding her public office as a congresswoman. However, much to the disappointment of many, it was reported that Imelda would appeal her convictions.[16] And it would seem that Imelda is never far from the limelight; her story, from rags to riches, is the subject of the disco musical, *Here Lies Love*, that premiered in New York in 2013 and since has been performed in other venues and won prestigious awards.[17]

November 2018 also saw the sale of three Impressionist paintings that were acquired by the Marcos' with embezzled funds. They were: *Langland Bay* by Sisley, Monet's *L'Eglise a La Seine a Vetheuil*, and Albert Marquet's *Le Cypres de Djenan Sidi Said*. The sale proceeds, USD$4.3M, will benefit claimants under a court order overseen by Robert A. Smith.[18]

Bautista lost her appeal and in December 2017 she finally surrendered and accepted the fact that she would have to serve her sentence at a New York state prison. At that time, aged 79 years and of ill health, she was given a reduced sentence of six years. Earlier, during the court proceedings it was suggested she could be sentenced with up to twenty years. Today the art collection remains in a high security climate controlled warehouse in Brooklyn, awaiting the outcome of a legal battle to establish ownership. Bautista continues to maintain that she was gifted some of the works and therefore rightfully owns them.

KIM ROBERTS WATSON AND PICASSO'S *SELF-PORTRAIT* (UNDATED) AND BEN NICHOLSON'S *STILL-LIFE* (1945)

Employers are often the targets for employee theft and it is no different when it comes to art. In well-appointed country houses, containing large collections of art and antiques, there is a line of thought by some deceitful employees that their employer will not notice if the odd object goes missing. Perhaps this was what Kim Roberts Watson had in mind when she helped herself to a Picasso drawing and a Ben Nicholson painting

from her elderly employer, Gloria Wesley, the Dowager Countess Bathurst (1928–2018), of Cirencester, England.

Watson, a former show jumper turned housekeeper, was already a career criminal when she became an employee at the Countess' home, a farmhouse where she and the late eighth Earl of Bathurst had relocated from the 'big' house in 1988, set in the grounds of the estate at Cirencester Park, Gloucestershire. During the 1980s and 1990s Watson was convicted for deception, shoplifting, and forgery. Out of financial desperation she had turned to domestic work, advertising her services in the upmarket English magazine, and go-to place for reputable domestic staff, *The Lady*. Her fraudulent references helped her secure a position. The light-fingered Watson stole £500K worth of art and antiques from the Dowager Countess after working for her for less than a month during the spring of 2013.[19]

At Watsons' hearing in April and May of 2015 she admitted to the thefts, though previously she had denied them saying that she had been given the works in question.[20] She also admitted to three other crimes: stealing from the Countess's London residence, the theft of a Volvo XC90 car from her previous employer, Emily Todhunter, in 2012 valued at £40K, and fraud (she had lied about her age to the domestic help agency when applying for a position). In 2015 Watson, aged 58, was sentenced to three years imprisonment.

What is interesting about this case is not so much how Watson went about amassing her collection while she was a housekeeper, but how she was caught red-handed. But first a little background. Ben Nicholson (1894–1982) was one of Britain's foremost modernist artists; in 1945 he returned to the subject of the tabletop still life, of which the Dowager's painting is an example. Works from this period of his career are highly desirable and valuable to collectors. For example, in 2014 Nicholson's, *Still life with mugs* sold for over £2 million[21] and another work from the same period, *1945 (Still life)* sold in 2017 for £509K.[22] Nicholson is well represented in major collections, including the Tate and the Guggenheim. With all this in mind, it would be fair to say that Watson clearly knew she was trying to sell high-end art. If she got away with it, there is no doubt that she would have profited well from selling Nicholson's *Still-Life* (1945). Furthermore, the other key work Roberts stole from the Countess' home was a drawing, an undated *Self Portrait* by Picasso.

Pablo Picasso's (1881–1973) drawing depicts the artist as a young man and possibly dates from his early twenties. The work is a representational

rendering and given the enormity of Picasso's legacy, and interest in his self-image, also highly desirable, albeit Watson would have to provide good provenance for a legitimate sale. Given her track record and the events that followed, we can assume that it was Watson's intention to sell both works. Interestingly, in 2012 the Art Loss Register released a report noting that Picasso was the most popular artist when it comes to theft, missing works, or disputes over ownership. At that time, there were 1147 Picasso works registered with them, giving a fair indication of the scale of the artist's popularity (though advertising this statistic could have given other would-be thieves ideas on what to 'collect').[23] Watson's barrister, Simon Burns, said of the Picasso sketch that it was very simple and not worth more than £100K. In an effort to play down the value of the work (and supposedly reduce his client's sentence), of the Nicholson, he opined that the works would not have been missed immediately as they were not on hung on the walls and therefore not being appreciated.[24] Prior to its theft, the Countess kept her Nicholson covered up in a study, which was her prerogative.

In July 2013, Watson contacted Michael MacDonald from Antique Vault, an online art valuation specialist. She gave her name as Kim Roberts-Fleming and said she was looking to sell her Nicholson painting. They arranged to meet and MacDonald would later describe this as a potentially dream find—a rare transitional Nicholson work with a provenance to the 1956 British Council exhibition in India (though my research was unsuccessful in confirming this exhibition detail). But Mac-Donald became suspicious at the meeting for Roberts became increasingly pushy and kept moving the goalposts.[25] MacDonald's instincts would prove correct. Cleverly, MacDonald got Roberts to leave the painting with him so he could have others appraise it. A sticker from the London art dealer, Lefevre Fine Arts, on the verso of the painting provided a breakthrough in the case. It so happened that Alexander Corcoran, of Lefevre Fine Arts, knew the Bathurst family and made contact only to find that the Nicholson was missing.[26] At the same time, the Countess found other items missing including the Picasso drawing. The police were called in.

A meeting set up by MacDonald, at the Landsdowne Club in Mayfair, London, coerced Watson; she came to the meeting to collect 'her' Nicholson where the police arrested her. Fortuitously, MacDonald had not agreed to sell the work on Watson's behalf given the discovery. After Watson's arrest she tried to sell other items to an antique dealer who

quickly took details and photographed her (stolen) car. Roberts' penchant for theft had finally caught up with her and she was subsequently convicted and sentenced. Judge William Hart praised the dealers involved in the sting operation for their efforts in Watson's arrest; their attention to detail and willingness to be involved was applauded. Of the thief, Judge Hart noted that the thefts were premeditated offences as an employee with the clearest intention of selling the items on.[27] It was also suggested that several items might have already been sold prior to Watson being arrested.

ROSE DUGDALE AND THE RUSSBOROUGH HOUSE ART COLLECTION HEIST

At 9.20 p.m. on 26 April 1974 Rose Dugdale knocked on the door of Russborough House, the impressive country home of Sir Alfred and his wife, Lady Beit. After giving a 'cock and bull story' about her car breaking down, she and her three balaclava-clad male accomplices, wielding Russian Kalashnikov AK-47s, forced entry into the Beit's home. The owners, relaxing in their library while listening to music, were startled (as were their servants) when the three men pistol-whipped Sir Alfred and his servants, tied them up, and then began to help themselves to the art collection. In the meantime, Lady Beit was put in the basement. During the art heist, Dugdale pointed out to her accomplices the most valuable works to take. The works were taken down off the walls and with screwdrivers the canvases were removed by way of levering them from their frames, rather than cutting the actual canvas.[28] In all, four thieves took nineteen paintings that night, inside ten minutes. It would take a further thirty minutes for Sir Alfred to find his wife and call for help. The works taken were:

1. Francesco Goya, *Portrait of Doña Antonia Zárate*, c.1810
2. Peter Paul Rubens, *Head of a Cavalier*
3. Unknown Artist, *Portrait of a Monk+*
4. Peter Paul Rubens, *Venus supplicating Jupiter*
5. Sir Thomas Gainsborough, *Portrait of Madame Bacelli*

6. Sir Thomas Gainsborough, Small Landscape (this work is possibly either *The Path Through the Woods* or *Landscape with Cattle and Figures*)
7. Gabriel Metsu, *A Man Writing a Letter*, c.1663
8. Gabriel Metsu, *A Woman Reading a Letter*, c.1663
9. Johannes Vermeer, *Lady Writing a Letter With Her Maid*, 1670–1671
10. Jacob van Ruisdael, *The Cornfield* (now in the collection of Ulster Museum)
11. Francesco Guardi, *The Piazzetta, Venice, with the Doge's Palace and the Libreria, San Giorgio Maggiore beyond*
12. Francesco Guardi, *Piazza San Marco, Venice, with the Basilica and the Campanile, with figures in carnival costume*
13. Francesco Guardi, *A Fantasia* (Landscape with figures and ruins in the foreground; in the distance a church and tower)
14. Francesco Guardi, *A Fantasia* (Landscape with figures in the foreground, and buildings on the left; to the right a tall column surmounted by the figure of a soldier, holding aloft a sword)
15. Diego Valesquez, *Maid in Kitchen with Christ and Disciples Outside the Window*, c.1617–1618
16. Frans Hals, *Man playing a lute*
17. Willem van de Velde the Younger, *Calm Sea with Boat*
18. Paulus Moreelse, *Lady Wearing a Ruff*
19. Edwin Landseer, *Untitled landscape with pond, swan and a church*

+At the time of the 1974 robbery this work was thought to be by Peter Paul Rubens. Subsequently is has been confirmed to be 'a Flemish work of museum quality, artist unknown'. Rubens did not paint it.

Dr Bridget Rose Dugdale (b. 1941) was no stranger to violence or theft when she forced her way into Russborough House. Born into a wealthy English family, she enjoyed a privileged childhood and was well educated. As a young woman, she was presented to Queen Elizabeth II as a debutante, an event she found abhorrent. With a PhD in economics, Dugdale worked as an economist before devoting her life and funds to those less

fortunate than herself. She rebelled against the class system and everything it stood for. When Dugdale became more involved with civil rights during the early 1970s, she cashed in her share of the family syndicate at Lloyds, at the time estimated to be in the region of £150K, distributing her funds to the poor people of north London.

On 6 June 1973, Dugdale made her first foray into art theft; alongside her partner at the time, criminal Walter Heaton, the couple burgled a house at Yarty Farm, Devon. The house was actually her own family's country home and Dugdale knew her parents would not be at home as they were out of town attending Derby Week. Dugdale and Heaton took silverware, Meissen porcelain figurines, and eight paintings to the total value of £82K, of which £77K was attributed to the paintings. At the time, it was suggested that the proceeds from the potential sale of items were to be donated to the Irish Republican Army (IRA). Heaton was sentenced to six years imprisonment and Dugdale received a two-year suspended sentence, the reason being that the judge, Mr Justice Park, thought the possibility of her reoffending was low-risk. Heaton would later make the comment that anyone who knew how strong a personality Dugdale had would realise how ridiculous the Judge's claim was.[29] Perhaps the Judge assumed that Dugdale took a traditional and submissive role in the couple's relationship or that she had learned her lesson. The family's stolen possessions were displayed as evidence in the Exeter Crown Court with her parents having to endure the embarrassment and humiliation that their daughter had caused. Alas, the Judge did not appreciate Dugdale's depth of passion about capitalism, the class system, or her commitment to a life of crime, if it meant she could affect change.

Following the trial, Dugdale headed to Ireland and became involved in an IRA active service unit operating between Northern Ireland and the Republic of Ireland. January 1974 saw Dugdale and others (including Eddie Gallagher whom she would later marry in prison and have a son with) hijack a helicopter in County Donegal to drop milk churns, containing bombs, on the Royal Ulster Constabulary station in Strabane in Northern Ireland. However, their plan failed, as the bombs didn't explode. The helicopter hijack signalled Dugdale upping her militant activity; her *pièce de résistance* would take place a few months later at Russborough House.

Dugdale's choice of Russborough House was both strategic and clever. Russborough, in County Wicklow, is a Palladian home designed by architect Richard Cassels for Joseph Leeson, the 1st Earl of Milltown. Built in

1741–1755, Russborough boasts being the longest house in Ireland and though it has an austere exterior, giving it a somewhat bleak appearance, the interior is the antithesis with its opulent decorations, furnishings, and art collection. The Beits purchased the house in 1952, ostensibly to house their art collection, made up of sixty old masters. The collection was substantial with works by Vermeer and Rembrandt as well as ones specifically painted for Russborough such as a quartet by Claude Joseph Vernet titled *Morning, Midday, Sunset,* and *Night.* The Beits, along with their home and its contents, represented everything that Dugdale rebelled against. During the art heist, Dugdale pointed out to her accomplices the most valuable works to take. Allegedly Dugdale had been a guest at the house previously and so she was acquainted with the collection. As noted at the time, 'Dr Dugdale was the obvious choice [for the job]. She knew about paintings, and the sort of people who owned them and cared for them.'[30]

Dugdale made a bee-line for the high-end value works, and specifically works such as Vermeer's *Lady Writing a Letter With Her Maid* that not only had high value monetarily, but also historical art value (see Fig. 6.2). Vermeers are few in number, which is useful in terms of future-proofing a potential bargaining chip for negotiating a deal. A Dutchman, Johannes Vermeer (1632–1675) has only thirty-four paintings attributed to him, thus making his works even more rare and desirable. Dugdale knew what she was doing. However, there were some highly valuable works that she missed during her haul, such as Adriaen van Ostade's, *Adoration of the Shepherds* of 1667 that had an auction estimate of £600K–800K in 2015, though the lot was withdrawn prior to the auction.

The Russborough House art heist was big news at the time; it attracted attention for the violence exercised towards the elderly home owners, the valuable items stolen, and that the ring leader was a woman and a well-off educated one at that. The total estimated value of the haul was IR£8M. However, frustratingly, contemporary reports and articles published never gave a complete list of the works. In most instances they mentioned highlights from the heist. This may have been an oversight or perhaps for security reasons was to ward off future thefts (though if so, it failed miserably). And yet a catalogue of works is necessary to document the enormity of an event. In 2018, preparing a list with the help of Russborough House staff proved useful as more is now known about several of the works including some that had been miscatalogued at the time of the heist. For instance, the *Portrait of a Monk* was once thought to be by Peter Paul Rubens but is now catalogued as simply having been from that era. The Willem van

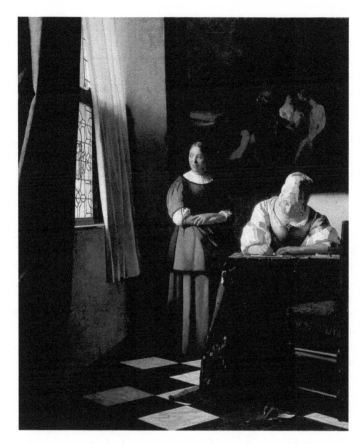

Fig. 6.2 Johannes Vermeer, *Lady Writing a Letter With Her Maid* (1670–1671). *Collection* National Gallery of Ireland

de Velde the Younger was also misattributed to Willem van der Velde the Elder. However, having commented on the inaccuracies of cataloguing it must be remembered that this was a private collection, well before the days of having staff to attend to such matters.

A massive search ensued for the missing works and the robbers. The theft took place on a Friday and during the following weekend the police—the gardaí as they are known in Ireland—visited 400 properties. Soon it became clear why Russborough was targeted that night; the IRA

members sent a ransom note offering to exchange the stolen paintings for IR£500K and the repatriation of four prisoners: Dolours Price, Marian Price, Gerry Kelly, and Hugh Feeney. All four were members of the Provisional IRA and incarcerated in London's Brixton Prison for their part in the car bombings at London's Old Bailey and British Army recruitment centre on 8 March 1973, in which 200 people were injured and one killed. The four immediately went on a hunger strike upon their arrival at Brixton Prison. The IRA wanted the four prisoners transferred to prison in Northern Ireland where they would be seen and treated as political rather than criminal prisoners. All four were repatriated in 1975.

The stolen paintings were quickly found. On 4 May 1974 the paintings were recovered from the boot of a car at Dugdale's rented house at Glandore, County Cork, which she had rented under the name of Mrs Merrimee of London. It was her 'foreign' accent that led the police to her door and her subsequent arrest under Section 30 of the Offences against the State Act. The following day, Dugdale was charged with the art theft along with helicopter hijacking. On 25 June 1974 Dugdale was sentenced to nine years imprisonment having pleaded 'proudly and incorruptibly guilty'. In October 1980 Dugdale, now a wife and mother, was released from Limerick prison.

The stolen paintings were reunited with the Beits relatively quickly. The works were examined by conservator Andrew O'Connor at the National Gallery of Ireland, not for any possible conservation that might be required, but also as evidence for the court trial (a police officer guarded the conservator's studio throughout this time in fear of another attempt to steal the works). Of the nineteen works, only four were undamaged in some way.[31] Vermeer's *Lady Writing a Letter With Her Maid* (1670–1671) had sustained six areas of damage. While examining the work, O'Connor noted that the surface was 'brown and murky'[32]— this was due to the darkening of re-touching over time and possibly from centuries of dirt that had settled on the painting's surface. For art historians this is where the story gets even more interesting; O'Connor, with the Beits' permission, proceeded to clean the Vermeer. Slowly he cleaned the dirt and grime off the painting's surface unearthing a small red area in the foreground of the painting. It turned out to be the sealing wax from the letter the young woman had received, and was replying to. The wax, ripped off in a hurried moment, had landed on the black and white tiles in front of her writing table. For O'Connor, this was a light bulb

moment. The Vermeer, returned to Russborough, had been on a journey in more ways than one. Art crime writer Matthew Hart commented:

> As scholars read the painting now, they see a woman who has received a letter from her lover, possibly breaking off the affair, and in a controlled frenzy she is dashing off a reply.[33]

Once the conservation on Vermeer's *Lady Writing a Letter With Her Maid* was completed the painting was far closer to its original cooler tones, just as Vermeer had painted it 300 years earlier.[34]

Though reunited with the collection, Russborough would unfortunately see many of the nineteen works stolen again over the next few decades. In 1976 the Beits, who were childless, gifted their home and its art collection to the people of Ireland through the establishment of the Alfred Beit Foundation. No longer a private home, today Russborough is open to the public. Selected works from the collection are now in other collections—the Vermeer, which was the only work by the artist with the exception of *The Music Lesson* (1662–1665) owned by Queen Elizabeth II's private collection—is now part of the National Gallery of Ireland's collection. Another work, *The Cornfield*, a painting by the seventeenth-century Dutch painter Jacob van Ruisdael (1628–1682), was gifted in 2017 to the Ulster Museum in lieu of the Beit Foundation paying death duty. In many ways, it is a shame that the collection has been broken up, with other works being sold to fund the ongoing upkeep of Russborough House and to offset taxes and overheads. Without the sales though, the House would struggle to keep up with the demands of maintenance and other operational costs.

Dugdale and her accomplices committed a heinous crime that night in April 1974. They threatened to destroy the works if the ransom was not met; fortunately it did not get to that fateful stage. Their crime was violent, the victims being the Beits and their staff and the nineteen paintings. The artworks, made by eminent artists, all dated from the seventeenth through to the nineteenth centuries, and because of their age were particularly vulnerable to damage. Removing them from their frames, at speed and with screwdrivers, could have caused long-term damage. With the exception of the Vermeer, few details were ever given about the restorative work carried out on the canvases. We can only assume that the rough handling must have meant they sustained some damage. The change from the stable temperature inside the house to the outside temperature, and

then the car boot, put the canvases at risk as the sudden movement of an aged canvas can cause *craquelure* (surface cracking from age or excessive movement). Photographs taken at the time of the recovery of the paintings show police officers handling the wrapped-in-blankets paintings, with at least one officer holding his cigarette very close to the painting! And like many highly valuable works held in family collections, many of the Russborough works were uninsured at the time of the theft, simply because the cost of the premiums was too prohibitive. Dugdale and her crew were no strangers to violence and appeared to show little compassion for the Beits and their employees. That all the works were recovered is exceptional when compared with other major art heists. Adversely, the attention inspired others; Dugdale and her crew 'flagged' the location as eminently soft which later inspired Martin Cahill's 1986 theft.[35] Following Dugdale's theft at Russborough, the building was fitted out with a new and elaborate security system linking it directly to the local police station, replacing the former system of push button alarms that had to be manually activated. When Dugdale and her three accomplices entered the library the Beits didn't have the opportunity to push the alarm button. However, the new security system did little to deter subsequent thieves.[36] Two other thefts followed Cahill's; one in June 2001 and another in September 2002.

A major difference of the 1974 art heist was that it had a female leader. Interestingly the media never named Dugdale's three male accomplices. Dugdale already had a media profile when she knocked on the door at Russborough House and indeed the police had plastered wanted posters far and wide in a bid to capture her for the helicopter hijacking. Her well-to-do background assisted in embellishing and sensationalising the story further for the media. That the crime was committed in a country house in Ireland gave it another point of difference. And, as criminologist Thomas D. Bazley notes, the Russborough theft was the world's most lucrative art theft up to that time.[37] The final point of difference was that all nineteen works taken in the heist were recovered. Now in her seventies, Dugdale continues to reside in Ireland, keeping a relatively low profile. Since her release from prison, she has given a limited number of interviews, in which she demonstrated little remorse for the heist.

JOAN HOWARD: THE AMATEUR ARCHAEOLOGIST

So far the case studies in this book have dealt purely with examples of the fine arts—drawings, paintings, photographs, and sculptures—but a story about pillaging cultural heritage is very topical, as such cases are at the forefront of contemporary art criminology. In late 2017, Australian daily newspaper *The West Australian* scooped the story of 95-year-old Joan Howard's collection of objects that she'd amassed from archaeological digs, undertaken during the 1960s in the Middle East. The story's accompanying photograph depicted a smiling Howard, at her Perth home, surrounded by her spoils. She holds a mask from Sakkara (also known as Saqqara), the ancient burial ground at Memphis, Egypt. Howard, well-coifed and attired, wears white cotton gloves to hold the ancient mask, just like a museum professional would to avoid letting natural oils from hands get onto the object. The photograph is a double portrait—the amateur archaeologist and burial mask—in which Howard looks very proud and comfortable with her treasure (see Fig. 6.3). It was hard to fathom what was worse, the cavalier attitude presented in the story, the accompanying photograph of Howard, or that she found it acceptable to remove a large number of objects from countries she was a guest in and take them

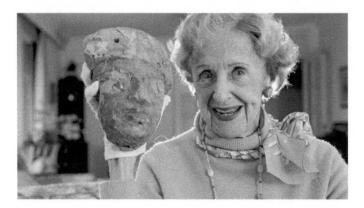

Fig. 6.3 Real life tomb raider Joan Howard pictured with a mummy mask she found at Sakkara, the ancient burial ground serving as the necropolis for the ancient Egyptian capital Memphis (*Photographer* Steve Ferrier *The West Australian*, 5 November 2017)

home to Australia. Needless to say the story went viral, especially raising the hackles of archaeologists.

Married to Keith Howard, a World War II veteran who later served as an Australian diplomat for the United Nations during the late 1960s, Howard accompanied her husband abroad and through his diplomatic connections visited Syria, Egypt, Lebanon, Jordan, Palestine, and Israel. Howard's hobby was searching for antiquities and she was very successful in her pursuit; diplomatic freedom granted her eleven years of access to archaeological sites.

Fast forward to 2017 and Howard, who regaled her stories to *The West Australian*, was lampooned through the media by archaeologists and others who raised the issue that this was a delicate and internationally sensitive situation. Howard told her story giving vivid accounts of crawling through tombs amongst scorpions and filling buckets with treasure. At the time, the media went into a frenzy about her collection claiming it was worth AUD$1M. Often such figures are only estimates, but in this case it could well be a more educated guess as Howard, having sold some of her treasures, would have had a level of awareness of their market values for some works at least. But it's the cultural value that is more significant in this case.

In New York's Christie's Ancient Jewelry (sale no. 2770) auction of 5 December 2012, Howard put up three items for sale: a necklace dating from the first century BC and two rings, one Egyptian dated *c.*94–924 BC and a Roman Red Jasper Ringstone from the second to third centuries AD. Each lot sold, totalling USD $10,375.[38] Significant is the wording relating to the objects' provenances:

Lot 315: A WESTERN ASIATIC BANDED AGATE AND GOLD BEAD NECKLACE CIRCA 1ST MILLENNIUM B.C.
 Provenance: Mrs Joan Howard, Lebanon and brought to Australia, late 1960s.
Lot 345: AN EGYPTIAN STEATITE SCARAB THIRD INTERMEDIATE PERIOD, DYNASTY XXII, REIGN OF SHOSHENQ I, 945–924 B.C.

> Provenance: Colonel Keith Howard (Australian Army and Chief of Staff for the United Nations Truce Supervision Organization) and Mrs Joan Howard acquired in Egypt and brought to Australia, *c.*1967.
> Lot 427: A ROMAN RED JASPER RINGSTONE, CIRCA 2ND–3RD CENTURY A.D.
> Provenance: Colonel Keith Howard (Australian Army and Chief of Staff for the United Nations Truce Supervision Organization) and Mrs Joan Howard acquired in Lebanon and brought to Australia *c.*1967. Property from an Australian Private Collection.

Though Christie's provided the provenance for each piece, it doesn't make it right either legally, morally, or ethically. The objects collected didn't belong to Howard—though she thinks differently—and arguably she had no right to sell them. Many have strongly suggested that the items should have been returned to their country of origin, rather than being sold. And those who purchased them should be aware of how and where the objects were obtained.

Given Howard 'collected' in the 1960s, some might see that her behaviour was acceptable within the context of the era. There certainly wasn't the awareness of pillaging cultural property that there is nowadays, and Howard saw it all as an adventurous hobby. Given that wives of diplomats and military personnel on international tours of duty were unable to undertake paid employment at that time, they were often on the lookout for activities to fill their time (and many had staff to assist them with domestic chores, freeing up even more time). 'Tomb raiding' seems like one of the more interesting and exotic pursuits to follow. Interestingly, Howard kept relatively quiet about her hobby. When asked why, she replied, 'You don't go around saying "I've been in a tomb".'[39] But the reader gets the sense that Howard has little remorse or appreciation of her inappropriate behaviour. She went on to comment, 'It was all good fun. Dirty work, of course. But as it turned out, very, very rewarding.'[40] By all accounts—and to the anger of many irate readers—Howard enjoyed telling her story that was somewhat glorified with the photography chosen to accompany the story. It depicts a mature Howard, in her Perth home, amongst her treasures wearing an expression of great pride.

In 1970 UNESCO adopted a convention that prohibited and pre-vented the illicit import, export, and trade in cultural artefacts. Australi-a's 1986 Protection of Movable Cultural Heritage Act ensures that for-eign cultural property is returned to its country of origin, if it has been imported illegally. The depth of feeling about Howard's collecting spree led to the presentation of a petition to the Department of Communica-tion and the Arts, Australian Government. It stated:

> It is not acceptable that Mrs. Howard behaved as a pirate and appropriated from the different archaeological sites. Mrs. Howard has broken all possible laws taking advantage of her diplomatic status. ... The celebratory tone of the article of her boasting on the destruction of archaeological sites sends a very negative image.[41]

By late November 2017, 500 people had signed the petition. And even if Howard collected the artefacts when it was not illegal to do so, on ethical grounds alone, her actions are now viewed as wrong and cultur-ally insensitive. Globally we are now seeing active repatriation of objects demonstrating a real shift in ethics and collection policies. Perceivably she has done little to remedy the situation since making the situation worse. She did gift a small number of objects to the West Australian Museum in Perth. These included cranial fragments, thirty fragments of an amphora from a Palestinian site [JH2010-01], a single-handed bowl/cup broken into nine pieces dating from the Jordanian Early Bronze Age [JH2010-02], plus four other pottery fragments from an unidentified piece. These objects, or rather fragments of objects, were accepted into the Museum's collection more as an exercise in conservation and possible reconstruction than for their intrinsic historic and archaeological values.[42]

In particular, members of the archaeological community were quick to judge Howard's actions. In an open letter to *The Western Australian*, dated 8 November 2017, Lara Lamb the president of the Australian Archaeological Association made several valid points. Firstly, she noted her disappointment at the newspaper for valorising Howard's collecting activities, and secondly, she outlined the laws that were in existence when Howard was collecting, which forbade hobbyists collecting ad hoc.

In Howard's defence, she had provided some evidence to quell accu-sations made in 2017. In 2011 she had penned an article for the Roman Archaeological Group's (RAG) journal.[43] In it she describes how she became involved in the digs and more significantly, how she acquired the

many artefacts that she showcased to *The West Australian*. Archaeologist and petition organiser Monica Hanna said Howard's digs were not authorised by any educational institution, nor given permission from Egyptian or other Arab authorities.[44] Hanna accused Howard of outright cultural theft.[45] Yet Howard discusses just how she came to be on various digs:

> While I was living in Damascus it was possible for me to attend Prof. J. B. Pritchard's 'dig' in Lebanon, travel from Egypt to Caesarea where Dr. Bull was working and to move from Tiberias on the Sea of Galilee to Samaria where Sydney University's (John) Basil Hennessy was with the British School. My studies were at the Albright Institute in Jerusalem, the Beirut Archaeological Museum, the libraries of the Jordanian Rockefeller Archaeological Museum and I attended lectures given by Jerome Murphy-O'Connor, OP, from École Biblique in Jerusalem.[46]

The RAG article is illustrated showcasing Howard's collection and significantly, she discusses just how she came to collect the artefacts:

> When the official excavations were completed the treasures discovered were dispersed as follows: The host country had first choice, and I guess it took at least half of the finds; the Institution, University of Archaeological School financing the project, had second choice; and the professional digging team had third choice. Volunteers, such as I, were given an item or two from what was left and these items were gratefully received.[47]

Furthermore, Howard notes that having found objects at the site of the 1923 excavation left by Frenchman Pierre Montet (1885–1966), she checked with the Beirut Museum who gave her permission to keep some of her finds. As noted above, other pieces were later gifted to the Museum of Western Australia, Perth. In 1967 the Egyptian Museum in Cairo was selling off small items including mummy masks and Howard purchased items to add to her collection. The RAG article presents a different perspective about the formation of Howard's collection. Times have changed, laws have been introduced, but I suspect there were others who enjoyed the same kind of collecting opportunities, and perhaps on a bigger scale, as Howard did.

Howard's revelation won her the moniker of 'Indiana Joan Tomb Raider' and yet her collection should be considered minor when compared with the much bigger problem of current-day looting in Syria and

Iraq for instance, or the on-selling of major ancient artefacts through auction houses, including Western museums who decide to de-accession parts of their collections. A case in point—in 2014 England's Northampton Borough Council sold an ancient Egyptian statue, *Sekhemka*, dating from 2400 BC. It sold at Christie's for a record-breaking £15.8M to an anonymous American collector. A huge backlash ensued about the sale, angering many. *Sekhemka* was gifted in 1880 but in 2012 the Council became aware of its potential monetary value. The funds from the sale—after being divided between Lord Northampton and Christie's—were to be invested back into the Council's art gallery and museum. However, one possibly unforeseen disadvantage of this was that Northampton Museums lost their accreditation with Arts Council England as a punishment for selling the work, many thinking the piece should have been repatriated to Egypt. In the big picture, Howard's collection is relatively minor and although it does not make it right by contemporary thinking, it should be considered within the broader context of the plundering of cultural heritage over time, past and present.

THE BABY JESUS

An objective for my research has been to explore patterns of gender and art crimes. One, though slightly quirky and proving that nothing is sacred, is the cases of women who steal representatives of the Baby Jesus from Christmas Nativity scenes. Further research revealed not only a Wikipedia site dedicated to the theft of Baby Jesus's but that it is a theft that has broader motivational factors beyond pranksters (usually men or teenagers), who are responsible for many of them disappearing and reappearing in less appropriate locations. In addition, and perhaps adding to the challenge, is the window of opportunity for stealing a Baby Jesuses, which is traditionally limited to the month of December.

On Christmas Eve 2017, a 21-year-old woman, carrying a Baby Jesus that had gone missing from a Nativity Scene at a park in Wisconsin, was arrested for theft. Her name was not released. The statue was a replacement one for another dating from the 1960s that was vandalised a week earlier. Another case in 2016 named the thief as 49-year-old Jacqueline Ross who stole a Baby Jesus valued at USD$2700 from the Bethlehem City Hall Plaza, Pennsylvania, and then took it to St Luke's Anderson Hospital with a note inscribed with, 'Jesus neglected by parents Joseph and Mary Christ'. She deposited the statue in a safe area for unwanted

babies. A condition of Ross' USD$30K bail was to undergo psychiatric evaluation. The statue was repaired quickly—due to Christmas rapidly approaching—and returned to the Nativity Scene.

A more high-profile theft occurred during Christmas 2017. The offender was Ukranian, Alisa Vinogradova. Topless, she entered the Nativity Scene area at St Peter's Square at Vatican City and attempted to grab the Baby Jesus from his crib. Security personnel intercepted her. As she made her way for the Baby Jesus she shouted 'God is Woman', the words were also blazoned across her back. Vinogradova is a member of the Ukrainian feminist group, FEMEN, and their objective was 'to highlight the Vatican's "infringement of the rights of women to their own bodies"'.[48] Three years earlier, on Christmas Day 2014, another FEMEN member made a similar attempt at the Vatican. Iana Aleksandrovna Azhdanova ran into the Nativity Scene grabbing the Baby Jesus. Topless and with the words 'God is Woman' written on her chest, she was stopped by security as she ran off with the statue. But unlike the myriad of pranksters who annually help themselves to Baby Jesus's the FEMEN activists had their motives (the group have also vandalised artworks in protest on occasion). Their attacks have the potential to completely rob the Nativity Scene of its central figure or inflict damage; during the 2017 attempt, Baby Jesus's halo was separated from his head. Arguably, some might suggest that Baby Jesus statues are easily replaced but this doesn't discount the intent to steal and that often it is a community organisation that has gone to the effort to set up the Nativity display, or that in some instances the Nativity figurines are part of a church's collection. In March 2018, a ceramic Baby Jesus in his manger was returned to Our Lady of Grace Church, Hoboken, New Jersey. He arrived completely anonymously, out of the blue, with the following message attached:

> My Mom told me that the Baby Jesus had been stolen from the church Nativity display at Our Lady of Grace when she was a young girl of about twelve years of age in the early 1930s. It came into her father's possession somehow, and I don't know why he didn't return it. Instead, he gave it to my Mother after she was married, and she too kept it until her passing when it came to me.[49]

Though it is unknown who committed the original theft, clearly as stated in the message, a woman had held onto it for years, even though she knew where it belonged. Only slightly damaged, the work had survived

its long-term leave of absence. Churches, where funds permit, continually try to step up security as they have a long history of being the target for thieves. As *Time* magazine reported in late 2015, given the spate of thefts, some churches now have less valuable decoy Jesus statues on display with the more valuable ones securely locked away.[50]

This chapter has focussed on theft—the motives, culprits, and successes. However, as with all narratives about art theft and crime, consideration should be given to the proportion of works recovered. Measuring this is complex; it is a given that many art thefts are not recorded for fear of copycat thefts. Some thefts are kept quiet in order to not draw attention to vulnerable collections, or not wanting to attract attention if there's any doubt about the work's provenance. In the age of stories going viral on the Internet, which can have positive outcomes for art crimes, the fear of copycat art crimes is far greater. With that in mind, the FBI estimates fewer than 10% of stolen works are recovered, with successful prosecution of thieves being even fewer.[51] As so few works are recovered, when it does happen it is newsworthy. The curious case, with a happy ending, of the return of de Kooning's painting *Woman-Ochre* in 2017 is detailed above. Another case involves a mysterious woman who posted USD$105K worth of stolen art back to the MOMA PS1 in late 2017.[52] Captured on surveillance camera, the woman was seen buying a postal tube to post the gelatin-silver photographs back to the art museum. The photographs were the work of Alex V. Sobolewski and depicted Carolee Schneemann's (1939–2019) nude performance art. Stolen from the exhibition, *Carolee Schneemann: Kinetic Painting*, the theft was reported on 30 October 2017. There was no sign of a break- in nor had the alarm sounded. Four days later they were returned, without explanation and in excellent condition. In another case, 56-year-old Carrie Hague, who stole a painting by John Gnatek of an ice cream parlour titled *Tasty Top*, from the Nash Gallery, Massachusetts in early 2018, was caught on surveillance video and apprehended. The painting was recovered and Hague charged with larceny from a building. But more often than not, artworks are not recovered. Entire books contain catalogues of lost art.[53] Even with sophisticated security surveillance and alarm systems in place, theft continues to occur.

Theft is not always about greed and monetary gain. From political motivations, to having a fetish for one particular artwork that the thief simply cannot live without, reasons are various when it comes to art theft.

Motives have not been itemised as gender specific, but art crime writing has traditionally been more focussed on men. Criminologist Thomas D. Bazley notes that the primary motivation for art theft is the lure of money.[54] However, of the examples presented here, only Bautista and Watson were intent on profiteering financially.

NOTES

1. Conklin John, *Art Crime*, Westport, CT: Praeger, 1994, p. 128.
2. Licence Number 1661, Home Office and Prison Commission, National Archives, Kew, London.
3. Lucy Williams, *Wayward Women: Female Offending in Victorian England*, Barnsley: Pen and Sword, 2016.
4. Lucy Williams, 'University Hopes to Solve 30-Year-Old Mystery of Missing Painting; University of Arizona Resurrects Appeal to Witnesses to Help Recover Willem de Kooning's "Woman-Ochre" Stolen in 1985', *The Telegraph*, 28 November 2015.
5. Antonia Farzan, 'The Mystery of a Small-Town Couple Who Left Behind a Stolen Painting Worth Over $100m', *Independent*, 4 August 2018.
6. Lorena Muñoz-Alonso, 'Spanish Police Arrest Collector's Disgruntled Employee for Alleged Basquiat Theft in Mallorca', *artnet news*, 1 August 2017.
7. Gareth McKeown, 'Co Antrim Doctor Admits Theft of Steve McQueen Portrait from Belfast Hotel', *Irish News*, 23 October 2016.
8. Gail Walker, 'GP Jill Purce Who Stole Steve McQueen Photo Doesn't Deserve to be Laughing Stock', *Belfast Telegraph*, 25 October 2016.
9. 'From Aquino's Assassination to People's Power', Federal Research Division of the Library of Congress, http://countrystudies.us/philippines/29.htm, retrieved 2 March 2016.
10. Howard Kurtz, 'U.S. Jury Clears Marcos in Fraud Case', *The Washington Post*, 3 July 1990.
11. Myles A. Garcia, *Thirty Years Later … Catching Up with the Marcos-Era Crimes*, eBooklt.com, 2016.
12. United State District Court Southern District of New York, filed 29 March 2018.
13. Rebecca Rosenberg, 'Former Philippines First Lady's Ex-secretary Sentenced for Monet Theft', *New York Post*, 13 January 2014.
14. United State District Court Southern District of New York, filed 29 March 2018, p. 10.
15. Oliver Holmes, 'Imelda Marcos Loses Legal Battle to Reclaim Confiscated Jewellery', *Guardian*, 14 February 2017.
16. Jason Gutierrez, 'Imelda Marcos Is Sentenced to Decades in Prison for Corruption', *The New York Times*, 9 November 2018.

17. *Here Lies Love* was a music album in the first instance, dating from 2010.
18. https://news.artnet.com/market/imelda-marcos-art-christies-1394818.
19. Simon Trump, 'The Cotswolds Conwoman Who Stole a Picasso: She Looked Perfect—Ads in *The Lady*, a Charming Manner and Immaculate References. But as Her Well-to-Do Victims Now Reveal, She Was a Brazen Thief Who Stopped at Nothing', *The Mail on Sunday*, 9 May 2015.
20. Simon Morris, 'Housekeeper Jailed for Stealing Antiques and Artwork from Employer', *Guardian*, 7 May 2015.
21. Modern British & Irish Art Evening Sale, Christie's, London, 25 June 2014, Lot 8, Sale 1543.
22. Modern British & Irish Art Evening Sale, Christie's, London, 26 June 2017, Lot 13, Sale 13295.
23. Rob Cooper, 'Picasso Is the Most Stolen Artist in the World with More Than 1,000 of His Pieces of Work Missing', *Daily Mail Australia*, 28 January 2012.
24. Simon Morris, 'Housekeeper Jailed for Stealing Antiques and Artwork from Employer', *Guardian*, 7 May 2015.
25. Roland Arkell, 'Judge Praises Trade's Role in Sting Operation', *Antiques Trade Gazette*, https://www.antiquestradegazette.com/news/2015/judge-praises-trades-role-in-sting-operation.
26. Roland Arkell, 'Judge Praises Trade's Role in Sting Operation', *Antiques Trade Gazette*, https://www.antiquestradegazette.com/news/2015/judge-praises-trades-role-in-sting-operation.
27. Simon Morris, 'Housekeeper Jailed for Stealing Antiques and Artwork from Employer', *Guardian*, 7 May 2015.
28. Andrew O'Connor, 'A Note on the Beit Vermeer', *The Burlington Magazine*, Vol. 119, No. 889, April 1977, p. 275.
29. Matthew Hart, *The Irish Game: A True Story of Crime and Art*, London: Chatto & Windus, 2004, p. 11.
30. Derek Brown, 'The English Lady and the IRA', *Guardian*, 26 June 1974, p. 13.
31. Andrew O'Connor, 'A Note on the Beit Vermeer', *The Burlington Magazine*, Vol. 119, No. 889, April 1977, p. 272 and p. 275.
32. Andrew O'Connor, 'A Note on the Beit Vermeer', *The Burlington Magazine*, Vol. 119, No. 889, April 1977, p. 275.
33. Matthew Hart, *The Irish Game: A True Story of Crime and Art*, London: Chatto & Windus, 2004, pp. 37–38.
34. Andrew O'Connor, 'A Note on the Beit Vermeer', *The Burlington Magazine*, Vol. 119, No. 889, April 1977, p. 275.
35. Anthony M. Amore and Tom Mashberg, *Stealing Rembrandts: The Untold Stories of Notorious Art Heists*, New York: Palgrave Macmillan, 2011, p. 23.

36. Security remained an issue for Russborough. In 2005 the Russborough County Wicklow Conservation Plan made the following suggestion: *A comprehensive review of security measures for the house and collections should be undertaken in collaboration with the National Gallery of Ireland. This should achieve levels of security that would allow loans of other collections to Russborough, as well as enhancing the security of the Beit Collection*, The Heritage Council of Ireland, p. 86.
37. Thomas D. Bazley, *Crimes of the Art World*, Santa Barbara, CA: Praeger, 2010, p. 51.
38. Hammer price plus buyer's premium.
39. Joseph Catanzaro, 'Indiana Joan: Meet WA's Real Life Tomb Raider, 95-Year-Old Joan Howard', *The West Australian*, 5 November 2017.
40. Joseph Catanzaro, 'Indiana Joan: Meet WA's Real Life Tomb Raider, 95-Year-Old Joan Howard', *The West Australian*, 5 November 2017.
41. 'Call for an Investigation Over Joan Howard's Illicit Antiquities' Collection', 9 November 2017, https://www.gopetition.com/signatures/call-for-an-investigation-over-joan-howards-illicit-antiquities-collection.html.
42. Electronic communication to author from Dr Moya Smith, Museum of Western Australia, 26 August 2018.
43. Joan Howard, 'How an Archaeological Collection Happened', *Roman Archaeology Group*, Vol. 6, No. 1, March 2011, pp. 2–4.
44. https://www.smh.com.au/world/95yearold-australian-indiana-joan-accused-of-looting-antiquities-from-egypt-20171121-gzq5fe.html.
45. https://www.smh.com.au/world/95yearold-australian-indiana-joan-accused-of-looting-antiquities-from-egypt-20171121-gzq5fe.html.
46. Joan Howard, 'How an Archaeological Collection Happened', *Roman Archaeology Group*, Vol. 6, No. 1, March 2011, p. 2.
47. Joan Howard, 'How an Archaeological Collection Happened', *Roman Archaeology Group*, Vol. 6, No. 1, March 2011, p. 2.
48. Spencer Feingold, 'Topless Protester Tries to Grab Baby Jesus Figure at Vatican', *CNN*, 26 December 2017.
49. Douglas Ernst, 'Jesus Statue Stolen from Church's Nativity Display Almost 90 Years Ago Returned', *The Washington Post*, 16 March 2018.
50. Maya Rhodan, 'Another Christmas, Another String of Baby Jesus Thefts', *TIME Magazine*, 29 December 2015.
51. Kris Hollington, 'After Drugs and Guns, Art Theft Is the Biggest Criminal Enterprise in the World', *Newsweek*, 22 August 2014.
52. MOMA PS1 is an exhibition space showcasing experimental and cutting edge contemporary art and is located at Long Island, Queens, New York.
53. See Simon Houpt, *Museum of the Missing: The History of Art Theft*, New York: Sterling, 2006; Noah Charney, *The Museum of Lost Art*, London: Phaidon, 2018.

54. Thomas D. Bazley, *Crimes of the Art World*, Santa Barbara, CA: Praeger, 2010, p. 37.

SELECTED BIBLIOGRAPHY

Amore, Anthony M. and Tom Mashberg. *Stealing Rembrandts: The Untold Stories of Notorious Art Heists*. New York: Palgrave Macmillan, 2011.

Arkell, Roland. 'Judge Praises Trade's Role in Sting Operation'. *Antiques Trade Gazette*. https://www.antiquestradegazette.com/news/2015/judge-praises-trades-role-in-sting-operation.

Bazley, Thomas D. *Crimes of the Art World*. Santa Barbara, CA: Praeger, 2010.

Brown, Derek. 'The English Lady and the IRA'. *Guardian*, 26 June 1974, p. 13.

Catanzaro, Joseph. 'Indiana Joan: Meet WA's Real Life Tomb Raider, 95-Year-Old Joan Howard'. *The West Australian*, 5 November 2017.

Charney, Noah. *The Museum of Lost Art*. London: Phaidon, 2018.

Conklin, John. *Art Crime*. Westport, CT: Praeger, 1994.

Cooper, Rob. 'Picasso Is the Most Stolen Artist in the World with More Than 1,000 of His Pieces of Work Missing'. *Daily Mail Australia*, 28 January 2012.

Ernst, Douglas. 'Jesus Statue Stolen from Church's Nativity Display Almost 90 Years Ago Returned'. *The Washington Post*, 16 March 2018.

Farzan, Antonia. 'The Mystery of a Small-Town Couple Who Left Behind a Stolen Painting Worth Over $100m'. *Independent*, 4 August 2018.

Feingold, Spencer. 'Topless Protester Tries to Grab Baby Jesus Figure at Vatican'. *CNN*, 26 December 2017.

Garcia, Myles A. *Thirty Years Later ... Catching Up with the Marcos-Era Crimes*. eBooklt.com, 2016.

Hart, Matthew. *The Irish Game: A True Story of Crime and Art*. London: Chatto & Windus, 2004.

Hollington, Kris. 'After Drugs and Guns, Art Theft Is the Biggest Criminal Enterprise in the World'. *Newsweek*, 22 August 2014.

Holmes, Oliver. 'Imelda Marcos Loses Legal Battle to Reclaim Confiscated Jewellery'. *Guardian*, 14 February 2017.

Houpt, Simon. *Museum of the Missing: The History of Art Theft*. New York: Sterling, 2006.

Howard, Joan. 'How an Archaeological Collection Happened'. *Roman Archaeological Group*, Vol. 6, No. 1, March 2011, pp. 2–4.

Kurtz, Howard. 'U.S. Jury Clears Marcos in Fraud Case'. *The Washington Post*, 3 July 1990.

McKeown, Gareth. 'Co Antrim Doctor Admits Theft of Steve McQueen Portrait from Belfast Hotel'. *Irish News*, 23 October 2016.

Morris, Simon. 'Housekeeper Jailed for Stealing Antiques and Artwork from employer'. *Guardian*, 7 May 2015.

Muñoz-Alonso, Lorena. 'Spanish Police Arrest Collector's Disgruntled Employee for Alleged Basquiat Theft in Mallorca'. *artnet news*, 1 August 2017.

Nairne, Sandy. *Art Theft and the Case of the Stolen Turners*. London: Reaktion Books, 2011.

O'Connor, Andrew. 'A Note on the Beit Vermeer'. *The Burlington Magazine*, Vol. 119, No. 889, April 1977, p. 275.

Rhodan, Maya. 'Another Christmas, Another String of Baby Jesus Thefts'. *TIME Magazine*, 29 December 2015.

Trump, Simon. 'The Cotswolds Conwoman Who Stole a Picasso: She Looked Perfect—Ads in *The Lady*, a Charming Manner and Immaculate References. But as Her Well-to-Do Victims Now Reveal, She Was a Brazen Thief Who Stopped at Nothing'. *The Mail on Sunday*, 9 May 2015.

Trump, Simon. 'University Hopes to Solve 30-Year-Old Mystery of Missing Painting University of Arizona Resurrects Appeal to Witnesses to Help Recover Willem de Kooning's "Woman-Ochre" Stolen in 1985'. *The Telegraph*, 28 November 2015.

Walker, Gail. 'GP Jill Purce Who Stole Steve McQueen Photo Doesn't Deserve to Be Laughing Stock'. *Belfast Telegraph*, 25 October 2016.

Williams, Lucy. *Wayward Women: Female Offending in Victorian England*. Barnsley: Pen and Sword, 2016.

Naming Rights

There are obstacles that make studying the history of women's art different from the traditional male-centric one. One of those obstacles is the name of artists. Traditionally women changed their names upon marriage. In the case of artist couples, the woman often lost her own sense of identity by taking on her husband's name. There are however other reasons for taking on a different name. Similarly, female writers in a bid to be published and/or taken more seriously have changed their names from the feminine to the masculine. George Eliot was Mary Ann Evans. The Brontë sisters became Currer, Ellis, and Acton Bell. Amantine Lucile Aurore Dupin was better known as George Sand. More recently, Harry Potter author Joanne Rowling is known as J. K. Rowling, deliberating not providing her first name in an effort to attract more boys to read her books. Though more popular, name changing is not exclusive to women; for instance Scottish novelist Emma Blair who penned twenty-nine romance books, was actually Iain Blair. The decision to use the name Emma Blair was made by his publisher, for evidence demonstrated greater sales, especially true in the 1980s, would be made if the writer were a female. Iain Blair managed to keep this a secret until he was nominated for the Romantic Novel of the Year in 1998 and felt he had to come clean. Using a different name is at the core of this chapter, which scopes the works of Australian artist Elizabeth Durack and American Margaret Keane. These two artists made and sold works under different names, switching genders, and changing the courses of their artistic careers. But

© The Author(s) 2020
P. Jackson, *Females in the Frame*,
https://doi.org/10.1007/978-3-030-44692-5_7

first, a digression to provide some context of women artists practising under a different name, or as it is sometimes referred to, a *nom de brush*.

Throughout the history of women's art, name changing has played different roles, for the most part without criminal intent. Given the low profile female artists took in a patriarchal-dominated profession, women took on masculine names to try to enjoy the same exhibiting and selling rights as their male counterparts. There is a beautiful painting that I have long admired in the collection of the Christchurch Art Gallery Te Puna o Waiwhetu, New Zealand, titled *La Lecture de la Bible* (1857) painted by French artist, Henriette Browne (1829–1901). The painting depicts two sisters who have just returned from church, sitting at a table with their Bible open, deep in contemplation. In the tradition of academic realism, Browne brings together a double portrait study with elements of the still life in this superb example of genre painting. As an undergraduate student I was blown away that it was the work of a woman artist—and possibly the first we had been exposed to in three years of study—but also discovering that Henriette Browne's real name was Sophie de Bouteiller. In 1853 de Bouteiller adopted the pseudonym Henriette Browne, the name of her maternal grandmother, in order to keep her professional artistic life separate from her domestic and personal life. Painting was not considered ladylike for a woman of her social standing. Furthermore, for someone of de Bouteiller's social standing (her husband was a foreign diplomat) having an artistic career was not seen as appropriate. It is hard to reconcile in the twenty-first century that Browne felt so compelled to consciously change her painting name, especially given her talent as an artist, for her work is represented in major public collections including the Tate Britain and the Victoria and Albert Museum. In addition she was a founding member of the Société National des Beaux-Arts, Paris, in 1862.

Perhaps ahead of her time, New Zealand artist, Helen Crabb (1891–1972) signed her work 'Barc'.[1] Almost, and intentionally meant to be, an anagram of Crabb, it seems more than likely that she wanted to be genderless; in other words, she did not want viewers to judge her work on the grounds of gender. A forthright character, 'Barc' enjoyed a long artistic career in New Zealand and Australia. Without the restrictions of marriage—something many of her contemporaries experienced—she was a great champion of the female artist. Perhaps the title of her biography goes some way to describe the kind of tough art teacher she was, *Sit There and Draw That!*

In America, Abstract Expressionist Lenore Krassner (1908–1984) struggled with being labelled 'Mrs Jackson Pollock'. An artist in her own right, during the 1940s and 1950s she either did not sign her work at all, signed it with her initials 'LK', or surreptitiously blended her signature into the painting, making it too difficult to read. Krassner wanted to be her own person, her own artist, and not to be judged within the context of her husband's work.

And lastly, Grace Hartigan (1922–2008), a second-generation American Abstract Expressionist painter, made the decision to go by the name of George Hartigan during the 1950s. Hartigan believed that by taking a masculine name she would not only be taken more seriously as an artist but would achieve greater recognition. Perhaps difficult to measure, one can only conclude that her situation must have been unsatisfactory to warrant such a change. And so switching genders and taking on another name isn't all that uncommon. But when an artist changes their name in an effort to deceive their audiences, this is fraudulent.

ELIZABETH DURACK: AKA EDDIE BURRUP

Researching the substantial Elizabeth Durack archives at the State Library of Western Australia, Perth, I came to two conclusions very early on. Firstly, Elizabeth Durack (1915–2000) enjoyed a long artistic career that included an impressive exhibiting history with much critical attention—not just in her homeland of Western Australia, but across Australia and offshore, including London. Secondly, Durack had a long-established history with, and understanding of, Australia's indigenous people, the Aborigine. Nowadays, what is perhaps remembered of Durack's career is the deception that brought her to the attention of the wider public during the final decade of her life. After such a long and illustrious career, Durack fouled her own nest by making works under the auspices of an Aborigine artist, Eddie Burrup.

Durack grew up on vast pastoral holdings in Western Australia. After being schooled at Loreto Convent, Perth, she spent 1936 studying art in London at Chelsea Polytechnic. Durack went on to enjoy an outstanding artistic career, despite the obstacles of being a woman and living in regional Australia, which was very much distanced from the major artistic centres of Sydney and Melbourne. Between 1946 and 2000 Durack hosted sixty-five solo exhibitions, as well as group exhibitions, alongside being a published author. Her repertoire included illustration work (she

published children's books along with her sister Mary Durack (1913–1994)[2] and Australian takes on more traditional subject matter such as the painting, *Broome Madonna* (1946), depicting an Aboriginal Madonna. A high point for Durack's career was exhibiting alongside fellow great Australian artists such as Sidney Nolan and Brett Whiteley in the 1961 exhibition, *Recent Australian Painting*, at the Whitechapel Gallery, London. Durack's love of the land and its people—whom she referred to as First Australians—was obvious in her work. From a young age, she established a relationship with the Mirriuwong-Gajerrong people of the Ord River area. She knew their folklore and maintained she understood its significance. Durack's work moved with the times in which she lived; during the 1970s and 1980s her work was imbued with her feeling of pride for the Aboriginal people who remained strong against the adversity of Government policy. Late in her career, Durack developed her work in a new way. Still continuing to challenge herself, her artistic finale known as 'The Eddie Burrup Years', would well and truly mar her life's work and create big ramifications for the Australian artistic community.

London art dealer Rebecca Hossack began her introductory essay for the July 2000 exhibition, held two months after the artist's death, *The Art Of Eddie Burrup*, with this statement:

> In 1997 the Australian art world was shaken by an amazing revelation. The work of the acclaimed aboriginal artist, 'Eddie Burrup', was in fact being produced by Elizabeth Durack, an octogenarian white artist and scion of one of the great pastoralist families of Western Australia.[3]

Hossack went on to justify Durack's deception by describing this lapse as an artistic alter ego. As debate raged, both publicly and within art circles, many disagreed with Hossack's stance.

To give Burrup credibility, Durack invented his life story. Born in 1915 (coincidentally the same year as Durack) at Yandeyarra Station on the Yule River, he grew up in the Pilbara region, attended a convent school, did a couple of stints in prison, and worked as a stockman. From an early age, Burrup enjoyed drawing, in particular Australia's indigenous animals and station life. Durack based Burrup on a combination of at least three real Aboriginal men—Old Jubul, Boxer the Stockman, and Jeffrey Chunuma. Durack knew each man personally.[4] As for his work, Durack described Burrup's style as 'morphological' and being 'concerned with the underlying connections between animate and inanimate forms'.[5]

Durack fabricated Burrup over the summer of 1994–1995. Officially, Burrup came into being in Durack's world on 28 December 1994. On seeing Durack's new work, her gallerist daughter Perpetua[6] suggested her mother's new paintings, were 'sort of Aboriginal'.[7] The date is important as it shows such an intentional and deliberate invention and recording of the event, making it significant in terms of how Burrup's exposure played out subsequently to the art world and media. By January 1995, Burrup's work was on exhibition at Perpetua's dealer gallery in Broome, a small North Western Australia coastal tourist town.[8] When initially exhibiting the work, Perpetua had the foresight not to offer them for sale. However, the gallery's Christmas card the following year depicted one of Burrup's works. Approximately one hundred cards were distributed and interest began to grow in his work. At this time in Australia, Aboriginal art was becoming more respected, attracting serious attention from collectors and scholars.

As Burrup's work gathered momentum he was invited to exhibit at the Tandanya Institute in South Australia. The exhibition, *Native Titled Now*, showed three of Burrup's works in Adelaide during April 1996. Interestingly, in a letter addressed to Perpetua about the Tandanya exhibition, she was asked to sign the enclosed contract.[9] In other words, this was a formal arrangement that required Burrup's signature, so whoever signed the papers acted fraudulently. A few months on saw two Burrup works in Telstra's 13th National Aboriginal and Torres Straight Islander Art Awards, during August to October 1996, in Darwin. Up until this date, none of Burrup's works were for sale. That soon changed though when Durack's brother and his wife, Bill and Noni Durack, minding Perpetua's gallery one day, sold a work inadvertently (though the works were labelled 'Not For Sale' according to the Elizabeth Durack website).[10] More sales followed, with supply meeting demand. However, by September 1996 Perpetua wanted to call an end to the whole business. Clearly she felt uncomfortable with the situation. But Durack was determined to give Burrup one last showing—she decided to enter *The coming of Gudea* (a diptych with each panel measuring 1880 × 920 mm) for The Sir John Sulman Prize.[11]

Perpetua agreed with her mother about the Sulman Prize entry, on the condition that once the exhibition was over she would offer to buy back all the sold Burrup works and that Durack would come clean about Burrup. Durack agreed to these conditions, putting a strategy in place; she went about entering *The coming of Gudea* but 'once alerted to the

repercussions of selecting a painting by Eddie Burrup, it was not diffi-
cult for the sole Sulman judge to drop the Burrup entry'.[12] The scandal
that followed would cast a dark shadow on the prestigious award. Since
1936 the Sulman Prize has been a prestigious award convened by the Art
Gallery of New South Wales, Sydney. The Sulman Prize is awarded to the
best subject painting, genre painting, or mural project by an Australian
artist. The finalists' works are exhibited at the Art Gallery of New South
Wales.[13] In other words, this is a worthy and serious annual event on
the visual arts calendar for Australia. Timing was all part of the plan; the
Sulman Prize was to be Burrup's swansong.

To make the announcement that Durack and Burrup were the same
person, Durack engaged Robert Smith—arts commentator and regular
contributor to *Art Monthly Australia* magazine, to break the story. *Art
Monthly Australia* is a well-read and respected quarterly art journal, with
perhaps the largest readership of an Australian art magazine at that time.
Smith spent time with Durack at her studio where she presented him
with her story, which must have put him in a precarious situation. Though
apparently not totally surprised, he wrote up the story for the March issue
1997.[14] Durack was totally unprepared for the fallout that followed and
yet she went on to exhibit Burrup's work through to the year 2000, when
Durack died (as did Burrup, I guess).

As an aside, it's a given that an artwork is only as good as its prove-
nance or back-story. The best artists involved in fraudulent ways never get
caught because they build a watertight case for the work. Durack cleverly
helped authenticate the Burrup works through the power of language;
works would often be embellished with the origin of the subject in col-
loquial Aboriginal-speak, including *The coming of the Gude*a, that came
with an eight-lined poem, referred to as Eddie's title.[15]

Some might argue that this was part of the work, intrinsic to its mean-
ing. Others would suggest that Durack was trying to give the work artistic
and cultural significance, to authentic its origins, to convince its audience
of its truly Aboriginal roots.

After Durack's death in May 2000 the exhibition 'The Art of Eddie
Burrup' revived interest in the imaginary artist. Hossack, on ABC news,
suggested that the exhibition was useful in opening up conversations
about 'black and white Australia'.[16] The exhibition, opened by David
Ritchie, the Acting High Commissioner for Australia, placed so-called
Aboriginal art in quite a foreign context, an upmarket London dealer
gallery. Indigenous Australian writer Herb Wharton (b. 1936) who

attended the opening, noted on camera that the paintings were far from being about 'dreaming', but rather were a 'nightmare'.[17] And so Durack's last artistic flourish became as much about politics as it was about art and deception.

Durack's plan for admitting that she was Burrup backfired; the revelation was colossal and clearly she had not envisaged the magnitude or the fallout from the announcement. Smith's article, 'The Incarnations of Eddie Burrup', that appeared in *Art Monthly Australia* was eloquent and to the point. He told it as it was; Smith alluded to the fact that though the works of Burrup were a recent addition to the art scene, the idea was much older:

> in about 1975, Elizabeth began producing a series of what she called her 'morphological paintings'. ... Her daughter Perpetua saw that they make more sense in the Aboriginal context.[18]

He goes on to note that it is only since the end of 1994, when Burrup was fully developed, that things got out of hand.[19] In other words, Burrup was well and truly alive and painting prior to his 'coming out'. Smith, with the knowledge of what was going on, quickly shut down any association readers might make with his part in the scam:

> I immediately begin pointing out to her some of the many contentious ideological and ethical issues raised by her invention of Eddie, but she is already well aware of them and anxious to extricate herself from a potentially damaging situation.[20]

Durack did not have to wait long to be ambushed by the art world, Aboriginal word, and media. Opinion was divided and played out in the media. Burrup was out for all to see and Durack was left with egg on her face. Curiously, and naïvely, she could not understand what all the fuss was about. In fact, one almost gets the impression that she was disappointed about having to confess to her misdemeanour:

> At times over the last two—going on three—years since working in direct union with Eddie I have experienced a feeling of tremendous happiness and a sense of deep fulfilment.[21]

For months after the announcement, Durack did not talk about the situation; she said she did not feel the need to speak, or justify her/his

art. And when Durack did eventually explain her morphological works she claimed that saw them as a 'gift' and that too many people misunderstood her. Accordingly, empathy with the land and the people presented itself through Burrup.[22] Posthumously, outspoken British artist and commentator Grayson Perry noted indignation that Durack was criticised for borrowing the special 'otherness' of the Aborigine people. He said Durack was borrowing the power. Grayson went on to question why there was not an outrage of the Aboriginal artist borrowing the power of being a contemporary artist.[23] And it is this very topic that Ian McLean was criticised for not including in his anthology by ninety-six authors about Aboriginal art in *How Aborigines Invented the idea of Contemporary Art.*[24] Clearly Durack was posing as Burrup during a time of complex and intense debate about notions of Aboriginal art and contemporary art, ideology, and its ownership.

The Burrup case is highlighted in a public resource about the correct protocols when working with Indigenous Australian art and artists. In this it is noted that Durack's invention of Burrup was particularly distasteful as there had been direct contact between the Durack Gallery, Doreen Mellor the Indigenous curator, and the presenting gallery Tandanya in Adelaide. The level of deceit around the lack of authenticity was shocking and it concludes by noting that the works were removed from the Adelaide gallery, under the instruction of the curator with television news crews filming the de-installation to witness the event.[25]

Durack may have naïvely thought that the *Art Monthly Australia* article would clear her of any wrongdoing—as perceived by others (as she did not believe she had done wrong)—but it did not. Additionally, she did not stop making works under Burrup's name, which didn't help matters. For example, *Njan Collecting his Followers*, painted in 1998 is signed and inscribed 'EDDIE BURRUP, Njan collecting his followers' on the verso.[26] There is also the question of who owns the copyright if they're signed by an imaginary painter?

The words 'fraud, hoax, imposture' are tough yet they're the ones chosen by Durack's biographer, Brenda Niall, to describe how the artist's invention of Burrup was viewed by others at the time.[27] Clearly, many were appalled by Durack's audacity and ignorance on all kinds of levels. But the big question, within the context of this book, is should Durack be labelled an art criminal? In short, yes. Not only that, but her gallery-owner daughter who played a role in the sales of the Burrup works, could also be labelled as such. Admittedly, blood is thicker than water and Perpetua may well have felt compelled to go along with her mother's artistic

swansong. However, as a gallerist there is also a code of ethics that should be upheld.

Durack maintained that the coming about of Burrup was organic and spiritual; fundamentally she saw nothing wrong with her imaginary artist and those who purchased these works must been seen as supporters—though admittedly some acquisitions were made prior to her coming clean. Durack demonstrated little remorse for her actions and saw herself as the victim. She underestimated people's lack of understanding about how the work evolved spiritually and reflected her love of the land and its people. The fact that Durack went on exhibiting Burrup works up until her death in 2000 demonstrates her lack of remorse or her intention to try to change her situation. In a television interview in 1997, Durack was questioned about the deception of using Burrup to channel her works. She answered, 'there is deception there but I didn't mean to ... the word hoax worries me terribly ... it was a device to get myself liberated'.[28]

Burrup will always be part of Australia's art history—the Internet guarantees this. For instance, a collection search on the Art Gallery of New South Wales' website for Burrup instantly brings up two works by Durack. This can only add to confusion. Generic Internet searches for Durack always bring up the Burrup controversy. Her own dedicated website is informative, including the Burrup works. Durack's name is forever now synonymous with Burrup's. And perhaps, this was initially her intention.

Trying to assess the damage done, or measuring the extent of Burrup's work in private and public collections, is next to impossible. In an ideal world there would be a moratorium for on-selling Burrup works. But that is not the case. In March 2015, Mossgreen, a well-known Australian auction house, offered 120 Durack lots in an exhibition auction ironically marketed as 'A Singular Australian'. Of the 120 lots, fifteen were Burrup works. At least four were signed Eddie Burrup and all fifteen works sold at auction. Clearly, there is still a demand for them. And though Durack's name is usually in the forefront of sales it does not diminish the fact that many of the works made during that phase are signed as Burrup. In some instances, works for sale are labelled Eddie Burrup/Elizabeth Durack, or vice versa, so as to cover anyone purchasing a Burrup unbeknownst to them that he did not exist in the real world. Burrup's signature often appeared in the form of a rock-crab mark, again in a bid to authentic the indigenousness of 'his' work. But the bottom line is that Burrup works are still available and being acquired by those who desire them and therefore

they remain on the open art market. Durack's deception continues to be affirmed and nurtured.

By creating a construct, Durack not only produced fraudulent works but also took on the identity of another person. For many Australians at the time, it was more about ethnicity than about the actual art. One might imagine that if an elderly Aborigine man had taken on the persona of a white female artist then there would also be repercussions. If Durack had stated from the outset that she was using a *nom de brush*, then the reception to her works might not as been so harsh. In hindsight, transparency may have assisted her and legitimised the works. Institutions exhibited works by an artist who did not exist. Such mockery appalled. Artist and academic Professor Ted Snell adamantly suggested:

> Yes it was clearly fraudulent for a non-Indigenous woman to create a false identity for a fictional artist to present the artworks he was purported to have painted to an Indigenous only exhibition.[29]

Furthermore, he notes that the deceit grew deeper when Perpetua offered works up for a commercial exhibition at the well-known Melbourne dealer gallery, Gabrielle Pizzi.[30]

Durack was a prolific artist. We know for instance that early on in her career she painted one hundred works during nine months of 1945, with a young family in tow. Painting was her life and she continued to paint large-scale works up until the end of her life. And so it is hard to get a measure of how many Burrup works she actually made and sold, for their names seem interchangeable. Having any available on the open market is tantamount to fraud; the years in which Burrup painted are now poignantly referred to as The Eddie Burrup Years—an obvious afterthought to get around the illegitimacy of painting under a make-believe name.

For some, the issue was more about Durack's attitude to the indigenous people of Australia. If she loved them so much, as she maintained, and had the great affinity with them as she often claimed, why would she 'use' them in this way? Many of her early works are best labelled as caricatures of the Aborigine and would be scorned today, but were nevertheless typical of their time. Durack's attitude was brazen. Delivering the opening address at *The Art of Eddie Burrup—Glimpses from the Ngarangani* exhibition opening in Broome, Durack said that by revealing her alter ego in *Art Monthly Australia* she had hoped to avoid any possible unfavourable

reaction but somehow this miscarried and what she had aimed to prevent, did happen. She went on to explain that it had taken her four months to come to terms with the situation and to get things on an even keel.[31] There were hints in her speech that made her audience think that she had realised the error of her ways, but when interviewed at the same function by a reporter who asked if she would keep on painting as Burrup, she retorted 'she couldn't help it'.

Durack did not face criminal charges. If her posing as Burrup was fraudulent then why was she not charged for her crimes? Or perhaps no one made a formal complaint? That Perpetua offered to reimburse collectors is an indication that she knew it was a scam. Vendors had trusted the Duracks, who were an old and trusted established Australian family. But the timing was not conducive to such artistic indiscretions. The 1990s saw Australians redressing their history. For well over a century Australians were brought up on what was termed the 'pale, male, celebratory view of Australian history'.[32] In 1992, Prime Minister Paul Keating announced, 'the starting point might be to recognize that the problem starts with us non-Aboriginal Australians'.[33] Lively and useful discussions followed. And it was within this context that Durack introduced Burrup to her beloved Australia. Her appropriation of art that was supposedly Aboriginal was seen by many as a 'colonial' act and couldn't possibly bring indigenous and non-indigenous Australians any closer together. The 1990s also saw revitalised interest in Aboriginal art—both the scholarship of it as well as exhibiting and selling it. As Australian criminologist Ken Polk surmised, with increased demand for Aboriginal art, the opportunity for those who would be tempted to produce and sell faked works increased.[34] Durack was seriously tempted and followed through.

WALTER KEANE: AKA MARGARET KEANE

The 1960s saw prolific and popular artist Walter Keane (1915–2000) enjoying a lavish lifestyle in San Francisco. Thanks to the sales of his paintings of young waif-like children with over-sized eyes and commissioned portraits of celebrities, Keane was able to support an enviable lifestyle. His house rocked to the sound of contemporary music and the swimming pool was often the centre of celebrity parties including guests such as the Beach Boys. Walter Keane was at the height of his artistic career. The buying public could not get enough of his work, so much so that

commercial prints were made of the paintings, making them more available en masse by selling at a reasonable price to all who craved their own KEANE (this is how he signed his works). America in the late 1950s/early 1960s was enjoying the dawn of consumerism. As people built sprawling houses in the suburbs they wanted to fill their walls with 'easy' art. Walter Keane's works could be picked up cheaply as reproductions, suiting those who struggled with the more avant-garde styles of Abstraction and Pop Art.

Walter Keane was, without a doubt, in the right place at the right time. But behind this glamorous lifestyle was Margaret Keane (b. 1927), Walter's second wife, who really was the artist of the ubiquitous 'big eyes' artistic phenomenon. Walter was in fact an amateur artist, with delusions of grandeur. It was Margaret Keane who was the professional artist. As Jon Ronson, of the *Guardian*, described her in 2014:

> She is the last person you'd expect to be a participant in one of the great art frauds of the 20th century.[35]

This unsuspecting nonagenarian was indeed the subject of fraud; unintentionally, and arguably, beyond her control, Margaret Keane was forced into a situation of painting numerous works over a decade, only to have them signed and sold as Walter Keane originals. Years later the truth would emerge, with Walter Keane subsequently shamed by the findings of the Federal Court. This is an unusual case of a female artist forced into artistic submission, who inadvertently became central to a dishonest practice. In many ways, it can be viewed as a form of domestic abuse. But Margaret Keane isn't the only woman whose husband took credit for his wife's work. Famously, French novelist Sidonie-Gabrielle Colette's (1873–1954) first four novels were published under her husband's name, Henry Gauthier-Villars, who retained the copyright and sizeable earnings even after the couple divorced.

Walter Keane's background was in sales, with shoes and real estate being his specialities. But Walter had a hankering, an ambition, to be an artist that saw him taking some lessons in Europe shortly after the end of World War II. The couple married in 1955, having met at an exhibition preview. From the outset their common ground was art. Margaret Keane demonstrated an aptitude for drawing from an early age, going on to complete formal studies at the Watkins Art Institute in Nashville and Traphagen School of Design in New York City. From early in her

career, Margaret Keane's work had a particularly individual look—portraits in which the sitter had large doe-like eyes—that would become in the decades that followed synonymous with the name Keane, and can be likened to being a brand. A great believer in the eyes being the window to one's soul, the over-sized and often sad looking eyes became symbols of vulnerability, with which Margaret Keane was well familiar with especially as time went on.

Walter Keane was a great marketer and quickly saw opportunities for selling Margaret Keane's 'big eyes' paintings—with the gift of the gab, Walter Keane quickly sidelined Margaret Keane to the back room—literally. He was of the belief that it simply made more sense if, when talking up the paintings in a bid to sell them, he posed as the artist. Photographs of him adding the finishing touches to paintings provided context and evidence that he was the artist. And Margaret Keane fell under his spell.

A typical day for Margaret Keane was spent painting for up to sixteen hours. Painting was her love, but it was the context in which it was carried out that made it become an impossible situation. At the couple's home in San Francisco Margaret Keane painted in a locked studio. The home was often abuzz with visitors, and the Keanes kept 'their' artistic role reversal secret, with no one being permitted to see inside her studio. Like the heroine of a Victorian novel, Margaret Keane painted canvas after canvas, locked up in her studio. In 1999, she would describe her situation as being likened to a prisoner's existence.[36] Even the household staff apparently had no idea that Margaret Keane was the one producing the paintings and thus the breadwinner for the family's lavish lifestyle.

Over the course of their decade-long marriage, the 'big eyes' of Margaret Keane's paintings became bigger and sadder but she kept up supplying the demand for her works. Paintings of the Kennedy children, John Junior and Caroline were sent to the White House, for such endorsements continued to promote sales. Walter Keane had no shame; he once boasted at Enrico Banducci's hungry i nightclub on Jackson Street in San Francisco, 'Nobody could paint eyes like El Greco, and nobody can paint eyes like Walter Keane.'[37] Such confidence went a long way to building up his empire and Walter Keane revelled in the fame. Meanwhile Margaret Keane was becoming increasingly unhappy with the deception, which was demonstrated through her work. Years later, Margaret Keane acknowledged that she went along with Walter Keane's claim of being the artist, as he'd threatened to kill both his wife and her daughter Jane Ulbrich

from her first marriage, if she revealed the reality behind what had become iconic images.[38]

For years Walter Keane successfully not only gave the impression that he was the artist of the 'big eyes' paintings but he also signed them as such. Many of the works were signed KEANE © on the front of the painting, others have plaques attached to the centre front of the frame with the same wording, KEANE. The verso of works also provided details of Walter Keane as the artist. On some of the commercial prints—still readily available and now referred to as 'vintage'—the plaques have the work's title and the 'artist', for example, 'No Dogs Allowed/Walter Keane'. And so the public were led to believe that the artist was Walter Keane, who enjoyed the limelight and was often the subject of popular magazine and newspaper articles. *Life Magazine* ran a feature in 1965 titled, 'The Man Who Paints Those Big Eyes: The Phenomenal Success of Walter Keane'. Years later, Walter Keane's daughter, from his first marriage, challenged the intellectual property of the 'big eyes' idea saying that it was her father who had the vision prior to meeting Margaret Keane. Whether he had the idea or not, it was Margaret Keane who executed the paintings and Walter Keane who took the credit for them, which is criminal given they were sold deceitfully. Walter Keane's signing of Margaret Keane's work was fraudulent. That Margaret was part of this deceit can also be viewed as criminal. Margaret Keane must have been aware of the implications but, because of the difficulty this would involve, she chose not to do anything about it until she was in a 'safe' time and place.

Having separated the previous year, the Keanes divorced in 1965. Their decade-long marriage had run its course and Margaret Keane moved on. However, even after the divorce was finalised Margaret continued to paint and send her work for Walter Keane to sell. Needing the financial security, Margaret Keane continued to live the lie. It would have been difficult to expose Walter Keane at this stage without implicating herself, given she was still benefitting from the scam. Relocating to Hawaii, Margaret Keane searched for a new life, well away from the domestic torture she had endured under Walter Keane's regime. Happier, her painting style changed. The sad eyes made way for smiling children in brighter happier environments. Margaret Keane became a Jehovah's Witness and in 1970 remarried, becoming Margaret McGuire. Though she had moved on, at the back of her mind nagged the reality of the dishonest practice of the Walter Keane years.

Perhaps it was her newly discovered freedom that empowered Margaret McGuire to reveal in 1970 that she was the real painter of the 'big eyes', and not Walter Keane. On a Hawaiian radio station, Margaret McGuire stated that she was the painter of the big-eyes phenomenon and not Walter Keane. Needless to say, this big reveal was sensational news and Walter Keane was unprepared for the subsequent backlash, underestimating his former timid wife. To set the record straight, for there were naysayers to the allegation, a solution was offered in the form of a 'paint-out' between Margaret McGuire and Walter Keane in San Francisco's Union Square, organised by a local reporter from the *San Francisco Examiner*, Bill Flang. Walter failed to turn up.

Sixteen years later, in 1986, the *USA Today* magazine claimed that Walter Keane was the real artist. This time, Margaret McGuire was not going to take this dishonest claim lying down and set about to reveal the truth once again. She sued both the magazine and Walter Keane, who represented himself. Margaret McGuire's lawyer, Bart Prom, told the jury that Walter Keane 'bullied' his wife while they were married into letting him claim credit for the paintings.[39] To settle the claim once and for all, during mid-1986 at the Federal Court in Honolulu the judge ordered both 'artists' to paint a big-eyed painting in full view of the courtroom. There would have been few, if any, precedents for such a case. The judge's request can be seen as both creative and definitive. Walter Keane, citing a sore shoulder, declined to paint. Margaret McGuire relished the opportunity and in a record-breaking fifty-three minutes painted a small boy with over-sized eyes. Exhibit 224, as it was labelled, proved she was the artist.[40] The trial had taken just over three weeks and Margaret McGuire was awarded USD$4M for emotional distress and damaged reputation as a result of Walter Keane's continued claims of being the real 'big eyes' artist. In 1990, the Federal Appeals Court upheld the verdict. In reality Margaret McGuire would not see any of the awarded funds, as Walter Keane was penniless by this stage, but ultimately she could claim legal ownership of the big-eyes works and after over two decades, the truth was finally exposed.

Love them or loathe them, Margaret Keane's big-eyes paintings were very much a product of the 1960s. She [he] was criticised at the time for the style of work; when the announcement was made in February 1964 that Walter Keane was the selected artist to paint a large work (*Tomorrow Forever*) for the Hall of Education at the World's Fair (1964–1965), *The New York Times* art critic John Canaday referred to the news as a

'grotesque announcement'.[41] Canaday's scathing review saw *Tomorrow Forever* taken down from exhibition by the World Fair. Others fuelled the demand for Margaret Keane's work. Often bandied about is Andy Warhol's pronouncement, 'I think what Keane has done is just terrific. It has to be good. If it were bad, so many people wouldn't like it.'[42] Regardless of opinion and taste, her work is represented in various public art collections—though in many instances the works were not acquired by institutional purchase but rather by donation (from Walter Keane and other relatives)—and numerous private collections. Her works have been commercially reproduced en masse and merchandised, for example, as

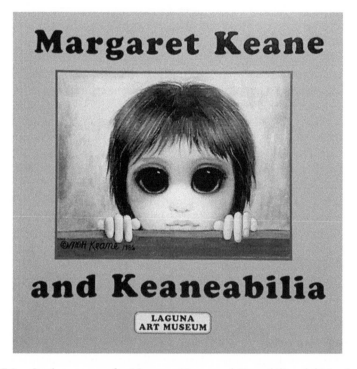

Fig. 7.1 Catalogue cover for *Margaret Keane and Keanabilia* exhibition hosted by the Laguna Art Museum, 2000, depicting Exhibit 224: the painting Margaret Keane painted in court mid-1986 to prove she was the artist of the Big Eyes phenomena (Curated by Tyler Stallings and published by Sympathetic Press)

jigsaws. For several months in 2000, the Laguna Art Museum in Cali-
fornia hosted the exhibition 'Margaret Keane and Keaneabilia'. Exhibit
224 (signed MDH Keane and dated 1986) graced the exhibition cata-
logue's cover (see Fig. 7.1).[43] The message with this choice was clear—
the painting depicting a young boy that Margaret Keane painted in court
removed all doubt about her ability at painting (and telling the truth).
The catalogue's cover art ticked all the boxes in terms of capturing Mar-
garet Keane's oeuvre; it evokes the 1980s era (in which Exhibit 224 was
made) including the Cooper Black font used, the painting is truly repre-
sentative of her signature and quintessential style, and by using Exhibit
224 the Laguna Art Museum brought a key work back into the public
arena. Those big black piercing eyes lure the reader and viewer into the
world of Keanabilia. In short, the cover art was a strategic design. The
exhibition was not only a celebration of the artist's oeuvre but also show-
cased and sold merchandise including dolls and collector plates. Collector
and fan of 'big eyes', Tim Burton, directed the biopic movie, *Big Eyes*
(2014) reviving the Keane case and introducing younger generations to
the wrongs of Walter Keane and the victimisation of Margaret McGuire.
As only to be expected, there were some who came out in defence of Wal-
ter Keane, suggesting that Margaret McGuire was at an advantage, being
alive, and therefore able to present her own story. In 2015, a nephew
of Walter Keane's defended his uncle, saying he could paint, but there is
too much circumstantial evidence to prove otherwise. Yes, Walter Keane
was an amateur artist but it was Margaret Keane who delivered the goods
to ensure and maintain their lavish lifestyle. Walter Keane's forte was his
ability at marketing and selling the iconic 'big eyes' brand.

* * *

Both Elizabeth Durack and Margaret Keane come across as very differ-
ent women; the former confident, perhaps overly so, the other, shy and
retiring. Durack said her paintings just flowed out of her. In fact she had
trouble stopping the flow even after the truth was revealed about her alter
ego. Similarly Margaret Keane had the same urge to paint, noting that
'those sad children were really my own feelings that I couldn't express in
any other way'.[44] And both artists delivered their news about the truth
of the real artist in dramatic ways through the media, maximising the
outcome. Gender is at the core of both the Keane and Durack deceitful
practices. These two women, though artistically very different, make for

good comparison, for at the heart of their stories is how something as simple as the name of an artist (and their signature) can create major and irreversible outcomes. These are two extreme examples but other brazen miss-use of names and signatures continue to populate the art market. British artist Mandy Wilkinson has been the victim of commercial forgers who have stolen her name.

An abstract artist, Mandy Wilkinson (b. 1970) graduated from the Cumbria College of Art and Design in the early 1990s. Since then she has worked hard at securing a reputation as a serious contemporary artist. However, in 2009 Wilkinson earned a new mantra, that of Britain's most forged artist.[45] In short, Wilkinson's paintings were being copied by art factories in Guangdong, China, and sold online. Thousands have been sold and many of the new owners began to contact Wilkinson. In particular they were interested in the title of their work, as they didn't come with one, and if Wilkinson took on commissions. It was when several owners mentioned that their works were signed on the front that Wilkinson grew suspicious as she only ever signs her works on the verso. Plus she paints on board, not canvas like the ones coming out of Quangdong. What is more, many purchased their Wilkinson paintings on the understanding that it was a genuine work. The crafty copyists finished the works off by hand—with the most part of the work being made by machine—so as to offer them as hand-painted. A quick Internet search locates several Wilkinson works, signed on the front, and painted on canvas. Such searches do not mention the works being a copy and indicate they are actually by Wilkinson.[46] These are not genuine works and they are in infringement of the artist's copyright, making Wilkinson very much a victim. The signature on the front of the work definitively makes it easy to confirm as a forgery.

The alter egos of Durack and Walter Keane led to fraudulent art practice. Like all those other adoring fans in the 1960s, I would never have thought that the little reproduction of a beautiful girl with doe-like eyes on my bedroom wall had such a big ugly back-story; painted by a woman forced to paint under duress, in an era known for social change and enlightenment including women's rights.

NOTES

1. Helen Crabb used other pseudonyms for articles and reviews she wrote. They were: Barc, Helen Barc, HPC, The Chiel (a masculine Scottish term for a young man), and Verdant Green.
2. In 1977 Mary Durack was made a Dame.
3. Rebecca Hossack and Elizabeth Durack, *The Art of Eddie Burrup*, July 2000, London: Rebecca Hossack Gallery, p. 4.
4. Brenda Niall, *True North: The Story of Mary and Elizabeth Durack*, Melbourne: Text Publishing, 2012, p. 224.
5. Brenda Niall, *True North: The Story of Mary and Elizabeth Durack*, Melbourne: Text Publishing, 2012, p. 224.
6. Perpetua also known as Perpetua Hobcroft and Perpetua Durack Clancy.
7. *Australia Biography: Elizabeth Durack*, produced by Film Australia, Lindfield, NSW, 1997.
8. According to the 1996 Census, Broome had a population of 13,717 (www.abs.gov.au). During the tourist season, June to August, the population trebles.
9. Letter to Perpetua Durack from Rosie Potter (Acting Manager, Visual Arts Program, Tandanya, National Aboriginal Cultural Institute Inc.), 23 January 1996.
10. http://www.elizabethdurack.com.
11. *The Coming of the Gudea*, private collection, Melbourne, Australia.
12. http://www.elizabethdurack.com/burrup_7_response.php.
13. The finalists are hung at the Art Gallery of New South Wales, however in the early years of the Prize all entries were hung.
14. Robert Smith, 'The Incarnations of Eddie Burrup', *Art Monthly Australia*, March 1997, No. 97, pp. 4–5.
15. See the poem at: http://www.elizabethdurack.com/artworks_series.php?img_id=189&series_id=33&curPage=0.
16. John Walsh, 'The Scandalous Outing of Eddie Burrup', *Independent*, 26 July 2000.
17. Herb Wharton at the Cork Street, London, opening 24 July 2000. https://www.youtube.com/watch?v=-FtOYCibrak.
18. Robert Smith, 'The Incarnations of Eddie Burrup', *Art Monthly Australia*, March 1997, No. 97, p. 5.
19. Robert Smith, 'The Incarnations of Eddie Burrup', *Art Monthly Australia*, March 1997, No. 97, p. 5.
20. Robert Smith, 'The Incarnations of Eddie Burrup', *Art Monthly Australia*, March 1997, No. 97, p. 5.
21. Robert Smith, 'The Incarnations of Eddie Burrup', *Art Monthly Australia*, March 1997, No. 97, p. 5.
22. *Australia Biography: Elizabeth Durack*, produced by Film Australia, Lindfield, NSW, 1997.

23. Khadijavon Zinnenburg Carroll, 'My Big Ugly Art World: Grayson Perry on Aboriginal Art and How to Be Undiplomatic in the History Wars', *Art Monthly Australia*, No. 285, November 2015, p. 39.
24. Ian A. McLean (ed.), 'How Aborigines Invented the Idea of Contemporary Art', *How Aborigines Invented the Idea of Contemporary Art: Writings on Aboriginal Art*, Brisbane and Sydney: IMA and Power Publications, 2011, pp. 333–345.
25. *Valuing Art, Respecting Culture: Protocols for Working with the Australian Indigenous Visual Arts and Craft Sector*, Sydney, NSW: National Association for the Visual Arts, 2001, p. 56.
26. Mossgreen, *A Singular Australian*, March 2015. For the complete catalogue see: http://www.mossgreen.com.au/content/event/elizabeth-durack-a-western-australian-icon.
27. Brenda Niall, *True North: The Story of Mary and Elizabeth Durack*, Melbourne: Text Publishing, 2012, p. 228.
28. *Australia Biography: Elizabeth Durack*, produced by Film Australia, Lindfield, NSW, 1997.
29. Ted Snell, 'The Fantasist: Elizabeth Durack and Eddie Burrup', *Westerly*, Vol. 4, No. 1, July 2009, p. 85.
30. Ted Snell, 'The Fantasist: Elizabeth Durack and Eddie Burrup', *Westerly*, Vol. 54, No. 1, July 2009, p. 85.
31. https://www.youtube.com/watch?v=KcH8mBObTRo.
32. Glenn Davies, 'Rewriting History', *Independent Australia*, 3 February 2014, https://independentaustralia.net/politics/politics-display/rewriting-history,6125.
33. Paul Keating, 10 December 1992, Redfern Park, New South Wales speech ahead of the International Year of the World's Indigenous People (1993).
34. Ken Polk, *Who Wins and Who Loses When Art Is Stolen or Forged?* Department of Criminology, University of Melbourne, 1999, p. 10.
35. Jon Ronson, 'The Big-Eyed Children: The Extraordinary Story of an Epic Art Fraud', *Guardian*, 26 October 2014.
36. Amy M. Splinder, 'An Eye for an Eye', *The New York Times*, 23 May 1999.
37. Jane Howard, 'The Man Who Paints Those Big Eyes: The Phenomenal Success of Walter Keane', *LIFE*, Vol. 59, No. 9, 27 August 1965, pp. 39–40, 42–45, 48.
38. James S. Kunen, 'Margaret Keane's Artful Case Proves That She—And Not Her Ex-husband—Made Waifs', *People Magazine*, 23 June 1986.
39. Jennifer Warner, *Big Eyes and All: The Unofficial Biography of Margaret Keane*, Bookcaps, Kindle Edition, 2013, p. 34.
40. Collection of the artist.
41. Jon Ronson, 'The Big-Eyed Children: The Extraordinary Story of an Epic Art Fraud', *Guardian*, 26 October 2014.

42. Jane Howard, 'The Phenomenal Success of Walter Keane: The Man Who Paints Those Big Eyes', *Life Magazine*, 27 August 1965, p. 42.
43. Tyler Stallings, Doug Harvey, Margaret Keane, and Judith E. Vida, *Margaret Keane and Keaneabilia*, Long Beach, California: Sympathetic Press 2000.
44. Jon Ronson, 'The Big-Eyed Children: The Extraordinary Story of an Epic Art Fraud', *Guardian*, 26 October 2014.
45. Cahal Milmo, 'How a Little-Known Welsh Painter Became Britain's Most Forged Artist', *Independent*, 2 September 2009.
46. An example of a signed Mandy Wilkinson is Lot 4311, J. Levine Auction & Appraisal, Scottsdale, AZ 85253, Abstract painting by Mandy Wilkinson, sold on 25 June 2015, signed bottom right hand corner.

SELECTED BIBLIOGRAPHY

Carroll, Khadijavon Zinnenburg. 'My Big Ugly Art World: Grayson Perry on Aboriginal Art and How to Be Undiplomatic in the History Wars'. *Art Monthly Australia*, No. 285, November 2015, pp. 38–41.
Casement, William. 'Art and Race: The Strange Case of Eddie Burrup'. *Global Society*, Vol. 53, 9 June 2016, pp. 422–424.
Clancy, Perpetua Durack. 'A Portrait of the Artist as a Young Woman: A Partial View of Elizabeth Durack'. Durack Memorial Lecture, University of Notre Dame Australia, Freemantle, 6 July 2008.
Fry, Patricia. *Sit There and Draw That! Helen Crabb ('Barc'): Artist and Teacher.* Wellington: Steele Roberts, 2009.
Greer, Germaine. *The Obstacle Race: The Fortunes of Women Painters and Their Work.* London: Secker & Warburg, 1979.
Hossack, Rebecca and Elizabeth Durack. *The Art of Eddie Burrup.* London: Rebecca Hossack Gallery, July 2000.
Howard, Jane. 'The Phenomenal Success of Walter Keane: The Main Who Paints Those Big Eyes'. *Life Magazine*, 27 August 1965, pp. 39–48.
Knight, Peter. *Fakes and Forgeries.* Newcastle upon Tyne: Cambridge Scholars, 2005.
Laurie, Victoria. 'Daughter Reveals Motivation for Eddie Burrup Art Scandal'. *The Australian*, 6 August 2016. http://www.theaustralian.com.au/news/nation/daughter-reveals-motivation-for-eddie-burrup-art-scandal/news-story/ec8c5582205d558aa78404499b067a8e.
McCulloch, Susan. 'Blacks Blast Durack for Her Art of Illusion'. *The Weekend Australian*, 8–9 March 1997, pp. 1 and 10.
McCauley, Patrick, 'The Landscapes of Eddie Burrup'. *Quadrant*, December 2015, pp. 102–104.
Morrison, Louise. 'The Art of Eddie Burrup'. Westerly [The University of Western Australia], Vol. 54, No. 1, pp. 77–83.

Niall, Brenda. *True North: The Story of Mary and Elizabeth Durack*. Melbourne: Text Publishing, 2012.

Parfrey, Adam and Cletus Nelson. *Citizen Keane: The Big Lies Behind the Big Eyes*. Washington: Feral House, 2014.

Perry, Grayson. *Playing to the Gallery*. London: Penguin, 2014.

Polk, Ken. 'Who Wins and Who Loses When Art Is Stolen or Forged?'. Department of Criminology, University of Melbourne, Melbourne, 1999.

Ronson, Jon. 'The Big-Eyed Children: The Extraordinary Story of an Epic Art Fraud'. *Guardian*, 26 October 2014.

Smith, Robert. 'The Incarnations of Eddie Burrup'. *Art Monthly Australia*, March 1997, No. 97, pp. 4–5.

Snell, Ted. 'The Fantasist: Elizabeth Durack and Eddie Burrup'. *Westerly*, Vol. 54, No. 1, The University of Western Australia, July 2009, pp. 85–87.

Zakrovsky, Ted. 'Australia's Third World'. *Quadrant (Sydney)*, Vol. 28, No. 4, April 1984, pp. 38–41.

The Professionals

The people one least expects to act criminally within museum and library environments, the professional staff, are often the ones who do. Such organisations are far from exempt of white-collar crimes; in particular, the back-of-house areas are often a hotbed for criminal activity. Beyond the public areas of a museum or library are storage facilities and where the majority of staff work from. In the majority of cases, the back-of-house areas contain more objects (as well archives) than are displayed in the public exhibition areas. Such crimes occur when an employee helps themselves to items from collections or have knowledge about collection items. Collections staff have the knowledge of the whereabouts of items, their value, but also when they are to be exhibited next, and therefore when they could be found missing, if ever.

Some collections still go unaudited and in many instances, only a small percentage of a collection is ever exhibited at any given time, meaning the majority is in storage. For instance, London's British Museum has a collection of 8 million objects of which approximately 80,000 are on display in its magnificent Bloomsbury building. This is just 1%.[1] The Museum of Fine Arts in Boston shows 4% of its collection. This is a universal phenomenon; closer to home, for me, New Zealand's national museum and art gallery, the Museum of New Zealand Te Papa Tongarewa, currently has just 1.5% of its art collection on exhibition.[2] Most major museums, including art museums, showcase somewhere on average between 2 and 4%,[3] meaning that extensive holdings are kept in storage. Equipped with the right knowledge, an employee can make an informed decision

© The Author(s) 2020
P. Jackson, *Females in the Frame*,
https://doi.org/10.1007/978-3-030-44692-5_8

about what to take, when, and how. Libraries have been included in this chapter for they store historically valuable materials—books, archives, photographs, artworks, and maps—that unfortunately continue to be the targets of employee theft. The women presented in this chapter highlight the ease in which these crimes are committed, the lack of guilt and remorse demonstrated once caught, and how as professional employees they used their knowledge to perform insider crimes for personal gain, jeopardising often long-standing careers.

In small museums and libraries, curators and collections staff often work in isolation and are relatively unsupervised. Arguably, they are professionals and should not require full-on supervision. Larger organisations often have a myriad of small rooms—closed off due to climate control—making it relatively easy to access objects without being noticed. Not all have the luxury of surveillance cameras. Not only do objects and documents go astray, but so too can the documentation about a collection item, including digital records. With the exception of human memory, all evidence that the object existed, and its location, can be erased. In turn this can mean a lengthy period between when an object and its paperwork is taken and when it is discovered and reported missing.

Like other art crimes, especially theft and forgery, the motivation for institutional theft is financial gain. Employees are entrusted with large and valuable collections, and the temptation to steal for some is just too great. Some get caught, some don't. Criminal behaviour is unacceptable and has huge ramifications for both the institution and the individual. For the institution, sponsors can be discouraged to support an organisation that is plagued by criminal activity as donors are loathe to leave objects to an organisation that clearly has had its security breached.

Museums in particular are often criticised for their lack of quality security within exhibitions; those working in the public areas, such as visitor hosts and security guards, hold very responsible roles and yet for the most they are remunerated with the basic living wage. When there is a breach of security—theft or vandalism—the public and other employees come down hard on security staff. And though there are back-of-house security protocol measures in place, a knowledgeable staff member will know ways around this. If they are determined, they will find the time to plan their crime accordingly.

Theft is not the only kind of white-collar crime that cultural organisations face. Fraudulent activities such as acquiring works that don't have good provenance or title are classed as white-collar crimes. A case in point

is the former curator at the John Paul Getty Museum, Dr Marion True (b. 1948). She will not be discussed in detail here as others have documented her case in full. In short, True was accused of participating in a conspiracy that laundered stolen goods through private collections in order to create a fake paper trail that would serve as the items' provenance.[4] True slipped up when in 1996 she accepted a loan from a collector couple, whose collection had been incorporated into the Getty, in order for her to purchase a holiday home in Greece.[5] In 2005 True was indicted by the Italian court. The following year, Greece followed suit. The Getty would eventually return valued artefacts to Italy and Greece. All charges were dropped against True in 2010; but her career was in tatters, True became an exiled curator.

REBECCA STREETER-CHEN

Between 20 April and 22 April 2007, the Rockland County Historical Society had an antique atlas stolen from their storage room. Titled *Tanner's New American Atlas*, dating from 1823, it was reported to be worth USD$65K at the time of the theft.[6] The Society had been undecided about whether to accession the Atlas or de-accession it, in other words they could sell it and put the funds back into the Society. For the Society, this was a valuable item, later described as the jewel in the institution's crown.[7] Just over a month after its disappearance, the Atlas was located. On 31 May 2007, thief Rebecca Streeter-Chen surrendered to the police. Streeter-Chen had tried to sell the Atlas to the Philadelphia Print Shop. The shop's owner, Christopher Lane, smelt a rat and contacted the police.[8] Streeter-Chen was duly charged and sentenced to twenty-four weekends of community service and five years probation.

What makes this crime worse is that Streeter-Chen was the Society's curator at the time of the theft. She had insider knowledge of the Atlas's value (both historical and monetary); its whereabouts, access to it, and its potential market. Streeter-Chen got unlucky and Lane was right to be suspicious, as Atlases don't come up that often for purchase. As the Society was undecided about the Atlas' fate it meant there were no markings on the Atlas with the exception of a library catalogue number, which was perhaps easily removable. This made it an even easier target for Streeter-Chen. Shockingly, when she stole the Atlas from the Society she was accompanied by her two children, who witnessed the theft.

When Streeter-Chen was sentenced her lawyers asked for leniency. As the breadwinner for her family it was argued that she was needed at home. Her husband, Melvin M. Chen, tried to take the blame for the theft saying he had a drinking problem and he had committed the theft.[9] This line of reasoning did not wash with the court.

Streeter-Chen was 50 years of age when she committed her crime. She held positions of responsibility and trust both at the Society as a curator and project director, as well as being the Collections Curator of the William Trent House. Since the theft and subsequent return of the Atlas, which is often described as the first American atlas of the nineteenth century, the Society has sold it.[10] At the time of writing, an Atlas of the same edition was for sale for USD$85K. Streeter-Chen clearly thought she was potentially onto a good thing when she took the Atlas. Fortunately, her plan went awry and the Atlas was reclaimed. For Streeter-Chen, and others in similar positions, it is hard to imagine that she could be trusted again to care for valuable historical objects. Rare and valuable books are all too vulnerable to theft. The Rockland Country Historical Society was exceptionally lucky to have their Atlas returned.

Streeter-Chen is certainly not alone when it comes to book theft. In Wales, librarian Elizabeth McGregor stole hundreds of books from the Pontypridd Public Library including Joan Miller's book, *Aberfan: A Disaster And Its Aftermath*. The book was put up for sale on the online auction site, eBay, for £400. More significant though, McGregor stole valuable and irreplaceable documents and records relating to the 21 October 1966 Aberfan disaster in which 116 children and twenty-eight adults died when a waste tip slid down the mountainside engulfing houses and the Pantglas Junior School. One of the documents taken was the *Report of the Tribunal of Inquiry into the Aberfan Disaster*. When McGregor grew suspicious that she was about to be found out (her employment was subsequently terminated) she burnt some of the evidence and disposed of others in a recycling bin at her home. Fortunately, much of her stash was retrieved. During her court trial, McGregor was described as a lonely individual who had suffered a number of mental and physical health problems.[11] Nevertheless, 57-year-old McGregor was found guilty in January 2018 and was sentenced to an eight-month prison term.

In another case, Kathleen Wilkerson, aged 34 years, was sentenced to seven years probation in 1991 for stealing 101 rare books and documents from her workplace. With a master's degree in English, Wilkerson was employed part-time in 1981 at the Charles Patterson van Pelt Library

at the University of Pennsylvania, in the Special Collections department. She began helping herself to material in December 1985, concealing the books on her person.[12] During the summer of 1989 Wilkerson upped her ante to include the Library's most valuable book, a 1611 edition of Shakespeare's *Hamlet* that was believed to be one of only eight in existence.[13] Valued at USD$1M it was fortuitously spotted by a Baltimore book dealer who alerted the Library. Wilkerson had an eye for valuable items; when later charged she was found in possession of Shakespeare's *Merchant of Venice* valued at USD$100K and Dante's *Divine Comedy* at USD$25K. Significantly, and to try to conceal her thieving tracks, Wilkerson also stole index cards for her spoils, some dating back to the nineteenth century. Only 60% of the collection was computer-catalogued. At the time of sentencing, her heist was reported to be valued at USD$1,798,310; suffering from multiple personalities and bibliokleptomania (the uncontrollable theft of books), Wilkerson received two years' concurrent probation for tampering with the Library's records, and fined.

MIMI MEYER

Volunteer Mimi Meyer (1946–2009) was entrusted with working with rare books and therefore effectively given professional status at the Harry Ransom Humanities Research Center at the University of Texas, Austin. Tasked with undertaking minor conservation jobs on rare books, Meyer was given access to the rare book area. Her long-term partner, bibliographer, and librarian John Putnam Chalmers (b. 1940), bestowed this privilege upon her. In the early 1990s Chalmers was dismissed from the Center and Meyer decided to take revenge against the library in the form of several thefts. It wasn't until years later that she was caught and the enormity of her crimes were realised.

Meyer slowly, over the course of a couple of years, helped herself to books that she thought had a high monetary value (though she later said she hadn't planned on selling them). With books concealed in her bag or on her person, she simply left the building, amassing a total of almost 400 items.[14] Her cache included Audubon's *Birds of America* (quarto edition), Japanese art books, and works by Lewis Carroll.

In September 1992 Meyer was dismissed from her voluntary position. She had made the mistake of having a rare book in her work area that hadn't been checked out to be in the secure area. Having violated this protocol, others became suspicious of her, and a routine check revealed

many missing items. However, no charges were laid, as the Center had no evidential proof.

In 2001 a rare and valuable copy of *Il Petrarcha,* dating from 1514, was put up for auction by Swann Galleries, New York. Listed as missing since 1993, a New York librarian raised the alarm with the Ransom Center. Swann Galleries confirmed that Meyer was the seller of *Il Petrarcha.* In fact, over time she had offered forty-six other items for sale, successfully selling thirty-four of them. The FBI were called in and subsequently confirmed that Meyer had sold an additional fifty-seven books. All up, Meyer had acquired USD$400K from sales and it was estimated that she had stolen 400 items over a two-year period. The FBI recovered 300 books from her home and returned them to the Center.[15] Unfortunately, and ironically given she had worked in book conservation, though many of the books were subsequently found, they had been damaged by her removal of bookplates and ownership stamps linking them back to the Ransom Center.

According to Meyer's lawyer, she hadn't set out to sell the books but financially had no choice. Meyer co-operated with the investigation and pleaded guilty (not doing so could have meant ten years in a federal prison and a USD$25K fine). In late January 2004 she was convicted of the theft of materials, receiving three years probation and USD$381,595 in restitution fees. At the trial, it was noted that Meyer suffered from alcohol and mental health issues.

The scale of Meyer's revenge was considerable. The fact remains that Meyer robbed a university collection of rare and irreplaceable books, she damaged books therefore devaluing them, she denied scholars access to materials both temporarily and permanently, and lastly she violated the trust the Center had empowered her with, as a volunteer. Sadly, rare book and document theft is rife, although electronic tracking has improved security significantly in the last few decades, making it more complex for the thief to be successful. The Ransom Center opened new facilities in 2003 with a much higher level of security in place. Some would argue that the Center was lucky to have many of the stolen items returned. This is uncommon for book theft. The Museum Security Network, a Dutch-based not-for-profit organisation set up to combat book theft, estimates that only 2–5%of stolen books are recovered.[16]

Interestingly, educated professionals, as shown here, often undertake book theft. Curator and expert on crimes against rare books Travis McDade notes that the majority of people who steal from these places

are part of the patron class, most being men over 35 years of age with at least a bachelor's degree or even a master's degree.[17] However, women can be added to this profile for, as demonstrated, they too have a penchant for book theft.

LARISA ZAVADSKAYA

For thirty years Larisa Zavadskaya worked as a curator at the Hermitage Museum in St. Petersburg, Russia. Her expertise was in the large enamels collection. In an effort to cover the costs for her necessary insulin, diabetic Zavadskaya stole from her employer; from 1999 through to 2005, she steadily took 221 items from the Hermitage, valued at £2.6M.

During her thieving years, Zavadskaya was never challenged by the Museum. Her catalogue of theft included items of jewellery, icons, silverware, and enamelled objects. Offering to work at the weekend perhaps gave Zavadskaya easier access, and more time unaccompanied, in the collection store. Once Zavadskaya got the items home, she and her history teacher husband Nikolai G. Zavadsky would sell them to various antique shops or pawn them.

In late 2005, Zavadskaya's department was due to be audited. However, she perhaps feared the worst—that her six-year long thieving spree would catch up with her—and it did. Sitting at her desk in November 2005, Zavadskaya aged 52, suffered a fatal heart attack. It was only after her sudden death that the thefts were discovered.

When the news of Zavadskaya's death and thieving habits hit the headlines local antique dealers were horrified to find they were in possession of 'hot' objects from the Hermitage's collection. The fallout had even bigger ramifications; President Vladimir Putin demanded a full inventory of all of Russia's museums. This was a tall order given there are reportedly somewhere in the region of five million objects in Russian collections. Furthermore, Zavadskaya's case highlighted a greater problem for Russia's museum sector. As it turned out, items Zavadskaya had stolen were not insured, as only objects on exhibition were ever insured. The cost of insuring the entire collection was beyond their budget. The Hermitage has an estimated three million objects in its collections, with approximately 60,000 on exhibition; the remainder are stored in more than 1000 rooms. And the Hermitage was not alone in this policy of not insuring items. Funding, or the lack of it, was highlighted and many reports about Zavadskaya's criminal behaviour noted that she stole to raise funds for

her insulin because she was only paid ₱3K per month, the equivalent of £60.[18] The thefts also raised the issue of lax security and antiquated record keeping at Russian institutions, further underscoring the funding crisis that plagued museums and archives since the 1991 Soviet collapse.[19] In short, Zavadskaya's misdemeanour highlighted several topical issues for Russia's cultural and heritage sector.

Following Zavadskaya's death, her husband was found to have colluded with her over the sale of stolen items. All up, he had sold off seventy-seven objects. Sentenced to five years' imprisonment, Zavadsky was also ordered to pay back £147K to the Hermitage. Others were subsequently thought to have been involved, including the couple's son, also named Nikolai, who worked at the Hermitage from 1998 to 2004 as a courier. He was later released without charges. Antiques dealer Maksim Shepel was also taken into custody but later confined to a psychological ward for an eye injury that may, or may not have, been self-inflicted. Ivan G. Soboler was implicated but was arrested and later released.[20]

Zavadskaya paid the ultimate price for her crime—with her life. This inside job, carried out over six years, was how she chose to finish her three-decade long career. It is not as if she had weakened once; this was a long-term enterprise on a relatively big scale. Zavadskaya was dishonest but the lack of security and irregular auditing allowed her to take opportunities, and abuse the trust of her employer. Of the 221 items stolen, approximately half had been returned a few years after her death. Many of the pieces will have left Russia, making the job of finding them more complex. One missing item, a silver medallion pendant with an engraved portrait of Peter the Great measuring 2.6 by 1.7 cms, was repatriated to Russia in 2010. The medallion was recovered from a Seattle antiques dealership in 2009 having previously been sold online before ending up for sale in America.[21] This was an excellent result but dozens of pieces from Zavadskaya's haul remain at large. And that is the crux of art crime, the loss of cultural material that is impossible to replace. Zavadskaya was not alone in her light-fingered tendencies. At the time of the Zavadskaya case, Boris Boyarskov, chief of Rosokhrankultura, the agency responsible for safeguarding cultural heritage, suggested that each year as many as one hundred artefacts were stolen from Russian museums, mostly the result of insider theft.[22] Like all art crime, this number only represents those crimes discovered. Frustratingly, the great unknown is how many go unnoticed and therefore unreported.

ELENA BASNER[23]

In a case that has similarities to the Patricia Cornwall case discussed in *The Lady Destroyers*, Elena Basner was accused of an art crime before all the facts were known and presented. Dr Elena V. Basner (b. 1956) is a Russian art historian specialising in avant-garde art dating from the first half of the twentieth century. Basner was employed at the State Russian Museum in St. Petersburg, where she worked in the area of oil and tempera paintings, and later at the Swedish-owned auction house, Bukowskis. Basner has authored and co-authored several books about avant-garde artists, including Natalia Goncharova and Kazimir Malevich. However, Basner's reputation as an art historian was tested when on 31 January 2014, aged 56 years, she was charged with large-scale fraud. Four days later, she was placed on house arrest.

Basner was accused of authenticating a painting that turned out to be fraudulent. The work was a gouache painting titled *In the Restaurant* (1913) and was painted by Russian artist Boris Grigoriev (1886–1939). In May 2009, Estonian Mikhail Aranson asked Basner to authenticate *In the Restaurant*. She did. Certified, the authenticated work was sold, with Basner's help, to publisher Leonid Shumakov. To assist in making sure the work was genuine, Basner personally visited Shumakov as he had authored a book on Grigoriev. The painting was not listed in his book, nevertheless Shumakov acquired the painting from Aranson for USD$200K. A few months later in July, Shumakov sold the painting for USD$250K to Russian art collector and dealer, Andrei Vasilyev. Basner was given USD$20K for her work.

In the Restaurant depicts a busy jovial Parisian café scene; the band plays in the background and the well-coifed diners are oblivious to the viewer. By all accounts it is a typical early twentieth-century French scene, in this case seen through the eyes of a 'Russian artist'. Grigoriev lived in Paris, returning to St. Petersburg in 1913. The painting's new owner kindly loaned it to Moscow's Kournikora Gallery for an exhibition, *Russian Parisians* (21 March–20 May 2010). Visiting the gallery, art restoration expert Yulia Rybakova saw *In the Restaurant*, which she recognised as a forgery.[24] Rybakova was familiar with the work having deemed it a forgery prior to Basner authenticating it. The original authentic painting, *In the Restaurant*, was owned by Professor Boris Okuneve and had been stored since 1984 at the State Museum, where Basner was formerly employed.

Later it would come out in court that Vasilynev's painting was more likely to have been made in the 1970s and its value was just €160. Prosecutors wanted Basner to be found guilty and receive a four-year prison sentence, fined, and ordered to reimburse Vasilynev a large sum in compensation. But in what was a very public court case, Basner was cleared; on 17 May 2016 she was found to be not guilty and on 11 August 2016 the St. Petersburg City Court acquitted Basner. The court ruled that Basner's assessment of *In the Restaurant* was wrong, however it was not premeditated. Basner had been under house arrest just short of a year. In 2018 Basner was compensated by the St. Petersburg Court, receiving funds from the Russian Finance Ministry.

Basner's case raised issues for the professional art expert. Firstly, now more so than ever before, those employed in public art museums are reluctant to authenticate artworks. The backlash if they are found to be wrong can be costly, both in reputation and livelihood, for individuals and institutions. Basner received both support and condemnation from other art professionals. Some queried Basner's lack of memory regarding the authentic *In the Restaurant* held in the Russian State Museum's collection, given her awareness about the scale of fraudulent works,

The number of avant-garde fakes out there today is unbelievable, probably more than the number of genuine works.[25]

Surely armed with this knowledge, authenticating a painting on visuals alone was unwise. Documentations about provenance and scientific testing can provide more accurate results. Reportedly, Basner had authenticated the painting, at her home, on sight. The irony (or perhaps a demonstration of how difficult authenticating art can be without the right equipment and knowledge) of Basner making a wrong call is that part of her work as an art historian has been working with scientists to help to distinguish forgeries from genuine works. The basis of this study was around isotopes found in works due to the 550 nuclear bombs detonated between 1945 and 1963.[26] In short, Basner et al. recognised that nuclear fallout could be used to spot fraudulent art. Basner was working in this area in 2008, the year prior to her authenticating *In the Restaurant*.[27] Furthermore, Basner was one of a committee of experts at the Russian Art Fair in 2009, London, offering advice about protecting buyers from purchasing forgeries.

The time from Basner's arrest in January 2014 to her acquittal in 2016 must have been stressful to say the least. When scrutinising the events around the sale of *In the Restaurant* it is easy to see how information could be misconstrued. It is highly likely that even though the original painting was in the Museum's collection, a copy was made with the aid of a colour photograph taken prior to it being gifted, as access to it while in storage was limited.[28] The interest in Russia's avant-garde art has not waned over time and, due to demand, too many forgeries have been supplied. Unfortunately, even the best of scientific testing cannot guarantee outing a forgery for as art critic Simon Hewitt notes, access to materials from the 1920s courtesy of the KGB meant new paintings, painted with old materials, passed scientific testing.[29]

This aside, Basner took a risk that tried and tested her professionalism. She was eventually compensated for loss of income after she sued the State for 2,200,000 rubles, but there is no compensation for one's loss of reputation. As art crime writer Antony Amore notes:

> The expert denied any wrongdoing, and her arrest set the Russian museum community into a frenzy, angry and fearful that a colleague would be imprisoned for being tricked by a clever forger.[30]

Unfortunately though, a forgery is deemed a forgery until proven otherwise. The USD$20K kickback Basner received for her part in the sale of *In the Restaurant* pales into insignificance when compared with the effort and time it takes to claw back, if it is ever possible, one's professional reputation from such an event.

ROSE VALLAND

A book about women, art, and crime would not be complete without including Rose Valland. I've left her to last, for her story is the antithesis of others presented here. Her story is an impressive one of bravery and loyalty. Rose Antonia Maria Valland (1898–1980) was a French art historian and teacher, with degrees in Art History from the École du Louvre and the Sorbonne. She became a volunteer at Paris's Jeu du Paume, located in the north corner of the Tuileries Gardens. For years she worked in a voluntary capacity until the museum's curator took ill and Valland stepped up to take on his duties. Originally an indoor tennis court, the

Jeu du Paume in Valland's time (pre-World War II) housed and show-cased contemporary art including the 1937 exhibition of abstract art.

During October 1940, the Occupation of Paris saw the Germans take over the Jeu du Paume, with the exhibition space becoming the headquarters for the Einsatzstab Reichsleiter Rosenberg (ERR)—the Nazi looting organisation established by Hitler—and used for storing, sorting, and despatching confiscated art stolen from French collections and dealers, many of whom were Jewish.

At this time Jacques Jaujard (1895–1967), the Director of the French National Museums, including the Louvre, insisted that Valland stay on in her position at the Jeu du Paume. This decision would turn out to be extremely significant as the war raged on. Valland witnessed the comings, and more importantly, the goings of art as well as the visits by Herman Göring who selected works for Hitler's personal collection and the planned Führermuseum in Linz, Austria. Goering also chose works for his own private collection, though he was mindful of Hitler's wanted list.

The Jeu du Paume was hung floor to ceiling with art. The list of artists included Rembrandt, Rubens, Vermeer, Goya, Gainsborough, Picasso; a serious haul. By the end of 1944 it was estimated that close to 22,000 artworks passed through the Jeu du Paume. In addition to paintings there were sculptures, decorative arts, and tapestries.

Valland's official job was to document the works before they were despatched, which she did from October 1940 to July 1944. Unbeknownst to the Germans, Valland was a fluent speaker of German and so she was privy to all their conversations regarding the fate of the artworks. She never let on about her ability to understand them but rather remembered it all, recording it out of hours and off-site. Unofficially, each day Valland took home the contact sheets from photographs taken of artworks, to be copied overnight and returned discreetly the next morning. She also memorised lists of works and where they were being sent, keeping a record at home. At the cessation of war, Valland gave the information to James Rorimer of the ERR to co-ordinate a massive programme of repatriation. Valland also provided the Resistance with crucial information to prevent the bombing of the trains that carried the precious cargo away from Paris. Carrying out each of these clandestine tasks put Valland significantly at risk. On a couple of occasions she came close to losing her position; for her, and the future of thousands of artworks, this could have

been disastrous. She had to keep a low profile. From a German perspective, even though the French technically employed her, Valland was committing crimes on a daily basis by providing intelligence about the confiscated artworks to the French. If caught, there is no doubting what her fate would have been. As *Monuments Men: Allied Heroes, Nazi Thieves, and the Greatest Treasure Hunt in History* author Robert M. Edsel noted of Valland:

> Her role was to spy, to be the quiet mouse that slowly but surely chewed a hole in the foundation of the house.[31]

At times, Valland had to witness what no art historian wants to—the destruction of art. Not only did she see works sent into hiding—and for all she knew they might have been destroyed en route or never see the light of day again—but she also saw works destroyed. Hitler disliked modern art; Degenerate Art (Entartete Kunst) was the term used by the Nazi Party from the 1920s for such art. To cement his dislike, on 27 July 1943 he ordered a bonfire, burning between 500 to 600 works by artists such as Dali, Klee, Leger, and Braque. The paintings were gathered together—on the grounds of style and content—ripped from their frames, and then set alight. Valland witnessed this sacrilegious act of iconoclasm.

At the end of World War II, Valland continued her work at the Jeu du Paume. It was her good work that saw the eventual repatriation of thousands of artworks to their rightful owners. For her efforts she was decorated; Valland was awarded the Legion of Honour, the Medal of the Resistance, the United States' Presidential Medal of Freedom, the Federal Public of Germany's Officer Cross of the Order of Merit, and was made Commander of the French Order of Arts and Letters. Her dedication to her profession was highly commendable. Valland was indefatigable, never letting up when it came to putting right the wrongs of those war years at the Jeu du Paume. Lyn Nicholas, author of *The Rape of Europa*, the seminal text on the fate of European art treasures during the Third Reich and World War II, notes that by 1965 it was put to Valland, by the Director of the French Museums, that it was time to look forward, to forget the past. But, as perhaps only to be expected from this loyal subject, Valland couldn't entertain this idea. Nicholas goes on to say that Valland 'retreated entirely into her world of secret documents, which at her death were relegated, unsorted and chaotic, to a Musées storeroom in Malmaison'.[32] Valland was a true professional and though she was personally

responsible for covertly tracking 20,000 pieces of art, it would shamefully take until 2005 for a plaque of gratitude to Valland to be installed at the entrance of the Jeu de Paume.

NOTES

1. The British Museum Fact Sheet, British Museum Collection, https://www.britishmuseum.org/pdf/fact_sheet_bm_collection.pdf.
2. Katie Scotcher, 'Only 1.5% of Te Papa's Collection on Exhibition', Radio New Zealand, 24 October 2018.
3. Geraldine Fabrikant, 'The Good Stuff in the Back Room', *The New York Times*, 12 March 2009.
4. Hugh Eakin, 'Marion True on Her Trial and Ordeal', *The New Yorker*, 14 October 2010.
5. Jason Felch and Ralph Frammolino, 'Ex-Getty Curator Received 2nd Loan', *Los Angeles Times*, 17 November 2005.
6. 'New City: Atlas Thief Sentenced', *The New York Times*, 15 November 2007.
7. 'New City: Atlas Thief Sentenced', *The New York Times*, 15 November 2007.
8. Jeremy Dibbell, 'Former Curator Charged in Atlas Theft', 1 June 2007, http://philobiblos.blogspot.com/search?updated-max=2007-06-03T09:51:00-04:00.
9. Jeremy Dibbell, 'Former Curator Charged in Atlas Theft', 1 June 2007, http://philobiblos.blogspot.com/search?updated-max=2007-06-03T09:51:00-04:00.
10. 2010/2011 Annual Membership Meeting of the Historical Society of Rockland County, 12 April 2011.
11. 'Book-Burning Pontypridd Librarian Jailed for Thefts', *BBC News*, 31 January 2018.
12. Everett C. Wilkie (ed.), *Guide to Security Considerations and Practices for Rare Book, Manuscript, and Special Collection Libraries*, Chicago: Association of College Research Libraries, 2011, p. 285.
13. Elie Landau, 'Van Pelt Book Thief Sentenced', *The Daily Pennsylvanian*, 2 April 1991.
14. Everett C. Wilkie (ed.), *Guide to Security Considerations and Practices for Rare Book, Manuscript, and Special Collection Libraries*, Chicago: Association of College Research Libraries, 2011, p. 233.
15. Everett C. Wilkie (ed.), *Guide to Security Considerations and Practices for Rare Book, Manuscript, and Special Collection Libraries*, Chicago: Association of College Research Libraries, 2011, p. 234.
16. Carmen Cowick, *Crash Course in Disaster Preparedness*, Santa Barbara, CA: Libraries Unlimited, 2018, p. 37.

17. Marylynne Pitz, 'Money Often Motivates Thieves to Purloin Rare Items', *Pittsburgh Post-Gazette*, 21 July 2018.
18. Zavadskaya's salary was well below the national average of about 8000 rubles per month. Andrew Osborn, 'Hermitage Curator Stole to Buy Medicine', *Independent*, 11 August 2006.
19. 'Curator's Husband Guilty in Art Thefts', *The Star*, Toronto, 15 March 2007.
20. Steven Lee Myers, 'Curator's Husband Guilty in Thefts from the Hermitage', *The New York Times*, 16 March 2007.
21. Lornet Turnbull, 'Stolen Peter the Great Pendant Found in Seattle Returns to Russian Museum', *The Seattle Times*, 4 March 2010.
22. 'Thefts From Hermitage Exposes Pattern', *Associated Press*, 7 August 2006.
23. Also referred to as Yelena Basner.
24. 'Russian Art Historian Elena Basner Faces Fraud Charges', *artnet news*, 27 February 2015. See to an image of the forged painting visit: https://news.artnet.com/art-world/russian-art-historian-elena-basner-faces-fraud-charges-271226.
25. Andrew Tarantola, 'How Historians Are Using Nuclear Fallout to Find Fake Art', GIZMODO, 11 June 2014.
26. Chad Upton, 'Fake Art Can Be Detected Because of Nuclear Bombs Detonated in 1945', Broken Secrets, 20 November 2012.
27. Edwin Cartlidge, 'Nuclear Fallout Used to Spot Fake Art', *Physics World*, 4 July 2008, https://physicsworld.com/a/nuclear-fallout-used-to-spot-fake-art.
28. Ragai Jehave, *The Scientist and the Forger: Probing a Turbulent Art World* (2nd edition). London: World Scientific Publishing, p. 75.
29. John Helmer, 'The Great Falshak', Moscow, www.counterpunch.org, 1 May 2015.
30. Antony Amore, *The Art of the Con*, New York: St. Martin's Griffin, 2015, p. 229.
31. Robert M. Edsel with Bret Witter, *Monuments Men: Allied Heroes, Nazi Thieves and the Greatest Treasure Hunt in History*, London: Preface, 2009, p. 181.
32. Lynn H. Nicholas. *The Rape of Europa: The Fate of Europe's Treasures in the Third Reich and the Second World War*, New York: Vintage, 1995, p. 441.

SELECTED BIBLIOGRAPHY

Amore, Anthony M. *The Art of the Con*. New York: St. Martin's Griffin, 2015.

Bouchoux, Corinne. *Rose Valland: Resistance at the Museum*. Wichita Falls, TX: Laurel, 2013.

Cartlidge, Edwin. 'Nuclear Fallout Used to Spot Fake Art'. *physicsworld*, 4 July 2008, https://physicsworld.com/a/nuclear-fallout-used-to-spot-fake-art.

Charney, Noah (ed.). *Art and Crime: Exploring the Dark Side of the Art World*. Santa Barbara, CA: Praeger, 2009.

Cox, Steven Peter. 'White Collar Crime in Museums'. *Curator: The Museum Journal*, Vol. 60, No. 2, April 2017, pp. 235–248.

Edsel, Robert M. *Saving Italy: The Race to Rescue a Nation's Treasures From The Nazis*. New York: W. W. Norton, 2013.

Edsel, Robert M. with Bret Witter. *Monuments Men: Allied Heroes, Nazi Thieves and the Greatest Treasure Hunt in History*. London: Preface, 2009.

Fabrikant, Geraldine. 'The Good Stuff in the Back Room'. *The New York Times*, 12 March 2009.

Helmer, John. 'The Great Falshak', 1 May 2015, Moscow. www.counterpunch.org.

Jehave, Ragai. *The Scientist and the Forger: Probing a Turbulent Art World* (2nd edition). London: World Scientific Publishing.

Myers, Steven Lee. 'Curator's Husband Guilty in Thefts from the Hermitage'. *The New York Times*, 16 March 2007.

New City: 'Atlas Thief Sentenced'. *The Associated Press*, 15 November 2007.

Nicholas, Lynn H. *The Rape of Europa: The Fate of Europe's Treasures in the Third Reich and the Second World War*. New York: Vintage, 1995.

Pitz, Marylynne. 'Money Often Motivates Thieves to Purloin Rare Items'. *Pittsburgh Post-Gazette*, 21 July 2018.

'Russian Art Historian Elena Basner Faces Fraud Charges'. *artnet news*, 27 February 2015.

Tarantola, Andrew. 'How Historians Are Using Nuclear Fallout to Find Fake Art'. GIZMODO, 11 June 2014.

Thefts From Hermitage Exposes Pattern, *Associated Press*, 7 August 2006.

Upton, Chad. 'Fake Art Can Be Detected Because of Nuclear Bombs Detonated in 1945'. *Broken Secrets*, 20 November 2012.

Afterword: Making a Noise About the Silence

My objective in writing this book was to try to change the way we think about women, art, and crime. Empowered with a catalogue of art crimes, and a greater awareness of their nuances, some patterns emerged. The last woman discussed was the loyal and indefatigable Rose Valland. Not only did she undertake dangerous work by being an astute unofficial art spy, overseeing the repatriation of thousands of artworks, but she is also a fascinating example of how history has been documented and presented. Too often Valland has been given a minor role in books about art crime but more significantly her gender has got in the way of how she is presented. Art historian Aubrey Catrone challenges this very notion in the *Journal of Art Crime*; 'A Feminine Legacy: Contemporary Views of Rose Valland's Sacrifice in Occupied France' (2016), where she discusses how Valland has been presented in literature and films as a very feminine character, and how this has framed how we position her within art crime history. According to accounts about Valland's physical appearance—both historical and contemporary—she 'did not possess the physical ability to seduce men, and thus she posed no threat to the Germans stationed within the museum'.[1] To the present day reader, this attitude shocks, as we know Valland's male colleagues were not evaluated on their physical appearance. Robert M. Edsel refers to Valland as matronly and not particularly attractive.[2] In fact, he devotes an entire paragraph to her physical appearance, and it's not complimentary! We need to ask why this is so relevant to Edsel. Valland's physical appearance should not come into the discussion, for ultimately it did not affect her ability to carry out her

© The Author(s) 2020
P. Jackson, *Females in the Frame*,
https://doi.org/10.1007/978-3-030-44692-5_9

clandestine work for which she was well qualified. In fairness to Edsel, others have made similar comment; Gerri Chanel in her 2018 book, *Saving Mona Lisa: The Battle to Protect the Louvre and Its Treasures from the Nazis*, describes Valland as 'plain-looking and plainly dressed'.[3]

Interestingly, in the 2014 movie *Monuments Men* Valland, played by Cate Blanchett, was re-named Simone. In this cinematic version, Valland is presented as gorgeous and sexy, making her the right candidate for the love tryst with James Granger (the story would have been interesting enough without this fictitious add on). An earlier movie, *The Train* (1964), presented Valland as a 'mousy little spinster'.[4] The 2014 cinematic version, with its romantic element, simply reinforces gender stereotypes, both generally and specifically to the world of art crime. If we used this 2014 version of Valland as a measure then it would seem we have some distance yet to go in order to provide a more accurate picture of women, art, and crime.

Physical appearances coupled with gendered language are very much part of how women, art, and crime have been presented in the past, including stories about Valland and her colleagues. The work of the Monuments Men, who worked tirelessly to rescue and repatriate artworks plundered by the Germans, has been well documented. More recently, Arthur Tompkins' book, *Plundering Beauty: A History of Art Crime during War* (2018) offers a more up-to-date insight into their work and as he accurately notes:

> Despite the active service in the field of a number of remarkable women, the section would become known as the 'Monuments Men'.[5]

The official Monuments Men website lists twenty-four women who were involved. Of those twenty-four, many held degrees in the fine arts or art history. Some stand out in particular for their significant work. Librarian Jenny Delsaux (1896–1977) led a sub-commission for the return of books stolen by the Nazis from France. When she left the commission in 1950 she had overseen the return of an estimated 1.1 million books to a total of 2312 dispossessed individuals and 412 institutions.[6] Britain's only female member of the Monuments Men team was Anne Olivier Popham Bell (1916–2018). An art historian, Bell was heavily involved in logistics at Bünde, Westphalia. In her fifteen months stationed there she was described as being indispensable; assigned the rank of an Army Major, Bell

helped track down plundered art from salt mines, castles, and monasteries, hidden across Germany. American Captain Edith Appleton Standen (1905–1998) was the only woman of the thirty-two officers to sign the Wiesbaden Manifesto on 7 November 1945, denouncing the decision to transfer 202 paintings from Wiesbaden Central Collecting Point to the National Gallery in Washington. Her work included the enormous task of inventorying the artistic contents of the Reichsbank in Frankfurt prior to its relocation to Wiesbaden.[7] She would later become the director at Wiesbaden. Working closely with Valland, Standen would go on to see the restitution of thousands of artworks. By all accounts these women were humble; on a mission they saw it as their contribution to the war effort and they were using their professional skills for an excellent cause. A black and white photograph taken in May 1946 of Valland and Standen shows the diversity and scale of repatriation (see Fig. 9.1).

The photograph is very much a posed one, contrived to show both Valland and Standen in uniform, holding objects to be repatriated to France. All bases are covered in this carefully composed image; amongst the booty is a still-life painting (perhaps by the seventeenth-century French artist Jean-Baptiste-Siméon Chardin), a small painting of a Madonna, two pieces of sculpture including one from Assyria, and in between the two women, a life-size suit of armour. There are other versions of this photograph perhaps proving that it was a photographic shoot set up especially to promote, and celebrate, the stalwart work of the Monuments Men (and in this case, women). Valland and Standen make it look like another day at the office but in reality it was testament to their stellar work. And that they don't smile for the camera further confirms the seriousness of the task at hand. There are too many women to individually itemise here, which makes the point that they were actively involved in roles in recovering cultural heritage, aside from just clerical and administrative roles.

Within the context of the time, the Monuments Men as an overarching team title was accepted. However, going forward this needs to be redressed in terms of how we use language when it comes to discussing women, art, and crime or more specifically include the good work of the Monuments Women in future accounts of this area. Gendered language is inescapable when reading about art crime, and as with any discipline, gendered language is loaded. It can distort how we frame our thinking about people and events; in an era where there's no excuse for gendered language, there seems to be an inordinate amount used in conjunction with the writing up of art crimes. We cannot change what has

Fig. 9.1 Edith Standen and Rose Valland with art about to be repatriated to France, May 1946 (Unknown photographer. https://bernsau.wordpress.com/2014/02/09/monuments-woman-rose-valland/)

gone before, and so Valentine Contrel (aged 27 years when she offended) being described as a 'girl' repeatedly in the *New York Times* during 1907 has to be passed over, accepted as of its time. The language often used to report art crimes, especially in newspapers and news feeds, is sensational in order to attract readership. The adjectives applied to art criminals can also be loaded. Jacqueline Crofton, who threw eggs at Martin Creed's work *Lights Going On and Off* at the Tate Modern, was referred to as a 'grandmother', which she was. Whether this was a deliberate ploy to shame the 52-year-old or not is anyone's guess, however her matriarchal

role in the family had no bearing on the crime she committed. Crofton is an artist in her own right, yet very few made reference to her occupation.[8] Hannelore K. who used ballpoint pen on Köpcke's work was referred to frequently by the media as both an 'old lady' and 'granny'.[9] On fewer occasions, she was referred to as a dentist, her former profession. But one has to ask whether a male counterpart would be referenced as a grandfather or 'old man'. Possibly not. Cecilia Giménez, the Spanish woman who 'restored' *Ecce Homo* in her local church and became an overnight Internet sensation was constantly referred to as a 'grandmother'. The inference here was perhaps that she should have known better as a senior member of the community or perhaps that we shouldn't be so hard on her because she is a grandmother! Neither excuses what she did. When an armed Dr Rose Dugdale forced her way into Russborough House in 1974, the reports—before they knew whom the culprit was—referred to her as the 'girl with the dark hair'. She was 33 years-of-age at the time. Again, if she was a male I doubt the papers would have been looking for a 'boy with the dark hair'.

Over time language has become a little less gendered, however there is still some distance to go. Edward Dolnick's *The Rescue Artist* (2005) is an interesting case in point. He devotes two pages to Stéphane Breitwieser's crimes mentioning Marielle Schwengel six times, and Anne-Catherine Kleinklauss once. However, Dolnick never refers to either woman by their name, and in doing so plays down their active roles in Stéphane Breitwieser's criminal activity. In 2016, when Dr Jill Purce and a female friend stole a painting of Steve McQueen from Belfast's Bullitt Hotel the headlines read, 'Two old dolls snatch Steve McQueen canvas from Belfast Hotel.'[10] Another referred to the two thieves as 'old biddies' with yet another, as 'pensioners'.[11] Dr Jill Purce is still a practicing general practitioner and therefore neither retired or a pensioner. Adding further insult to their ages, one report said that one of the two women used a Zimmer frame. Viewing the surveillance footage shows one woman carrying a walking stick, not a Zimmer frame. Again the implication here is that she had limited mobility, and perhaps the two women were older than they looked. Clearly she was relatively mobile given she removed the large canvas! And lastly, the term 'cleaning lady' has been used over time when discussing artworks that have either been destroyed or damaged by a female cleaner. We never see 'cleaning man' used in this context and yet there are examples of male cleaners who have also accidently damaged or destroyed artworks.

As with Valland, descriptions of physical appearances have often been used when reporting about women, art, and crime. Writers, such as Edsel, surmised that she was plain, apparently advantageous to her completing such admirable work. More recently Hermitage Museum curator, Larisa Zavadskaya, was described as 'heavyset'. The media were trying to make a link with her size, her diabetes, and the crimes she committed in order to subsidise the purchase of medication for her diabetes. In another report, Zavadskaya was described as 'a sickly, cherub-faced museum curator'.[12] Wendy Whiteley, the widow of Australian artist Brett Whiteley, likened Sydney art dealer, Germaine Curvers' appearance to actress, Zsa Zsa Gabor, noting she had puffed up blonde hair, red lippie, the jewellery, and so much more.[13] Tatiana Khan was described by art crime writer Anthony Amore as being sickly and having severe scoliosis making her frail, which she used to her advantage to con people.[14] Amore goes one step further, embellishing his description of Khan to that of the Dickensian character, Miss Havisham.[15]

Another common trait to emerge from the cases presented here is the importance of familial ties and personal relationships to art crime. It is a major difference between the genders, art, and crime. Many of the subjects have committed crimes motivated by a desire to protect those closest to them, their family. The three mothers—Dogaru, Schwengel, and Greenhalgh—acted to protect their deviant sons. Clementine Churchill acted to protect the image of her beloved husband and Margaret Keane continued to paint to satisfy her husband's lifestyle and to protect herself and her daughter. Streeter-Chen's two children accompanied her when she stole the highly valuable Atlas and subsequently her lawyer asked for leniency in her sentence, as she was the family's breadwinner. Perpetua Clancy kept quiet about her mother selling works under the auspices of Eddie Burrup, protecting her in the short term from what would turn out to be a major controversy. And Mimi Meyer stole books from her place of work as revenge for her partner's loss of employment. Each of these examples demonstrates the strong link between art crime and personal partnerships and family.

Fictitious family ties also play a role here; Olive Greenhalgh created a story about her great-grandfather's art collection, a charade that was convincing. Petra Kujau's confusing relationship with her uncle/grandfather was fabricated to assist her with legitimising fraudulent works. And the two women aren't alone in taking advantage of deceased relatives. Helene Beltracchi (b. 1958), married to one of the world's most successful and

notorious forgers, Wolfgang Beltracchi (b. 1951), also called on deceased relatives to build up a back-story for having such a fine collection of art. Historic photographs of paintings, especially in situ, are gold to the provenance researcher. With this knowledge, Helene dressed up as her late grandmother Josefine Jägers and posed to be photographed. The story that Helene and Wolfgang Beltracchi would present to potential buyers was that Helene's grandfather was a Jewish industrialist who had a large collection of art that he hid on his German estate so as to avoid it being plundered by the Nazis. When he died, Helene inherited the collection. The photograph that proved this was of Josefine sitting in a room with four paintings and sculpture, all by contemporary artists such as Max Ernst and Fernand Léger. In reality, the paintings were black and white photocopies of forged paintings and Josephine was Helene, donned in a 1920s outfit (and of course there would have been a family resemblance that further endorsed the image). Cleverly, Wolfgang used a pre-war box camera, printed the image onto photographic paper from the time, and slightly underexposed it to give it a fuzzy out-of-focus vintage appearance (see Fig. 9.2).

It worked. Helene took the photograph with her to clients who never questioned its authenticity. For four decades Helene and Wolfgang Beltracchi amassed a fortune from making and selling fraudulent art. However, the law caught up with them in 2011 and they were handed down prison sentences and ordered to reimburse the many collectors they'd conned.[16]

Another fundamental difference between gender and art crime activity is that women are by and large not career art criminals; the majority of crimes committed by women are single one-off events (though some of the 'professionals' committed crimes over longer periods of time), either random or intentional. Men however, have 'enjoyed' long-term and more strategic careers. And many have continued in the art crime sector once caught, writing and sharing their knowledge and skill set. And this is a reason why men, art, and crime have received more attention. Returning to Noah Charney's specific observation that set me on my course of research, it is reasonable to surmise that there is little or no evidence to support the existence of the female forger of a similar ilk as the ones he presents us with. But of course Elizabeth Durack, Margaret Keane, and Petra Kujau were all art forgers in their own individual way. Nevertheless the female forger, closer in type than the male ones we know

Fig. 9.2 Photograph of Helen Beltracchi posing as her grandmother Josefine Jagers (*Photographer* Wolfgang Beltracchi, https://itsartlaw.com/2018/12/18/wywh-tricking-the-art-market-on-forgery-beltracchi-and-scientific-technology/)

of, have a place in fiction; typically they are young with good painting skills, and are often forced into making fraudulent works to make ends meet. In Barbara Shapiro's novel *The Art Forger* (2012), the protagonist Claire Roth imagines herself as a twenty-first-century Han van Meegeren. In the story, finding that the only forgers online are male, she considers that she might be the first female to join their illustrious ranks, saying to herself that she always wanted to be a gender-busting role model.[17] Annie Kincaid in *Feint of Art* (2006) was imprisoned as a teenager for making fraudulent art, and Dominic Smith's *The Last Painting of Sara De Vos* (2016) sees struggling graduate student Ellie Shipley make a copy of a seventeenth-century painting, *At the Edge of a Wood*, to be sold as the authentic work. Remorseful and regretting their actions, each of these characters have good reason to compromise their career when undertaking the task of making fraudulent work. Given their common ground, you

could be mistaken in thinking there was a model for the contemporary female forger, but alas she has eluded us in the real world.

Backtracking in time slightly, the nineteenth century saw the art forger as the preserve of men. As Aviva Briefel suggests in her book *The Deceivers*:

> Nineteenth century critics were unwilling to recognize either great or mediocre female forgers. These critics went to great lengths to preserve the image of the forger as a projection of middle-class masculinity.[18]

Such critics included Victorian artist and writer, John Ruskin, who pronounced it was better for women artists to copy the work of men than make their own frivolous and useless art.[19] And copy they did.

In the nineteenth century the copying of paintings, especially Old Masters, was considered essential to formal art education, despite gender. Generally speaking, once a male artist had conquered copying and produced original work they dispensed with the former. For the female artist though, earning a small income from making and selling copies was often her only option. But in terms of reputation, copying art achieved little for though it demonstrated skill, it lacked originality. This kept women at bay from exhibiting and therefore selling their work and being critically reviewed alongside male artists. Women were encouraged to copy by artists and critics such as Sir Joshua Reynolds and Ruskin. Amongst such men, there was a general attitude that women were not expected to produce original works of merit.[20] But that was the nineteenth century and since then, sometimes unbeknownst to those involved, subsequent generations have sold copies as authentic originals. In other words, a copy has the potential to become a forgery.

Access to copying of the Old Masters is at the very core of the male forgers' rise to prominence. Men traditionally faced fewer obstacles in becoming artists (and forgers), having had greater access to art education and copying in museums. In a more contemporary context, the Old Masters always attract much attention compared with lesser-known artists and so forgers such as Shaun Greenhalgh and Wolfgang Beltracchi sustained long and significant careers long before they were outed.

Hopefully the material in this book has both introduced the reader to new case studies and a new way of looking at women, art, and crime. As researchers and writers we often look to others for inspiration. Mary

Beard, a scholar whom I pay great heed to and who is a Professor of Classics at the University of Cambridge, encourages us think outside of the box, speak out, and be heard, which I hope I've done here in presenting another art history, for there are many art histories. Interestingly, Beard suggests to her reader in *Women & Power: A Manifesto* to close their eyes and 'try to conjure up the image of a president or—to move into knowledge economy—a professor'. She goes on to say that what most of us see is not a woman.[21] Likewise, when you search on the Internet for 'president' or 'prime minister' you get images of men. Applying the same process for an art criminal will result in sourcing portraits of male art criminals. It's not because they're the only ones committing such crimes, but rather it's how histories are written as well as how several male art criminals have relished the limelight. Beard talks of not being able to fit women into structures already coded as male[22]; only by changing the structure of how art crime is documented will a more accurate and equal picture be recognised. Beard wants women to be heard; by writing specifically about women, art, and crime, I too want to make a noise about the silence that has existed.

Profiling of art criminals has typically drawn similar conclusions. Psychologist Gerrit Breeuwsma noted 'that offenders are commonly male, single or recently divorced, and may have a history of mental problems'. In addition they may have 'also experienced some kind of traumatic event, have a penchant for fraud, or be artists who have failed to gain recognition for their own work and have discovered a skill for copying the work of others'.[23] Breeuwsma is right in that of the well-known art criminals there are certainly many common traits. More recently, Australian art historian Felicity Strong analysed the mythology specifically of the art forger as having the following traits: they struggle (poverty, disability, maligned by the art establishment), have artistic ability (talent in painting in another artist's style), and act on revenge (on the art market, art experts or wealthy collectors).[24] Though aligned with the male art forger they are useful nevertheless for making comparisons with the women featured here. However, one size does not fit all; finding common elements is both complex and has led to the development and acceptance of 'structures' that can cloud our thinking.

Art crimes become public knowledge through the media; art criminals aim to go under the radar (unless that is their intent such as a political protest), but when they are caught it becomes news and the sensationalism around reportage of art crime stories is attractive to readers. There

is no avoiding the fact that art crime makes for a good story, both in the real and imaginary worlds. Movies such as *Dr No* (1962), *The Train* (1964), *The Thomas Crown Affair* (1999), *The Italian Job* (2003), and the *Monuments Men* (2014) are very male-centric, skewing the reality of crimes against art. These movies present us with women in minor roles and more often than not, their characters are glamorous and alluring assistants. However, the very British and bungling character Mr Bean, played by Rowan Atkinson in *Bean* (1997), offers a counterbalance; he is not like the stereotypical suave characters found in the other examples cited above. In fact his task of couriering the 1871 painting, *Whistler's Mother*, ends in disaster. A recent slight redressing, in which woman are the protagonists, as well as being based on true events, are the movies *Woman in Gold* (2015) and *Big Eyes* (2014). Admittedly, both these movies have their fair share of glamorous women in them.

Having argued that the genders are treated differently in the way art crimes are presented—both fictional and non-fictional—it has to be noted that there is of course some common ground. For example, as already established, greed is more often than not the motivation for committing an art crime. One trait that male art criminals share as a group, is their willingness and lack of shame to be in the public arena. Of the women profiled in my study, few would have enjoyed the notoriety that crimes against art bring. However, in our age of the Internet, keeping out of the news is next to impossible and so their stories have become widely known and enjoyed.

The Internet, often that initial source alerting us of an art crime, can also be the platform for misinformation and ridicule. A case in point is two exhibitions hosted by the National Gallery of San Francisco. In 2015 an exhibition titled *The Right Thing to Do: Analysing Ash Material* was curated by Olga Dogaru. And the following year, the Gallery showcased *Petra Kujau: The Paintings*, hailing her as a leading German artist.[25] There was also an online review with images of Petra Kujau's work.[26] As it turned out, both exhibitions didn't exist in the real world, but did in the cyber world. That Petra Kujau's work called on Old Masters was a nod to her fraudulent practice and Olga Dogaru's curatorial skills were a tongue-in-cheek dig at her burning of Old Masters stolen by her son and his assistants. Staging them at the National Gallery of San Francisco was clever. As an institution it doesn't exist, yet sounds very plausible. As a folly or hoax, these exhibitions could send anyone researching the crimes of Olga Dogaru and Petra Kujau on a wild goose chase. It did me. And I

guess that's part of the objective, making fun of art, exhibitions, and the professionals who work in the sector.

Several of the art crimes discussed here are unsolved. It's likely that many will remain as such. For works stolen, and not recovered, there's always a little ray of hope that they will be found. And just sometimes it happens. De Kooning's *Woman-Ochre* was repatriated after thirty-one years, the *Portrait of Marta Ghezzi Baldinotti* dating from the seventeenth century was recovered in Palermo in 2018 having been stolen in 1986 from the Palazzo Chigi just outside of Rome. And two Vincent van Gogh paintings, missing from the Van Gogh Museum in Amsterdam since 2002 were found by police in Naples during a raid in 2016. These are feel-good art crime stories, but sometimes hopes are raised prematurely and cruelly.

In November 2018 there was much excitement for approximately twenty-four hours when Picasso's *Harlequin Head* (1971)—which Olga Dogaru may or may not have incinerated—was found underneath a tree in Tulcea County, Romania. And so Olga Dogaru's name was news again. The Picasso was one of seven works taken in a heist from the Kunsthal, Amsterdam, during October 2012. Journalist and writer Mira Feticu (b. 1973) was given a tip-off to locate the work. She duly located the work and handed it into the Dutch embassy in Romania. The work was then sent to the National Museum of Art of Romania in Bucharest for authenticating. It was found to be a fake, with strings attached; *Harlequin Head* was a cruel hoax set up as a marketing ploy for a performance called *True Copy* about the forger Geert Jan Jansen (b. 1943) who after two decades of getting away with making and selling fraudulent art, and pocketing approximately €10 M, was caught. The directors of *True Copy*, Yves Degryse and Bart Baele, marketed their play that was premiering in Berlin, by using a fake artwork. There was much media excitement (which was free) about the possible Picasso find and Olga Dogaru's name went public again for her role in the heist. Some imaginative planning had gone into the stunt for the woman directed to unearth the Picasso was none other than the author of *Tascha: De roof uit de Kunsthal* (*Tascha: The Robbery from the Kunsthal*), a novel about the 2012 art heist.

The label 'art criminal' is problematic. Calling Lady Churchill an art criminal might not sit well with her descendants or those who respect her, yet arguably given what she did to the three works (that we know about), has earned her the label. Equally, labelling Margaret Keane an art criminal, in comparison to say Wolfgang Beltracchi, doesn't seem right either; given

the context in which she was making her art for her husband to call his own and sell. There are different degrees of art criminal behaviours; the mothers who feature in Chapter 3 may have individually thought they had good reason for doing what they did but once an Old Master has been shoved down the waste disposal unit, there's no way back. Their crimes were heinous and they are deserving of being labelled art criminals.

For me, the Suffragettes' story is perhaps the most compelling; if there were ever a case of legitimate art vandalism, the Suffragettes take the cake hands down. The rampage that the British Suffragettes went on to make their voices heard is poignant given the time of my study. It is serendipitous that I was researching and writing this book in the year that New Zealanders celebrated 125 years of Women's Suffrage. New Zealand was seen as the social laboratory of the world, giving women the vote made us world leaders. It is a century since British women also won the vote—but not all women, just those who qualified: women over the age of 30 who were householders, the wives of householders, occupiers of property with an annual rent of £5, and graduates of British universities. Art is a great vehicle to aid in redressing and conveying women's history; 2018 saw the unveiling of Turner prize-winning Gillian Wearing's (b. 1963) 254 centimetre high statue of suffragist, Millicent Garrett Fawcett (1847–1929). The timing was not only significant, but also well overdue. The statue is the first of a woman to be located in London's Parliament Square and was initiated by feminist campaigner Caroline Criado-Perez (b. 1984). Fawcett is surrounded by historical male figures and ironically positioned so she looks across to Sir Winston Churchill, who was opposed to votes for women (mind you, so was Queen Victoria). And to make up for lost ground, the statue's plinth contains a gallery of fifty-nine portraits of both women and men who were instrumental in achieving women's suffrage, which goes someway to demonstrate equity. Statistically, Wearing's work joins just 3% of statues in Britain that depict real, non-royal women.[27] Furthermore, 2018 saw the historic moment when women in Northern Ireland were given the option of having legal abortions in their own country. The #MeToo movement, though in existence since 2006, took a greater hold in 2017 forcing issues of gender inequality and sexual harassment with significant results. Transparency is necessary to achieve equality on all kinds of levels including the documentation of women, art, and crime.

Finally, there is no doubting that women have been actively involved in art crime. Along the journey there were discoveries that I did not

foresee; for example, with the exception of Yazmeen Sabri, all the crimes against art featured were works by male artists. Even the forgers—Durack, Kujau, and Keane—made works that were exhibited and sold as those of male artists. As noted earlier, Germaine Greer's groundbreaking book *The Obstacle Race* was a watershed text in the development of redressing women artists' significant role and bringing them into mainstream art history. Published in 1979, she wrote, 'Part of the function of this book is to stimulate the curious reader into making *his* own enquiries.'[28] I am hoping that the material here will encourage curiosity. For me it is the obligation of art historians to research and write about artists and aspects of art history that have been neglected by others. In my opinion, the cases and issues around about women, art, and crime, fulfils a much-neglected area. In 1971 Linda Nochlin's essay, 'Why Have There Been No Great Women Artists?' was a catalyst for change. She probed a very male-centric art history and explored the obstacles that prevented an art history that included the myriad of women artists. Using her mantra I have continually asked the question, 'Why have there been no great women art criminals?' Whether 'great' or not, there certainly have been, and always will be, art crimes committed by women. However, there are plenty of cases for others to research and bring to light, all in an effort to provide a more complete picture.

NOTES

1. Aubrey Catrone, 'A Feminine Legacy: Contemporary Views of Rose Valland's Sacrifice in Occupied France', *The Journal of Art Crime*, No. 15, Spring 2016, p. 60.
2. Robert M. Edsel with Bret Witter, *Monuments Men: Allied Heroes, Nazi Thieves and the Greatest Treasure Hunt in History*, London: Preface, 2009, p. 134.
3. Gerri Chanel, *Saving Mona Lisa: The Battle to Protect the Louvre and Its National Treasure from the Nazis*, London: Icon, 2018, p. 221.
4. As described by Corinne Bouchoux in *Rose Valland: Resistance at the Museum*, Dallas, TX: Laurel, 2013.
5. Arthur Tompkins, *Plundering Beauty: A History of Art Crime during War*, London: Lund Humphries, 2018, p. 128.
6. See The Monuments Men Foundation, https://www.monumentsmenfoundation.org/the-heroes/the-monuments-men.
7. Lynn H. Nicholas, *The Rape of Europa: The Fate of Europe's Treasures in the Third Reich and the Second World War*, New York: Vintage, 1995, p. 377.

8. *The Telegraph* was an exception. See Marie-Claire Chappet, 'The Turner Prize's Most Controversial Moments', 20 October 2011.
9. 'Granny Fills in €80,000 Artwork Thinking It's a Crossword', *The Local*, 15 July 2016.
10. http://teakdoor.com/the-teakdoor-lounge/169984-two-old-dolls-snatch-steve-mcqueen.html.
11. 'Two Pensioners Attempt to Steal Steve McQueen Artwork', *The Irish Times*, 17 October 2016.
12. Alex Rodriguez, 'The Inside Job at Russia's Hermitage', *Chicago Tribune*, 20 August 2006.
13. James Morton and Susanna Lobez, *King of Stings: The Greatest Swindles from Down Under*, Melbourne: Melbourne University Publishing, 2011, p. 246.
14. Anthony M. Amore. *The Art of the Con*, New York: St. Martin's Griffin, 2015, p. 169.
15. Anthony M. Amore. *The Art of the Con*, New York: St. Martin's Griffin, 2015, p. 168.
16. For further details about the Beltracchi case see *Contemporary Perspectives on the Detection, Investigation and Prosecution of Art Crime: Australian, European and North American Perspectives* by (eds. Duncan Chappell and Saskia Hufnagel), Farnham: Ashgate, 2014.
17. Barbara A. Shapiro, *The Art Forger*, Chapel Hill, NC: Algonquin, 2012, p. 224.
18. Aviva Briefel, *The Deceivers: Art Forgery and Identity in the Nineteenth Century*, London: Cornell University Press, 2006, p. 32.
19. Aviva Briefel, *The Deceivers: Art Forgery and Identity in the Nineteenth Century*, London: Cornell University Press, 2006, p. 36.
20. Pamela Geraldine Nunn, *The Mid-Victorian Woman Artist: 1850–1879*, unpublished PhD thesis, University College, London, 1982, p. 328.
21. Mary Beard, *Women & Power: A Manifesto*, London: Profile, 2017, p. 53.
22. Mary Beard, *Women & Power: A Manifesto*, London: Profile, 2017, p. 87.
23. Gerard Breeuwsma, 'de rust van het onherstelbare; een kleine psychologie van het kunstvandalisme (Themanummer: kunst en criminaliteit)', *Justitiële Verkenningen* 1 (23) in Penelope Jackson, *Art Thieves, Fakers & Fraudsters: The New Zealand Story*, Wellington: Awa Press, 2016, pp. 161–162.
24. Felicity Strong, 'Challenging Public Perceptions of Art Crime', Artcrime2017, New Zealand Art Crime Research Trust Annual Symposium, Wellington, New Zealand, 14 October 2017.
25. https://nationalgallerysf.com/exhibitions.
26. http://www.dissolvesf.org/issue-4/petra-kujau-the-paintings.
27. Alexander Topping, 'First Statue of a Woman in Parliament Square Unveiled', *Guardian*, 24 April 2018.

28. Germaine Greer, *The Obstacle Race: The Fortunes of Women Painters and Their Work*, London: Secker & Warburg, 1979, p. 11.

SELECTED BIBLIOGRAPHY

Amore, Anthony M. *The Art of The Con*. New York: St. Martin's Griffin, 2015.

Beard, Mary. *Women & Power: A Manifesto*. London: Profile, 2017.

Briefel, Aviva. *The Deceivers: Art Forgery and Identity in the Nineteenth Century*. London: Cornell University Press, 2006.

Catrone, Aubrey. 'A Feminine Legacy: Contemporary Views of Rose Valland's Sacrifice in Occupied France'. *The Journal of Art Crime*, Issue 15, Spring 2016, pp. 59–62.

Chadwick, Whitney. *Framed*. London: Macmillan, 1998.

Charney, Noah. 'The Secrets of the Master Forgers'. *BBC Culture*, 1 June 2015. http://www.bbc.com/culture/story/20150601-the-secrets-of-the-master-forgers.

Dolnick, Edward. *The Rescue Artist*. New York: HarperCollins, 2005.

Edsel, Robert M. with Bret Witter. *Monuments Men: Allied Heroes, Nazi Thieves and the Greatest Treasure Hunt in History*. London: Preface, 2009.

Goodwin, Christopher. 'A Real Con Artist: How an Art School Dropout Pulled Off the Biggest Forgery Scam in History'. *The Times Magazine*, 10 May 2014, pp. 28–34.

'Granny Fills in €80,000 Artwork Thinking It's a Crossword'. *The Local*, 15 July 2016.

Greer, Germaine. *The Obstacle Race: The Fortunes of Women Painters and Their Work*, London: Secker & Warburg, 1979.

Jackson, Penelope. *Art Thieves, Fakers & Fraudsters: The New Zealand Story*. Wellington: Awa Press, 2016.

Jackson, Penelope. 'The Mothers of All Art Crimes'. *The Journal of Art Crime*, No. 18, Fall 2017, pp. 11–20.

Lind, Hailey. *Feint of Art (An Annie Kincaid Mystery)*. New York: Signet, 2006.

Morton, James, and Susanna Lobez. *King of Stings: The Greatest Swindles from Down Under*. Melbourne: Melbourne University Publishing, 2011.

Shapiro, Barbara A. *The Art Forger*. Chapel Hill, NC: Alconquin, 2012.

Smith, Charles Samarez. 'Anne Olivier Bell Obituary'. *Guardian*, 19 July 2018. https://www.theguardian.com/artanddesign/2018/jul/19/anne-olivier-bell-obituary.

Smith, Dominic. *The Last Painting of Sara de Vos*. Melbourne: Allen & Unwin, 2016.

Tompkins, Arthur. *Plundering Beauty: A History of Art Crime During War*. London: Lund Humphries, 2018.

Topping, Alexander. 'First Statue of a Woman in Parliament Square Unveiled'. *Guardian*, 24 April 2018.

INDEX

Ingram Content Group UK Ltd.
Milton Keynes UK
UKHW011813150323
418636UK00001B/120